輝煌時代
羅馬帝國特展

A SPLENDID TIME
The Heritage of Imperial Rome

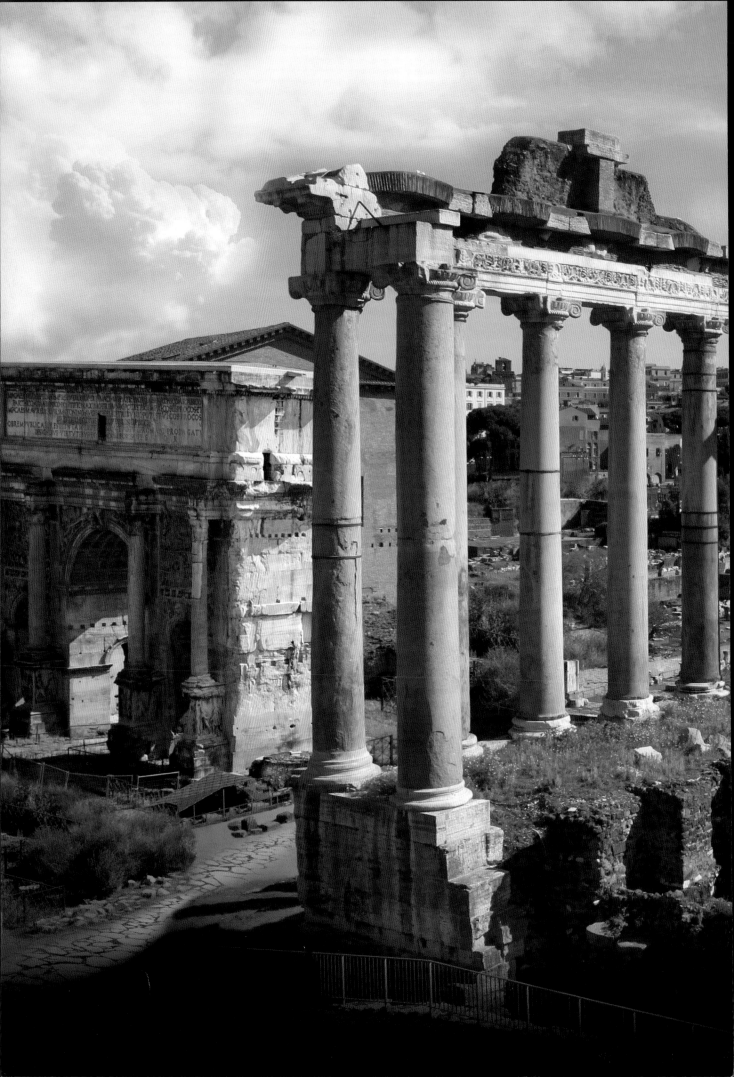

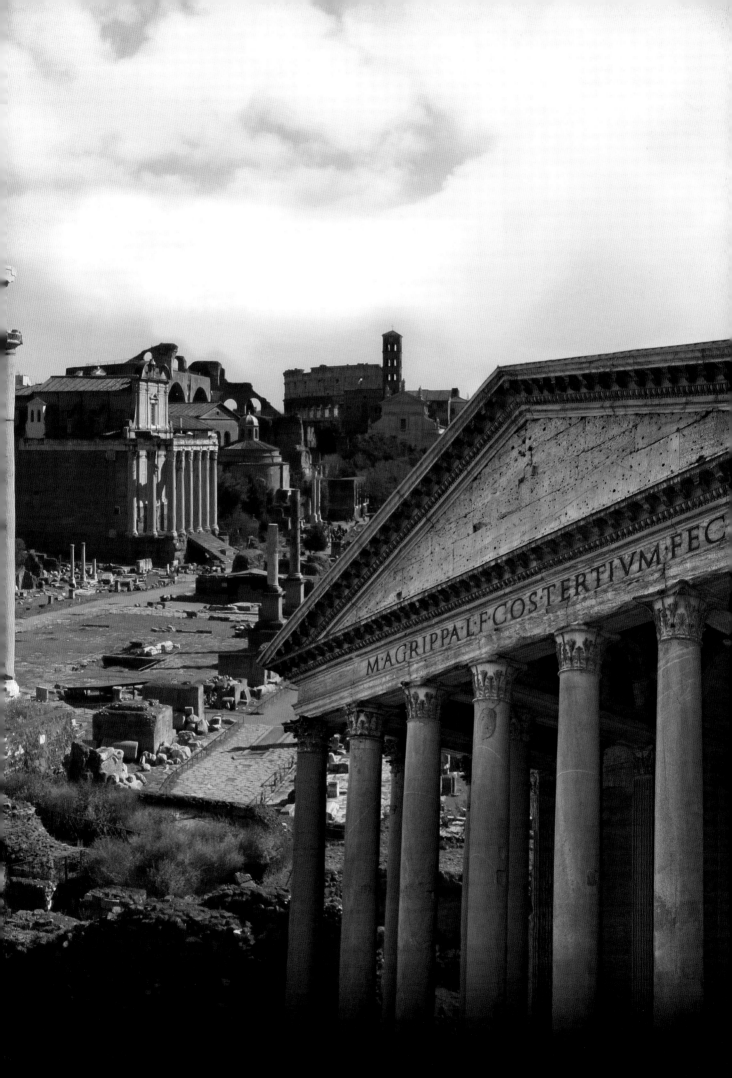

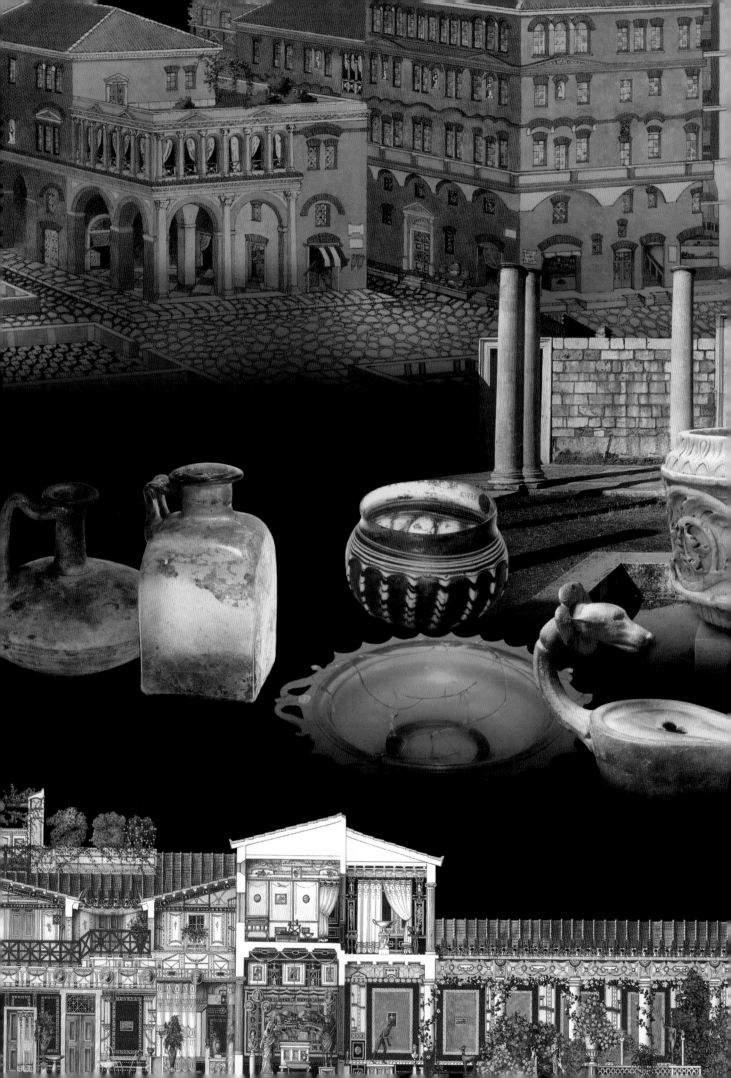

目　錄
CONTENTS

前言
Foreword

序

為了讓人們瞭解和欣賞源於義大利的偉大文明，我們籌辦「輝煌時代-羅馬帝國特展」以饗公眾。主辦單位相信，文物本身所包含的視覺資訊就是傳達展覽所蘊含的史實和文獻意義的最佳方式。

此次展覽最重要的目標是加深人們對羅馬帝國時期的瞭解和興趣，我們將竭盡所能為您呈現古羅馬文化的璀璨歷史。

得益於考古的研究成果，我們如今已擁有大量可供呈現羅馬文化的藝術遺產。展覽從中精選出最為人珍視的藝術品呈現在您的眼前。透過展示具有文化特色和藝術特點的文物，我們能揭示出羅馬文明的一般面貌和特質。此次特展為觀眾提供了全面瞭解羅馬文明的藝術品和古羅馬世界的機會。

展覽的宗旨是傳達明確清晰的資訊。為此，我們精心挑選能明確呈現帝國時代下古羅馬生活和藝術精髓的文物。另外，主辦單位格外注意文物的陳列順序和環境佈局，使之有內在的邏輯聯繫和易於觀看。對於大量封存多年的文物來說，此次展覽是極富心意的，也正因如此，應予以極大的關注和讚賞。

此次展覽將展示從西元前一世紀到西元三世紀中期羅馬帝國巔峰時期的君主文化。西元前27年，羅馬時代真正的轉捩點"羅馬紀元(Urbe)"出現了。這一年，羅馬元老院授予屋大維"奧古斯都"的尊號，屋大維即為羅馬帝國的開國皇帝。羅馬黃金時代自此揭開序幕。然而，西元244年，由元老院推舉的最後一位皇帝戈爾迪安三世死去，羅馬帝國隨之衰落。這是羅馬霸權終結的明顯標誌。從此，羅馬城和義大利不再是帝國政治和經濟的中心。其實，衰落趨勢的徵兆早在塞維魯王朝便已出現，公眾和社會生活的新觀念和新方式在那時候開始在帝國內部流行。戴克里先(西元284～305年)統治時期，這一系列的變革削弱了帝國基礎，對整個帝國政治和社會結構的轉變具有深刻影響。隨著羅馬帝國的衰落，蠻夷國家日益強大，並形成了歐洲中世紀的國家雛形。

此次「輝煌時代-羅馬帝國特展」共蒐集近300件展品，主要來自托斯卡納各博物館，尤其是義大利佛羅倫斯國家考古博物館。展品分佈於六個主題，其中有大量成套的硬幣、陶器、瓦器、玻璃器皿、雕像、甕罐、雕工精美的石棺雕刻、大理石雕塑、小型銅器和珠寶。

　　我要強調的是，此次展覽我們主要關注的是挑選最具代表性的羅馬藝術文化品，它們在體現羅馬帝國整體風貌上，遠勝於那些反映軍事或意識形態的器物。特展所涵蓋的羅馬帝國時代的文物事實上已不僅只是羅馬及其居民藝術品味的反映，也是融合了不同文化和不同歷史時期整個羅馬帝國的文化遺產。

　　後世歐洲藝術文化的發展正是因汲取了羅馬文明的獨特之處，因此羅馬文明也被視爲共同的歷史根源。羅馬藝術決定了整個歐洲大陸的藝術品味，推動了各地的藝術創作。羅馬藝術除了那些固有的價值之外，也因帝國內不同文化的融合保留了獨有的鮮明特色，具有極高的普世價值和歷史意義。

　　實際上，羅馬藝術主要突出的特點爲折衷主義。它糅合了古義大利、伊特拉斯坎和希臘元素於一體，最終形成其獨特的藝術風格。此外，羅馬藝術作品採用現實主義手法，討厭過於理想化、符號化或城市化的風格。羅馬藝術形式風格多樣，不能簡單地歸爲羅馬帝國年復一年的自然發展，而是羅馬帝國強勢擴張的產物。

　　在帝國時代，隨著羅馬軍團馳騁疆土，羅馬帝國的霸權擴展到整個西方文明世界。與此同時，羅馬文明因融合其被征服地的文化差異而變得日益龐雜。

　　古羅馬人不喜歡純粹的唯美主義，無用之物在他們看來是不可思議的。在他們數量龐大的藝術遺產中，即使是奢侈手工藝品也有不同功用。考古學家發現了大量使用貴金屬或銅製作，飾有精緻圖案及採用模子製作的精美陶瓶，大量的小雕像、寶石和浮雕寶石。除物品本身的美學價值外，羅馬人更看重它們所象徵的權力和財富。

　　在帝國時代前期，一些袖珍藝術品，如雕刻寶石、金屬浮雕工藝品和帶浮雕的陶器在藝術表達上的呈現已至巔峰。

　　在雕塑和淺浮雕藝術品中，肖像是羅馬藝術最具特色的組成部分。這些雕像的製作目的是爲歌頌羅馬社會精英，或置於喪葬的場合。

　　在這裏我想強調一下本展展品的另一重要意義：這些文物都擁有偉大的藝術和歷史價值。認識當下的唯一方式是瞭解自身的歷史，因此我們都負有不可推卸的責任去保護和保留這些文化和藝術遺產，因爲它們讓我們能夠重新審視和構建人類文明的不同階段。

佛羅倫斯國家考古博物館館長
吉斯皮納・卡洛塔・錢菲諾尼

INTRODUCTION

The proposal for an exhibition dedicated to the culture and art of Imperial Rome came from the desire to increase awareness and appreciation of this great civilisation that originated in ancient Italy. This project was organized with the conviction that the visual messages contained within artifacts are absolutely the most efficient instrument for conveying the meaning of the information and documentation contained within the exhibition.

It seemed to us that the most important objective of this exhibition should be to create a picture of ancient Roman culture during the Imperial age that is as complete and detailed as possible, in order to create a deeper understanding and appreciation of the period.

Thanks to archaeological research, we now have at our disposal a huge artistic legacy that enables us to choose among its works of art, those pieces that can be definitely regarded as the most significant ones. By exhibiting them, we can address both general themes and specific aspects of the Roman civilisation focusing on its most characteristic cultural and artistic features. This exhibition offers the public the opportunity to become acquainted with the outstanding artistic production of this civilisation, while also providing a general overview of the ancient Rome world.

With the criteria to give clear and direct pieces of information, we have chosen to exhibit objects that can readily depict and convey the essence of ancient Rome life and art during the Imperial age. Great attention has been paid to the arrangement of the artifacts and their order is intended to form a neat, logical framework. This context has given new meaning to a large number of the objects that have not been exhibited for many years and that, on the contrary, deserve greater attention and admiration.

The exhibition focuses on the Roman culture of the Emperors and, in particular, on those centuries when Rome was at the apex of its powers, that it is to say from the 1st century BCE to the middle of the 3rd century CE. 27 BCE can be considered the real turning point in the history of the "Urbe". In that year, indeed, the Roman Senate conferred the title of Augustus upon Octavian and elected him first Roman Emperor. This was the beginning of the golden age of Rome. On the contrary, the decline on the Roman Empire began in 244 CE when Gordianus III, the last Emperor elected by the Senate, died. This occurrence clearly marked the end of Roman hegemony. From that year on, Rome and Italy ceased to be the center of the political and economic power of the Empire. The first signs of this trend can be traced back to the Severan Dynasty when new ideas and new ways of conceiving of both public and social life began to impose themselves. During the reign of Diocletian (284 - 305 CE), these changes deeply affected and transformed the political and social structure of the whole Empire undermining its foundation. After the fall of Roman Empire, barbarian states strengthened and formed the basis of the future national states that shaped the Middle Ages in Europe.

This exhibition, Imperial Rome, assembles three hundred objects, primarily belonging to museums in Tuscany and in particular, the National Museum of Archaeology of Florence, Italy. Among the objects, are a large suite of coins, pieces of pottery, earthenware and glassware, portraits, urns, sarcophagus reliefs, marble statues, small bronzes and jewellery. They are distributed in six thematic sections.

Let me stress once again that one of our main concerns in the selection of the objects for this exhibition, was to focus attention on the strength of what can be called the Roman artistic culture that succeeded in unifying the extensive empire better that any army or ideology. Indeed, above all during the Imperial Age that is encompassed in this exhibition, Roman fine arts gradually ceased being simply the artistic expression of Rome and its inhabitants and evolved into the heritage of the entire Empire, melding together different cultural and historical legacies.

European artistic cultures owe much of their future development to this unique feature of Roman civilization that they all regard as the common historical root. Roman art shaped the taste of an entire continent and gave impetus to local artisan productions. Besides its intrinsic and undisputed value, Roman art is also universally and historically significant because it preserves the unique and distinctive features of all the different cultures annexed in the Empire.

In fact, the main and outstanding peculiarity of Roman Art is its eclecticism that succeeded in synthesizing Italic, Etruscan and Greek elements in a perfect and unique style. Moreover, Roman works of art are characterised by a well-balanced realism averse to any excessive idealization, symbolism or stylisation. Roman Art shows a great variety of forms and styles that cannot simply be ascribed to its natural chronological development but that are the outcome of the Roman expansionary attitude.

Indeed while its Legions conquered territories and spread Rome hegemony to the entire western civilised world during the Imperial Age, the Roman civilisation absorbed the different cultures it came into contact with, becoming more rich and heterogeneous.

The ancient Romans did not love pure aestheticism; the idea of objects being an end in themselves was simply inconceivable. Among their huge artistic legacy, even luxury handicrafts have different significance. Archaeologists have brought to light a large number of wonderful vases made of precious metals or bronze and decorated with refined figurative patterns together with ceramic ones manufactured on their model, and a large number of little statues, gemstones and cameos. Romans appreciated all these objects not for their aesthetic value but because they represented and emphasized the power and wealth of their owners.

During the first half of the Imperial Age, some of the so called minor arts such as glyptics, toreutics and ceramics in relief, came to the height of their artistic expressiveness.

As far as sculpture and bas-reliefs are concerned, portraits are the most distinctive attribute of Roman art. They were intended to celebrate eminent figures of Roman society or to be inserted into funerary contexts.

Please let me stress another important aspect of the objects displayed in this exhibition: they are all of great artistic and historical value. The only way to understand the present is to know our history; for this reason we all have a responsibility to protect and preserve the cultural and artistic heritage that allows us to reconsider and reconstruct the different phases of our civilisation.

Director of Museo Archeologico Nazionale di Firenze
Giuseppina Carlotta Cianferoni

序

　　近年來國民生活水準提高，本地藝文活動蓬勃發展，舉辦國際性展覽的頻率也愈來愈高，從十多年前的數年一次，演變至今的一年數次；展覽活動的熱絡，代表著臺灣民眾對於藝術喜愛程度與欣賞能力的提升，相對的，展覽規劃的需求也日趨精緻。此次，本處與聯合報系金傳媒集團再度攜手合作，共同主辦這次臺灣首見以羅馬帝國為主題的大型國際特展，內容豐富精采可期。

　　羅馬文明對於世界文化、歷史的發展及變遷極具影響，帝國歷史跨越千年，一度還稱雄於歐亞非三大洲，即便經過千年，她在法律、建築、語言、哲學、政治、藝術…等領域，仍深深影響著西方世界。

　　今夏，聯合報系與本處隆重引進的「輝煌時代－羅馬帝國特展」，展品多數來自義大利佛羅倫斯博物館，展件包括雕塑、錢幣、首飾、生活用品等近300件文物，以各層面展現出羅馬帝國政治、經濟、文化、軍事以及宗教等各方面的當時狀態，讓民眾有機會親眼目睹羅馬帝國輝煌壯闊的歷史篇章，實屬難得。

　　眾所周知，地中海地區是孕育人類文明與其發展的重要地區。人類歷史上的四大文明中，就有兩個是誕生在地中海沿岸。而亞平寧半島位處地中海的北岸，海的南岸是早期文明高度發達的北非地區，東方與西方文明另一發祥地－希臘隔著愛琴海相望。正是在這獨一無二的地理條件之下，孕育出人類文明史另一高度發達地區的代表－羅馬帝國。

　　羅馬帝國在相當長的歷史時期裡，以其自身的高度發展的文化、政治、經濟、軍事影響著周邊地區。其源始起步於城邦，最終將版圖連接著歐、亞、非三個大洲。在兩千多年以前，人類的生產力尚不發達的時代，從不列顛島到尼羅河畔都曾經是這一帝國的疆域，整個地中海成為羅馬的內湖，可以想見當時羅馬帝國國力之強盛。

　　羅馬帝國的興起、繁榮、鼎盛而至衰落、滅亡，其每一階段，莫不伴隨著整個歐洲人類歷史所發生的重大事件。羅馬城邦的誕生，是人類文明發展的結果；羅馬的帝國化，是歐洲生產力進步的體現；而羅馬的覆滅，則是人類社會進步的必然趨勢。從某一角度看，羅馬帝國已經不再是一個城邦的簡單發展史，而是一本鮮活的人類文明演進教科書。

　　聯合報系這次與本處、及義大利佛羅倫斯博物館聯合舉辦展覽的主要目的，就是希望能為亞歐大陸東岸，曾是一個偉大帝國的後裔們，提供一個與其祖先同時代的亞歐大陸西岸，另一個偉大文明的後裔們彼此認識和瞭解的機會，也期望藉由此次展覽，開啟中義歷史文化交流的新頁。

　　本次展出內容，不僅是珍貴的文化資產，更是一場精采的歷史文明饗宴，相當值得品讀觀賞；值此付梓之際，謹誌數語以為序。

國立中正紀念堂管理處　　處長

序

　　俗諺說羅馬不是一天造成的。羅馬發源於西元前八世紀，台伯河下游山丘的部落；西元前509年，羅馬王政時期最後一位伊特拉斯坎國王被人民驅逐，改採執政官、元老院、公民大會相互制衡的共和政體。

　　逐漸強盛的羅馬在地中海地區進行的軍事擴張，造就凱撒等軍事統帥，野心勃勃躍上政治舞台。凱撒遇刺後，他的甥孫暨養子屋大維在一連串權力鬥爭中贏得霸權。西元前27年，屋大維接受元老院授予的「奧古斯都」稱號，成為第一位羅馬帝國皇帝。奧古斯都宣稱尊重共和，實際上以君王專權進行穩定改革，為日後的羅馬帝國奠下雄厚的根基。

　　奧古斯都之後兩百餘年，是羅馬帝國最興盛繁榮的時代，雖偶有騷亂，這段「羅馬和平」仍稱得上人民安居樂業的承平時期，尤以西元二世紀的「五賢帝時代」最富盛名。

　　2013年聯合報金傳媒集團與義大利佛羅倫斯國立考古博物館共同策畫，並與托斯卡尼、羅馬、龐貝、奧斯提亞等地的考古機構合作。為國人引進台灣首見以古羅馬為主題的【輝煌時代-羅馬帝國特展】。

　　這次特展共展出近三百件真跡文物，展品主要聚焦於羅馬帝國的顛峰時期。西元前27年至西元244年，羅馬元老院授予屋大維奧古斯都的尊號，揭開羅馬帝國的序幕，至元老院推舉的最後一位皇帝戈爾迪安三世戰死，這段羅馬帝國顛峰時期的相關文化遺產。並特別規劃真跡結合羅馬時期的情境布置；運用精緻的展示科技，讓觀眾能透徹欣賞展品。

　　謹此感謝國立中正紀念堂管理處，提供良好的展覽空間，義大利佛羅倫斯國立考古博物館提供珍藏的羅馬文物精品；讓台灣民眾有機會親臨古羅馬遺址的現場。聯合報系非常榮幸，與這些夥伴共同參與輝煌時代！

<div style="text-align:right">

聯合報系金傳媒集團　　執行長

黃素娟

</div>

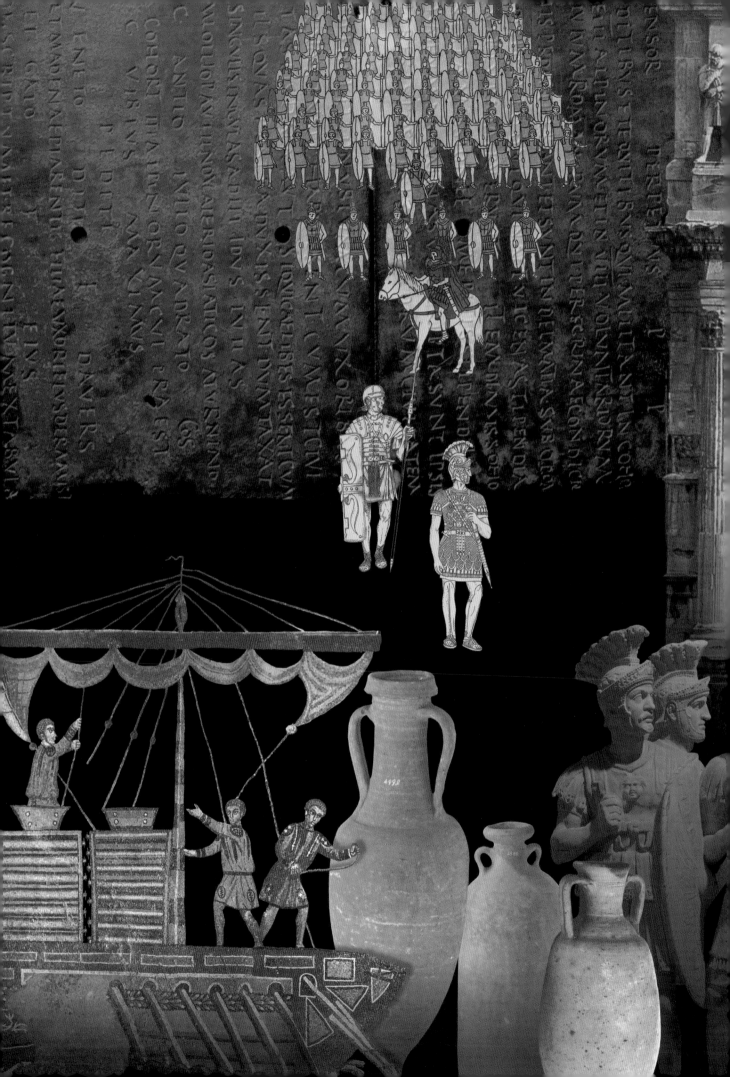

專文
ESSAYS

羅馬帝國之城市建築

佛羅倫斯大學 建築系教授 歐金尼奧・馬特拉

帝國時期的羅馬文化精髓莫過於建築藝術與城市構造。西元前31年，馬克・安東尼(Mark Antony)敗於希臘亞克興海戰，從此獨裁式統治的穩固政權開始形成，這就是歷史上赫赫有名的羅馬帝國。帝王一人獨攬大權後對包括建築在內的諸多領域有著深遠的影響，明顯的一點就是更多的資源可以有組織地爲公眾提供資助。

在建築領域，舉國上下大規模修建公共建築項目。其中，修復和完成凱薩(Julius Caesar)時代的遺留工程成爲首要之舉。作爲歌頌君權的重要手段，修建工程中對公共設施、市民工程以及宗教場所都賦予了象徵性元素。這對穩固政權意義重大。也因此，帝國時期的建築物並無特定風格，而是直接借鑒並融合了古希臘時期的古典傳統建築和義大利伊特拉斯坎藝術細節。

歷史學家一致認爲"奧古斯都古典主義(Augustan classicism)"扼制了上世紀共和體制下興起的自主創新。於強盛的帝國統治期間完工的建築雖氣勢恢宏且設計獨特，但其眞正新意並非表現於個別建築物本身，而是它們於城市格局中的傳播和組織影響力。單一建築不比公共建築彙聚的宏偉氣勢，然而帝國時期所建城市的統一結構展現了羅馬帝國非同凡響的主導地位。迄今爲止，這點仍能在諸多國家與其各異的文化中感受一二。此外，建築方面，城市基礎設施的建設是展現羅馬帝國權勢的最好佐證之一：橋樑、引水橋以及道路至今都能顯現出古代公共建築群卓爾不凡的價值。

在羅馬帝國不斷擴張期間，羅馬城始終是帝國不容置疑的政權中心。疆域的擴張使得歐洲、北非以及小亞細亞區域的每個角落都烙上了羅馬的印記。殖民城市、自由城市和納貢城市，這些不同類型城市的歷史沉澱鑄就了羅馬帝國的特色。據估計，羅馬帝國在衰退之前擁有大約5600個獨立城邦。羅馬帝國統治時期，隨著城市概念的逐步形成，西方人歷史上第一次體會到了所謂的開放世界，即法律和秩序優先，所有人都享有公民權益的概念。

羅馬城市的文明形成源於兩大藝術源流：伊特拉斯坎(Etruscan)文化和希臘(Hellenic)文化。在融合了伊特拉斯坎人的建築技術和古希臘建築成就之後，羅馬進行了自主創新，並塑造出一個宏偉國度的非凡城市形象。通過吸收臨近北部地方的伊特拉斯坎文明，羅馬文化將宗教信仰和對神的情感與城市建設和發展聯繫在一起。每座城市建立之前，都會請牧師進行預言講道，並利用犁溝出城市的邊界。

此外，城市建設根據基本方位點來定向，以符合自然規律。

城市呈方形建設，佈局特色是將南北走向的大道(cardo)和東西走向的大道(decumano)作爲主幹道。Cardo和decumano在城市中心地帶交彙，從而引申出"中心"的概念。市中心矗立著宗教建築和廣場，類似於集市(Agora)廣場和雅典衛城的羅馬建築交相輝映，彰顯宏偉氣勢。迄今帝國麾下區域的許多其他城市，仍能體現羅馬城市規劃的精髓。阿爾及利亞提姆加德市規整，棋盤式格局分佈，柱廊環繞大街，兩條主要道路Cardo和decumano十字相交，交彙處建有廣場、劇院及公共休閒場所，典型的城市佈局盡顯無遺，因此被稱之爲"規整的生活場所"。

從英國的賈斯特(Chester)到小亞細亞的安提俄克(Antioch)和以弗所(Ephesus)，此種類型的規劃在整個帝國隨處可見。城市的理想規模為2400 × 1600英尺。出於防禦目的，城市規模不能超出該範圍。新城按照最多容納50,000人口的標準來建設。

羅馬城的建設使得城市與農村環境間的平衡恰到好處，而確定這些城市規模和居民容納數的理想數值是其取得成功的主要因素之一。在很多地區，城市周邊的疆土也納入"幾何化"的城市規劃範圍，同時也勾勒了城市週邊領域的劃分和道路的方向和線性設計。羅馬式的區域劃法"centuriation"這種城市規劃體系使得義大利東部的達爾馬提亞(Dalmatic)以及北非景觀迄今仍保持一致。

羅馬城市規劃有著非常鮮明的歷史烙印，其主導地位也保持了幾個世紀。雖然歐洲城市空間規畫歷經了各類變遷，但直到十八世紀才出現大量實質性的藝術創新。毫無疑問，儘管沿習了古希臘的建築藝術，但羅馬建築的重要性和價值並不在於建築本身的華麗。羅馬城本身足以證明這一點，工程師的傑出才華與軍隊支持的完美結合，鑄就了眾多輝煌雄偉的公共建築。

建於西元前六世紀的大型汙水處理系統馬克沁下水道規模龐大，是古代羅馬最為宏偉的建築工程之一。帝國時期的羅馬已發展成為擁有百萬居民的大都市，而該下水道也緊跟其腳步發揮其重要的作用。該建築修建非常牢固，即使今天也仍在使用中。

很多歷史學家指出，希臘人建造城市注重其美觀性和軍事防禦，而羅馬人卻更為注重鋪路、水源供應及排汙體系的建設。西元前321年，克勞狄烏斯負責修建了羅馬第一條真正意義上的道路——阿庇安古道(The Appian Way)。帝國時代統治期間，所有的城市道路都由石頭鋪設。羅馬工程師的預期方案，如通過水平層面劃分區域來分離行人和車輛，在若干世紀後，被李奧納多·達文西作為基本規範所採用。並非所有的城市要素都由羅馬人發明，其中有不少要素在羅馬帝國建立之前已經得到廣泛的應用。而羅馬帝國的優勢在於讓這些要素成為城市建設須具備的"最低要求"。

總而言之，正因為羅馬帝國的城市建設或擴張，不同文化才得以在空間特徵相似的城市環境下和諧共存。事實上，如今已統一在歐盟名下的昔日各國，其有利條件之一就是都有著共同的特徵。

Architecture and the City in the Roman Empire

Eugenio Martera, Professor, Faculty of Architecture, University of Florence

The architectural works and structure of a city were important aspects of Roman culture during the Imperial period. With the victory over Mark Antony at the battle of Actium in 31 BCE, a stable political system was established based on an authoritarian structure historically defined as the Roman Empire. Power concentrated solely in the hands of the Emperor alone led to important consequences also in the field of architecture, with increased and institutionalized recourse to public patronage.

In the architectural field, a large-scale program of public works was implemented, initially with the resumption and completion of the sites and projects inherited from Julius Caesar. Public, civic and religious buildings were infused with symbolic significance and played an important role in political stabilization. Also for these reasons, the architecture of the period, although not definable as a single style, showed a marked classical and traditional tendency seen in the recurrent reproduction of Greek models and in recourse to Italic and Etruscan detail.

Historians agree on the observation that "Augustan classicism" did much to curb the autonomous innovation that took place during the last century of the Republic. Although often remarkable, it was not the single architectural works realized throughout the vast empire that represented true innovation, but rather their diffusion and organization in the form of a city. The combined power of public works, rather than their individual aspect, and the homogeneous structure of cities built during the Imperial period that still today represent an exceptional common denominator in so great a number of different countries and cultures. Moreover, one of the best examples of the power of Imperial Rome in architecture can be seen in structures which do not represent power, but rather embody the city's infrastructure: bridges, aqueducts and roads that still today provide outstanding insight into the value attributed to public works in ancient times.

The Roman Empire originated from the expansion of the city of Rome, which remained the sole, undisputed center of power. The characteristics of this expansion left the mark of the city of Rome everywhere in Europe, North Africa and Asia Minor. The Empire was characterized by the foundation of different types of cities: colonial cities, free cities, tributary cities. It is estimated that just before its decline, the Roman Empire consisted of approximately 5600 separate civic units. In the history of the formation of the concept of a city, it can be said that during the Roman Empire, western man, for the first time, perceived an open world in which law and order prevailed and the concept of citizenship was a privilege shared by all.

The origins of the Roman city derived directly from two important civilizations: Etruscan and Hellenic. From each it inherited various characteristics, but produced an autonomous and singular model that, as we have seen, gave rise to the urban image of a very vast area. Roman culture drew on the Etruscan civilization in nearby northern areas for religious implications and superstitions connected with the foundation and development of its cities. Before each city was founded, presages were interpreted and the city boundaries were traced with a plough of a priest.

In addition, the city was oriented according to the cardinal points so as to relate to a universal order.

Cities were rectangular in shape and the urban layout featured two main roads known as the cardo and decumano, respectively running from north to south and east to west. The cardo and decumano intersected in the center of the city, giving rise to the concept of a "center", where stood the religious buildings and the forum, the Roman equivalent of the agora and the acropolis united in a single space. The merits of Roman town planning can still be seen today in many towns throughout the areas united by the Empire. The city of Timgad, with its checkerboard layout, portico-covered avenues, and the presence at the cardo and decumano crossroads of the forum, theater and public conveniences, represents a typical city layout intended as "a structured living place".

This typology can be seen all over the empire, from Chester in England to Antioch and Ephesus in Asia Minor. The ideal size was 2400 by 1600 feet. Anything larger was considered detrimental for defensive purposes. New cities were built to accommodate a maximum population of 50,000.

The definition of these optimal measurements was one of the main values of a Roman city which, of this size and with this number of inhabitants, succeeded in keeping an excellent balance between the urban and rural environment. In many areas, the "geometrization" of the urban layout also regarded the territory surrounding the city, and outlined the division of fields and the direction and linearity of the roads outside the city. This system of "centuriation" still today unifies the landscapes of Italy, Dalmatia and North Africa.

Thus, the main characteristics of a Roman city were so dominant that they remained unaltered for many centuries and it can be said that although European urban space underwent various changes, it was not subject to any substantial innovations until the 1700s. Without a doubt, the importance and value of Roman architecture cannot be attributed to works of great aesthetic value even though of unequivocal Hellenistic derivation. For proof of this, suffice it to examine the city of Rome itself, where the work of engineers and the military combined masterfully to produce great public works.

One of the greatest feats of Roman engineering is considered to be the Cloaca Maxima, the great sewage system built in the VI century BCE on such a monumental scale that it was still functional even when Rome became a metropolis of 1 million inhabitants during the Empire. It was so sturdily built that even today, great stretches of it are still in use.

Many historians have pointed out how, in building a city, the Greeks were concerned above all with aesthetics and fortifications, while the Romans were more concerned with paving roads and supplying the city with adequate water and sewage systems. In 321 BCE, Appius Claudius had the first authentic Roman road built, the Appian Way, and during the Imperial period almost all city roads were paved. Roman engineers anticipated solutions postulated many centuries later by Leonardo da Vinci such as separating vehicular from pedestrian traffic through differentiating levels. Not all these urban endowments were of Roman invention; many had already been applied in times and places preceding Imperial Rome. The merit of the Roman Empire was that of having made them the "minimum requirements" for a city.

To conclude, thanks to cities founded or expanded during the Roman Empire, a great number of different cultures now live in urban environments with similar spatial characteristics. In fact, one of the benefits of the unity of those countries that have today been brought together under the name of Europe is precisely that of having this characteristic in common.

羅馬帝國疆域圖

MAP OF THE ROMAN EMPIRE

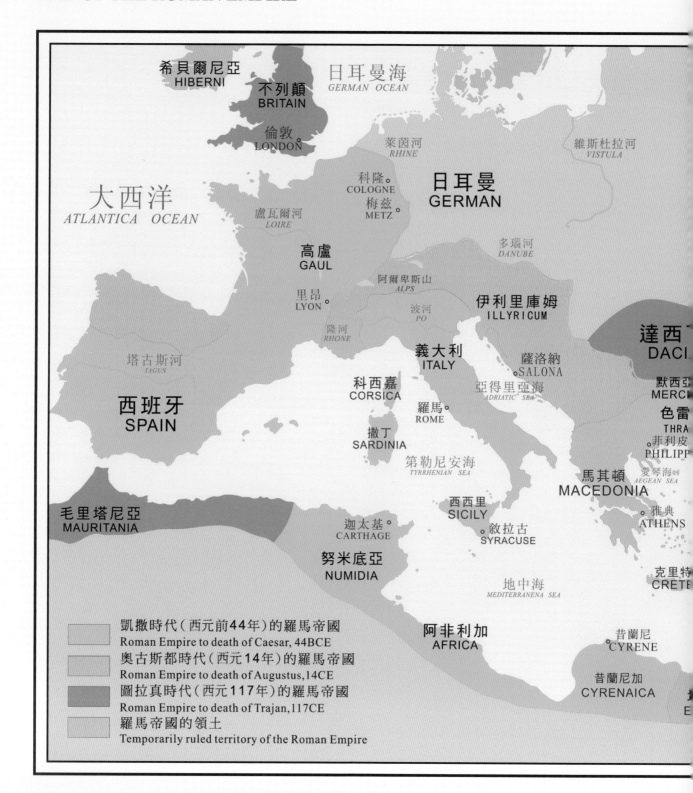

希貝爾尼亞
HIBERNI

不列顛
BRITAIN

日耳曼海
GERMAN OCEAN

倫敦
LONDON

萊茵河
RHINE

維斯杜拉河
VISTULA

大西洋
ATLANTICA OCEAN

科隆
COLOGNE

梅茲
METZ

日耳曼
GERMAN

盧瓦爾河
LOIRE

高盧
GAUL

多瑙河
DANUBE

里昂
LYON

阿爾卑斯山
ALPS

波河
PO

伊利里庫姆
ILLYRICUM

達西
DACI

隆河
RHONE

塔古斯河
TAGUS

義大利
ITALY

薩洛納
SALONA

亞得里亞海
ADRIATIC SEA

默西亞
MERCI

科西嘉
CORSICA

羅馬
ROME

西班牙
SPAIN

色雷
THRA

菲利皮
PHILIPP

撒丁
SARDINIA

第勒尼安海
TYRRHENIAN SEA

愛琴海
AEGEAN SEA

馬其頓
MACEDONIA

毛里塔尼亞
MAURITANIA

西西里
SICILY

雅典
ATHENS

迦太基
CARTHAGE

敘拉古
SYRACUSE

努米底亞
NUMIDIA

地中海
MEDITERRANENA SEA

克里特
CRETE

阿非利加
AFRICA

昔蘭尼
CYRENE

昔蘭尼加
CYRENAICA

凱撒時代（西元前44年）的羅馬帝國
Roman Empire to death of Caesar, 44BCE

奧古斯都時代（西元14年）的羅馬帝國
Roman Empire to death of Augustus,14CE

圖拉真時代（西元117年）的羅馬帝國
Roman Empire to death of Trajan,117CE

羅馬帝國的領土
Temporarily ruled territory of the Roman Empire

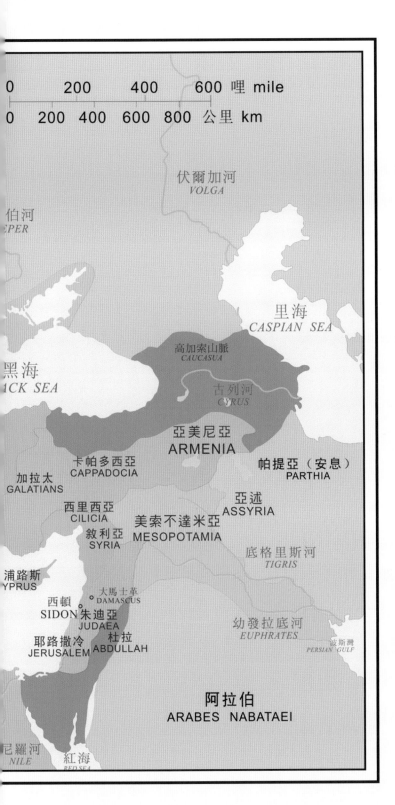

羅馬在共和時期最後的兩百年帝國版圖強勢的擴張，於圖拉眞時期(西元98～117年)達到了鼎盛。在其極度的擴張後，羅馬帝國的疆域北面包括不列顚、萊茵河以西、多瑙河以南所有的歐洲大陸，以及亞洲幼發拉底河以西的大部分、北非的沿海區域和所有的地中海島嶼。

The Rome achieved most of its expansion during the last two centuries of the Republic, and reached its greatest extent under the emperor Trajan (98-117 CE). At its maximum expansion, the Roman Empire encompassed Britain in the North, all of continental Europe west of the Rine and south of the Danube, most of Asis west of the Euphrates River, the coastal areas of Northern Africa and all the Mediterranean islands.

圖　版
PLATES

歷代帝王

THE EMPERORS

國際博物館展覽藝術史學家
琳達·卡瑞奧尼
Linda Carioni

Art Historian, International Museum Exhibitions

　　西元前八世紀，羅馬發源於台伯河岸邊的一個小村莊。羅馬帝國時期，西元前27年至西元前四世紀中期左右，羅馬的政治、經濟、軍事力量已在西方文明世界中居主導地位。而在羅馬帝國勢力範圍擴大的同時，其文化的影響也達到頂峯。

　　西元前509年，羅馬開始共和時期。在元老院（相當於現在的參議院）的領導下，羅馬建立了自己的政治體制，同時在地中海地區進行軍事擴張。然而，西元前一世紀，元老院執政危機引發了內戰。這場意義非凡的爭戰導致羅馬共和走向消亡。羅馬帝國亦應運而生。羅馬成功地擴張了其疆域後，面臨著由元老院代表的舊統治階級和平民階級主張民權和政治權利的新興社會力量之間的政治衝突。最終，擁有軍隊支持的平民獲得了勝利。西元前60年，元老院被迫承認了由凱撒、龐培和克拉蘇組成的"前三頭同盟"（Triumvirate）的合法地位。凱撒不斷的征服外族領地的行為招致了同僚和元老院的憎恨。西元前45年，他最終擊敗了所有反對他的人，施行了獨裁統治。在元老院的存亡之際，他們於西元前44年3月15日，由布魯圖斯密謀刺殺了凱撒，但這個舉動並不足以改變羅馬共和的命運。由馬克·安東尼、屋大維和雷比達組成的"後三頭同盟"（Second Triumvirate）誕生了，新的矛盾亦隨之產生。西元前31年，屋大維在希臘亞克興海戰中大獲全勝，事件也以安東尼和埃及女王克列奧帕特拉在亞歷山大城的自殺而告終。

　　西元前27年，屋大維接受了元老院賜予的榮譽稱號"奧古斯都"，成為了第一位羅馬帝國皇帝。依循羅馬共和的形式和傳統，他務實地回應著羅馬當時所存在的各種問題，並確保其統轄範圍有著長期穩定性和繁榮昌盛。他的權力涉及到整個羅馬領土及所有城中最高的統帥和官員。此權力雖大，卻也需要每年由元老院授予這項大權。然而他真正的力量卻源自於其個人的魅力基礎，也因此賦予了他日後無與倫比的聲望。像所有羅馬人一樣，他也有三個名字，其中"凱撒大帝·奧古斯都"的稱號最受到日後帝王們的高度讚譽。他還有一個由羅馬人民自己命名的民間稱號"元首"，意為羅馬第一公民，以區別於首個專制政府的第一個皇帝稱號。奧古斯都所取得的成就和羅馬人的社會快速發展，使奧古斯都文化在整個地中海國家廣為傳播成為必然。

　　雖然他並無子嗣，然而他那至高無上的地位驅使著他必須選擇一位接班人。這位接班人必須秉承其建立的帝國基質，就是奉行在百年後將由有

奧古斯都血統的繼承者來繼承王朝統治。他的繼承者包括提比略，殘酷瘋狂的卡利古拉，併吞英國的克勞狄和因火燒羅馬事件而遺臭萬年的尼祿。

　　當尼祿自殺時，提圖斯在東歐。西元69年，羅馬帝國處在逆轉期，在埃及、敘利亞和多瑙河的羅馬軍團擁立韋斯巴薌爲皇帝，他的兩個兒子，提圖斯和圖密善也接續帝位，三人執政期間稱爲弗拉維王朝。他們成功的統治了羅馬，且恢復了國家的財政穩定，並大規模修建了羅馬競技場等公共建築。

　　西元二世紀被認爲是擁有眾多傑出帝王的時代，例如圖拉眞、哈德良、安敦尼和馬可·奧里略。西元180年，馬可·奧里略的去世標誌著這一時代的結束，從某方面來說，也象徵著衰亡的開始。馬可·奧里略他那腐敗無能的兒子康茂德繼承了帝位，西元193年他被暗殺，亦吹響了南北戰爭的號角。塞普蒂米烏斯·塞維魯從南北戰爭中勝出，並建立了一個軍事獨裁的塞維魯王朝。而他的兒子卡瑞卡拉則是一位兇殘的暴君，隨後被他自己的部下刺殺身亡。接任的兩位塞維魯弗倫斯帝王都落得了類似的下場。這個模式從西元235年最後一位帝王沿襲到西元284年戴克里先的改革措施，才再次重建了羅馬帝國。在北非，一些對王座虎視眈眈的國家層出不窮，高盧和敘利亞頻頻發動國內戰爭，日爾曼部落始終在北部邊境步步逼近，波斯在東部邊境時有威脅。

　　歷經了這三個世紀的眾多起起落落之後，羅馬居民和其他奴隸既經歷過紛爭、遭受過暴行，也享受過一時繁榮。他們沉浸於戰爭勝利帶來的喜悅中，或受帝王的命令而行動。西元四世紀羅馬進入了君士坦丁一世的統治時期。他是第一位信仰基督教的羅馬帝王，曾一度想將拜占庭設爲首都。然而羅馬城依然維持它的中心地位，不光是地理位置上而言的帝國中心，同時也是人們信仰中奉爲聖地的城市。

Although Rome began as a small village of huts near the banks of the Tiber River in the 8th century BCE, it was during the age of Imperial Rome from 27 BCE to about the mid 4th century CE that Rome as the dominant political, economic and military power of the western civilized world, also achieved its utmost cultural impact throughout the vast sphere of Roman influence.

In the 5th century BCE, the Republic of Rome was founded. Led by its Senate, Rome was empowered by its political institutions at home and military expansion throughout the Mediterranean region. In the I century BCE, however, a profound crisis of Senate authority led to civil war and resulted in the birth of the Roman Empire and the death of the republic. Due to the success of its expansion into the provinces, Rome faced conflict between the ruling class of the past, embodied by the Senate, and emerging social forces that urged for civil and political rights for the plebian (general citizenry) class. Eventually, plebian interests with the support of the army took over and in 60 BCE, the Senate was forced to recognize the legitimacy of the first ruling Triumvirate, consisting of Caesar, Pompey and Crasso. Resplendent in his power derived from foreign conquests, Julius Caesar aroused the antipathy of both his fellow consuls and the Senate. He eventually defeated his enemies in 45 BCE and imposed authoritarian rule. In a last gasp of vitality, the Senate conspired to assassinate Caesar in 44 BCE on the Ides of March (March 15), but that event did not alter the republic's fate. The creation of a second Triumvirate, composed of Mark Antony, Octavian and Lepidus, led to a new conflict that would only end with the unequivocal victory of Octavian at Actium and the suicide of Mark Antony and Cleopatra in Alexandria in 31 BCE.

Through honours bestowed by the Senate including the name, Augustus, Octavian became the first Roman Emperor in 27 BCE. Respecting republican forms and traditions, his pragmatic responses to the problems of Rome and its provinces ensured stability, continuity and prosperity. Wisely, his power although perpetual, was annually bestowed, including imperium proconsulare majus (high command and governorship) of the city and all Roman territories. His real power, however, laid in his charisma that conferred unrivalled prestige. Like all Romans, he carried three names, but his, Imperator Caesar Augustus held such magic that later emperors would appropriate them as titles. His unofficial title, *princeps* (Prince), a term bestowed by the people of Rome and meaning first citizen, distinguished him as the first Emperor and his government as the first principate. The accomplishments of Augustus and Rome's predominance made inevitable the diffusion of Augustan culture throughout the Mediterranean world.

Although he had no son, again his unassailable position entitled him to select a successor thus establishing a system of Imperial adoptions that allowed dynastic rule that in later centuries would be by bloodline. His choice was Tiberius, the second of the Julio- Claudian emperors. Others included the cruel and insane Caligula, the capable Claudius who annexed Britain, and the notorious Nero, held accountable by history for the burning of Rome.

Titus Flavius Vespasian was in the East when Nero committed suicide. As the situation in Rome deteriorated during 69 CE, the Roman legions in Egypt, Syria and the Danube declared for Vespasian. Assured of their support, Vespasian marched on Rome where he was hailed as the new emperor. His two sons, Titus and Domitian, would follow him to the throne and the three of them represent the Flavian dynasty. They ruled successfully, restored fiscal stability and were responsible for massive public building projects such as the Colosseum in Rome.

The second century CE is considered the era of the good emperors - Trajan, Hadrian, Antoninus Pius and Marcus Aurelius. The death of Marcus Aurelius in 180 CE signals the end of the era and in some ways, the beginning of the decline. He was succeeded by his son, Commodus, corrupt and inept, whose assassination in 193 CE led to civil war.

Septimius Severus emerged victorious from the civil wars and installed a dynastic, military dictatorship. His son, Caracalla, a cruel tyrant, was assassinated by his own officers. The two Severan emperors that followed met similar ends. This was to be the pattern from the last Severans in 235 CE until Diocletian restructured the Empire in 284. Rival candidates for the throne and revolts in North Africa, Gaul and Syria meant almost constant civil wars. And all the while, Germanic tribes were pressing in on the northern frontier and Persians were threatening the eastern frontier.

Throughout the many ups and downs in the course of these three centuries, citizens of Rome and other subjugated populations of the Empire endured periods of strife, suffered atrocities, enjoyed periods of prosperity, rejoiced in military triumphs at the mercy and whim, sometimes the guidance and caution, of its emperors. From the climatic assassination of Julius Caesar to the rule of Constantine I, the first Roman emperor to convert to Christianity, who would make Byzantium his capital, the city of Rome would remain the pivotal center, both in the tangible sense as center of the Empire, but also in an intangible concept represented by the deification of the city.

奧古斯都肖像
Portrait of Augustus

奧古斯都時期(西元前27年~西元14年)
大理石
高40公分
佛羅倫斯國家考古博物館

Reign of Augustus (27 BCE -14 CE)
Marble
H. 40 cm
National Archeological Museum, Florence

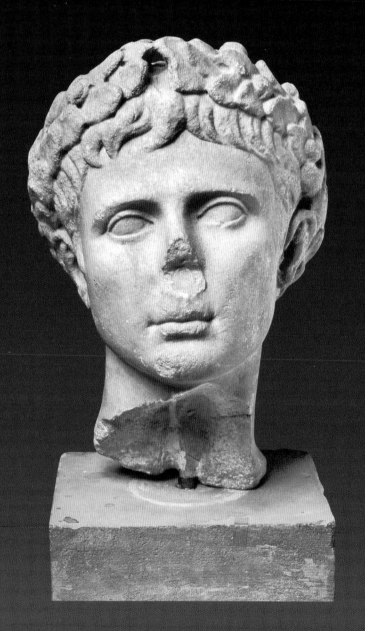

從臉部特徵上可以辨認出這是奧古斯都的肖像，尺寸要比同類型肖像稍大，暗示這可能是一件死後的肖像。

花冠上鑲有一塊經雕琢的寶石或刻有浮雕的貝殼(在奧古斯都的前額中心)。由寶石裝飾的橡樹和花冠是皇帝的標誌，從奧古斯都到君士坦丁，許多皇帝的肖像中都有所表現。學者猜想花冠是克羅那花冠(城市花冠)，但是尖狀的樹葉包圍著圓形的花朵顯示出這是月桂樹的花冠。這是唯一所知的描繪奧古斯都戴有頭飾的圓雕塑像，此類肖像在貨幣和珠寶上也很常見。

Recognizable from the facial features as a portrait of Augustus, the dimensions are slightly larger than other examples of the same type, suggesting that it may be a posthumous portrait.

A gemstone or a cameo was probably set in the hole in the wreath (in the middle of Augustus?forehead). Oak and laurel wreaths embellished by a jewel were imperial insignia and are present in portraits of several emperors from Augustus to Constantine. Many scholars have supposed the wreath to be the corona civica (civic wreath), but the foliage of pointed leaves interlaced with round flowers suggests that it is a laurel wreath.

This is the only known full relief sculpture that depicts Augustus wearing such a headdress, but this kind of portrait is quite common on coins and jewels

屋大維 (凱撒・奧古斯都) OCTAVIAN (CAESAR AUGUSTUS)

　　西元前31年，馬克・安東尼和克列奧帕特拉在亞克興角(希臘西部外海)被屋大維擊敗，這兩個情人雙雙自殺。之後，奧古斯都統治了羅馬五十五年。在經歷了一個世紀的政治動盪之後，他為羅馬帝國帶來了穩定、和平和繁榮。

　　奧古斯都小心翼翼地隱藏起他的個人野心，把自己偽裝成一個重建共和的君主。他改革了政府，為自己及繼任者的獨裁統治而將相應法規制度化。他更喜歡"第一公民"(princeps)的稱號，以及後來被稱作元首制的那段帝國統治時期。

　　奧古斯都拓展了帝國的邊界，並直接管理文化事務，美化羅馬。他聲稱接手的是一個磚頭建造的城市，而留下的是一個大理石建成的城市。羅馬帝國在其統治管理之下也終於得以歇息，國泰民安，經濟繁榮。他的成就和羅馬的優勢地位使奧古斯都文化，在整個地中海地區傳播開來成為必然。

　　After the defeat of the armies of Mark Antony and Cleopatra at Actium (off the coast of Greece) and the subsequent suicides of the two lovers in 31 BCE, Augustus ruled for the next forty-five years. He and brought stability, peace and prosperity to the empire after a century of political turmoil.

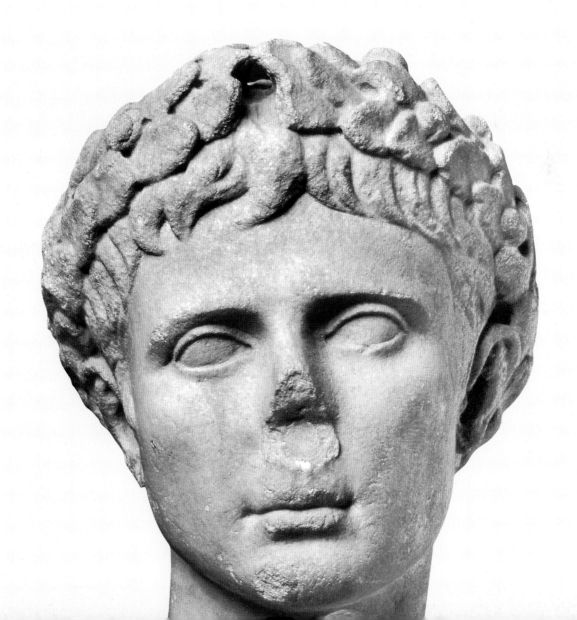

圖拉眞肖像
Portrait of Trajan
圖拉眞時期(西元98~117年)
大理石
高27公分
佛羅倫斯國家考古博物館

Reign of Trajan (98-117 CE)
Marble
H. 27 cm
National Archeological Museum, Florence

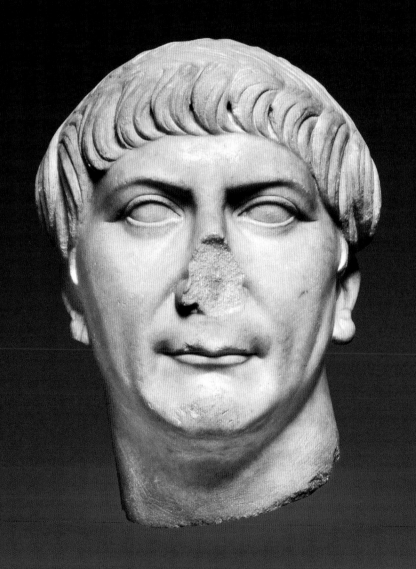

圖拉眞是一位非常成功且受
歡迎的皇帝，留下了許多雕
像。他低眉、短髮、鼻隆
(此件已殘),嘴唇寬而薄。西
元53年,他出生於西班牙的
義大利卡市。 之後,他成為
上日爾曼行省的總督,並被
涅爾瓦皇帝收為養子,被任
命為下一任皇帝。

Trajan was a very successful and
popular emperor, and many of
his portraits have survived. He is
identifiable by his low brow, hair
brushed down in bangs, pointed nose
(missing in this portrait), and wide,
thin lips. Born in 53 CE in the Spanish
city of Italica, Trajan was serving as
governor of Upper Germany when
Nerva, by adopting him, designated
him as the next emperor.

哈德良肖像
Portrait of Hadrian
哈德良時期(西元117~138年)
大理石
高70公分，寬60公分
佛羅倫斯國家考古博物館

Reign of Hadrian (117-138 CE)
Marble
H. 70 cm, W. 60 cm
National Archeological Museum, Florence

哈德良是首位以落腮鬍形象出現在雕像中的皇帝，也許反映了他喜歡所有希臘的東西。古代傳說另有他以鬍子掩飾臉上缺陷的說法。圖拉真和哈德良都來自同一個西班牙的城市。圖拉真的妻子普洛蒂娜鍾愛哈德良，慫恿哈德良娶了圖拉真的侄女葳葳·沙比娜，使圖拉真在死前收養哈德良，並任命他繼位。

Hadrian was the first emperor to be depicted in portraits wearing a full beard, possibly reflecting his love for all things Greek. One ancient source gives a different explanation he beard covered blemishes on his face. Trajan and Hadrian were cousins and from the same Spanish city, but apparently it was Trajan wife Plotina who took a special interest in Hadrian. She encouraged Hadrian marriage to Trajan niece Vivia Sabina, and may have been largely responsible for Trajan deathbed adoption of Hadrian, which designated Hadrian as the next successor.

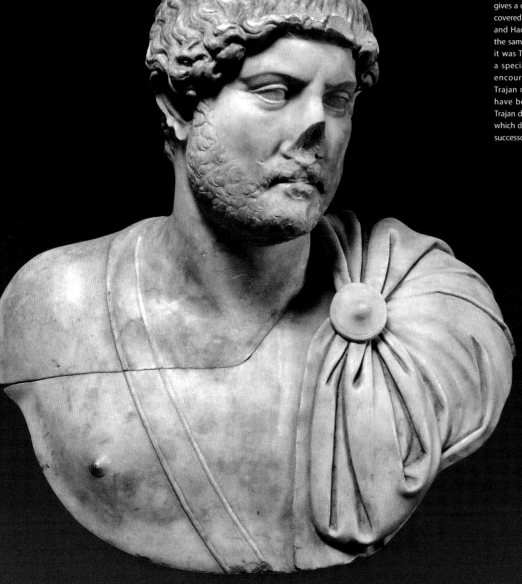

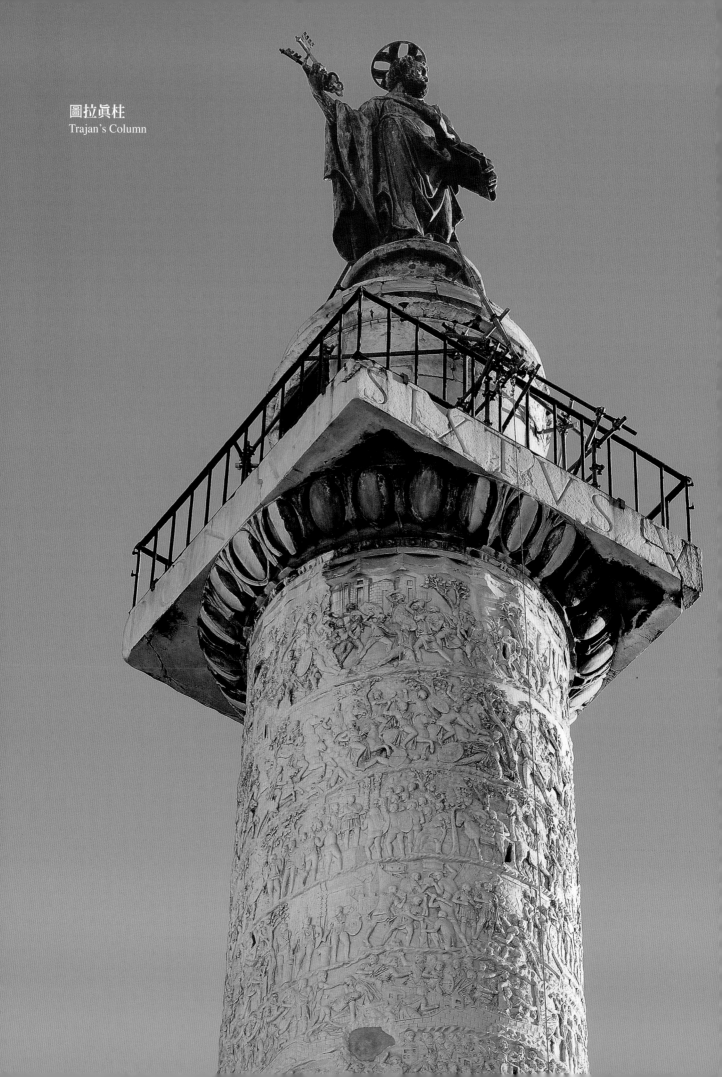

圖拉眞柱
Trajan's Column

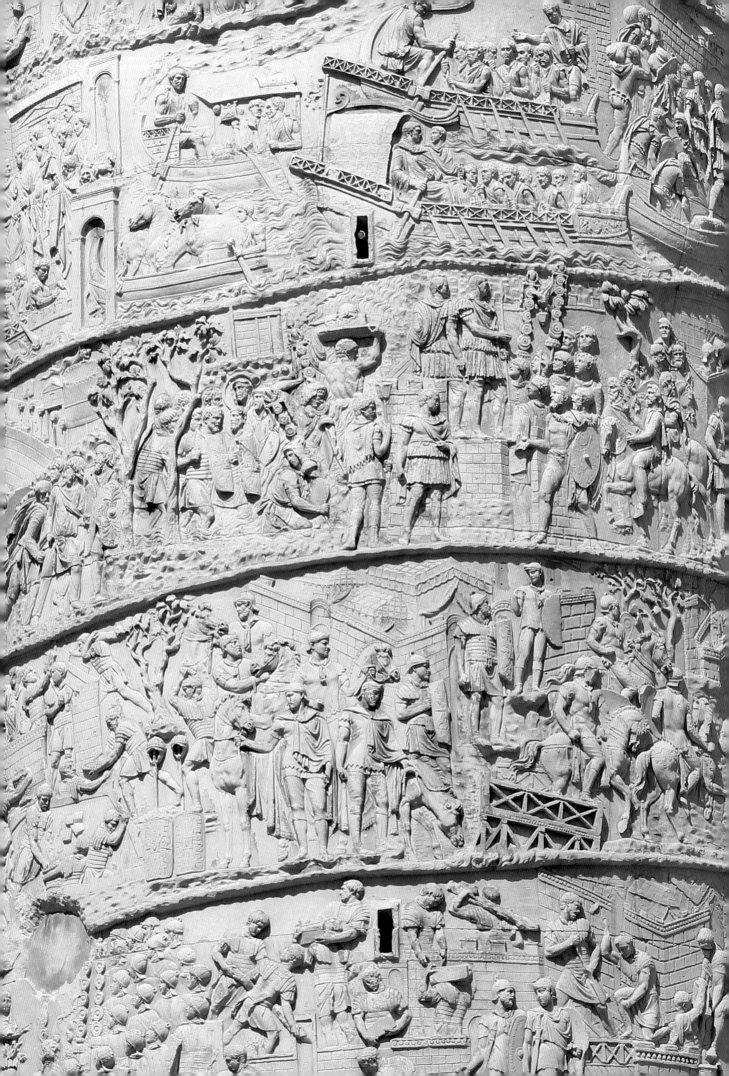

盧修斯・維魯斯肖像
Portrait of Lucius Verus

盧修斯時期(西元161~166年)
大理石
高72公分，寬62公分
佛羅倫斯國家考古博物館

Reign of Lucius (161-166 CE)
Marble
H. 72 cm, W. 62 cm
National Archeological Museum, Florence

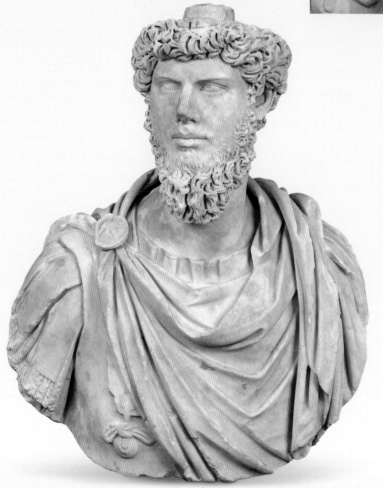

這件肖像是盧修斯・維魯斯最常見的形像，他是安敦尼皇帝的養子。西元161~169年他與馬可・奧里略共同擔任皇帝。這件用鑽頭雕出的長卷鬚髮的雕像詳細地展現出盧修斯・維魯斯的面貌。

This bust is an example of the most common portrait type of Lucius Verus, adopted son of the emperor Antoninus Pius and co-emperor with Marcus Aurelius from 161 to 169 CE. It shows Lucius Verus' rounded profile and long curly beard and hair rendered in sculpture by the use of a drill.

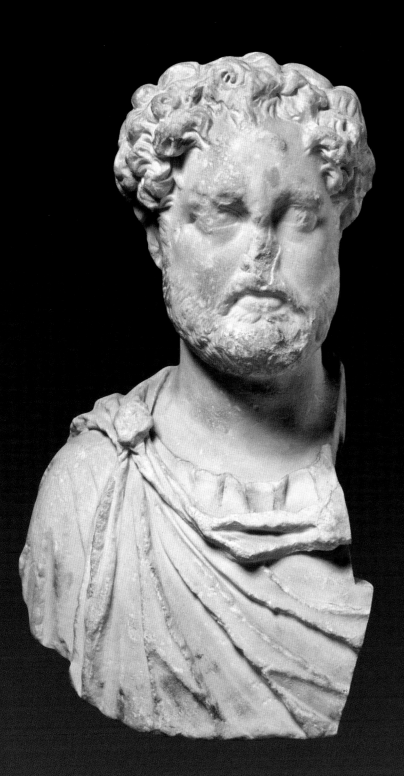

康茂德肖像
Portrait Statue of Commodus

康茂德時期(西元180~192年)
大理石
高65公分，寬30公分
佛羅倫斯國家考古博物館

Reign of Commodus (180-192 CE)
Marble
H. 65 cm, W. 30 cm
National Archeological Museum, Florence

由鬍鬚可知，康茂德這件肖像
的時間是其統治的後期。康茂
德顯然自比希臘大力神海克力
斯，他的其他肖像也和海克
力斯雕像一樣，有著獅皮和棍
棒。

This portrait of Commodus can be dated
to the final years of his reign because of
the beard. Clearly deranged, Commodus
identified himself with the Greek god
Hercules and other portraits depict him,
like Hercules, with a lion skin and club.

卡瑞卡拉以暴君著稱，其肖像也展現出這一性情。正如該石像所示，他通常是皺著眉頭、斜眼而視，一臉怒容。他寧可殺死自己的兄弟，也不願與其共擁帝位。他的統治充斥著恐怖的氛圍，他也在這種殘酷的環境中死去。

Caracalla gained the reputation as a cruel tyrant and his portraits display that disposition. Usually, as in this one, he has a threatening scowl, wrinkled brow, and sidelong glance. He killed his brother rather than share the throne, unleashed a reign of terror, and met his own death under brutal circumstances. .

青年卡瑞卡拉肖像
Portrait of Young Caracalla
卡瑞卡拉時期(西元211～217年)
大理石
高31公分
佛羅倫斯國家考古博物館

Reign of Caracalla (211-217 CE)
Marble
H. 31 cm
National Archeological Museum, Florence

加冕表
Patronage Table
西元101年
銅
長43.5公分，寬 35.8公分
佛羅倫斯國家考古博物館

101 CE
Bronze
L. 43.5 cm, W. 35.8 cm
National Archeological Museum, Florence

碑文上刻有義大利拉齊奧區
弗萊底努姆市的元老院法
令，任命波姆波尼奧巴索(T.
Pomponio Basso)為守護
神。

The inscription bears the ordinance
with which the Senate of Ferentinum, a
city of Lazio region of Italy, appointed T.
Pomponio Basso as patron.

小阿格麗品娜肖像
Portrait of Agrippina the younger

尼祿時期(西元54~68年)
大理石
高21公分
佛羅倫斯國家考古博物館

Reign of Nero (54-68 CE)
Marble
H. 21 cm
National Archeological Museum, Florence

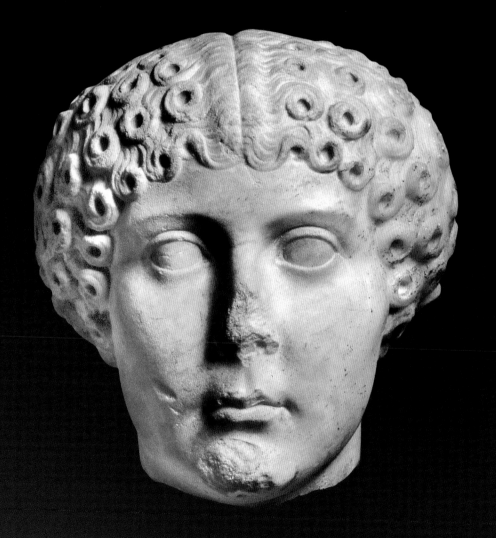

從髮型就可以明顯看出這是小阿格麗品娜的肖像。中分、四股扁平的卷髮遮住耳朵。小阿格麗品娜是卡利古拉的姐姐，後來嫁給了克勞狄皇帝。克勞狄是她的叔叔，對雙方來說都是第二次婚姻，通過支配克勞狄，她在帝國中有相當大的權力。她說服了克勞狄收養她與前夫的兒子尼祿，據傳她為了讓尼祿儘快繼位而毒害了克勞狄。不久之後，尼祿將其母親殺死。

The hairstyle strongly suggests that this is a portrait of Agrippina the Younger. It is parted in the middle and arranged in four rows of flat curls that cover her ears. Agrippina the Younger was the sister of Caligula and married to the emperor Claudius. Claudius was her uncle, it was a second marriage for both, and by dominating Claudius she exercised considerable power in the empire. Also she persuaded Claudius to adopt Nero, her son by a previous marriage, and allegedly poisoned Claudius in order to hasten Nero accession to the throne. Later Nero had her murdered.

小阿格麗品娜肖像

克勞狄童年肖像

Portrait of a Julio-Claudian Child

西元一世紀初期
大理石
高18.8公分
佛羅倫斯國家考古博物館

First half of the 1st century CE
Marble
H. 18.8 cm
National Archeological Museum, Florence

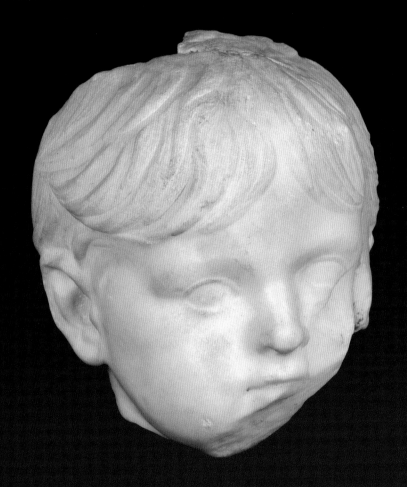

這尊肖像是一個約兩三歲的孩子。鑒於石像的品質以及至少兩個以上的副本，這個孩子極有可能來自克勞狄家族。孩子的髮型暗示著這是在提比略統治後期或者卡利古拉的統治時期。

This statue portrays a child about two or three years old. Considering the quality of the portrait and the fact that there are at least two other copies of it, the child was probably someone from the Julio-Claudian family. The child hair style, characterized by flat locks, suggests a date late in the reign of Tiberius or during the reign of Caligula.

克勞狄肖像
Small statue of Julio-Claudian prince
克勞狄時期(西元前27年~西元68年)
大理石
高39.5公分
佛羅倫斯國家考古博物館

Julio-Claudian dynasty (27BCE - 68 CE)
Marble
H. 39.5 cm
National Archeological Museum, Florence

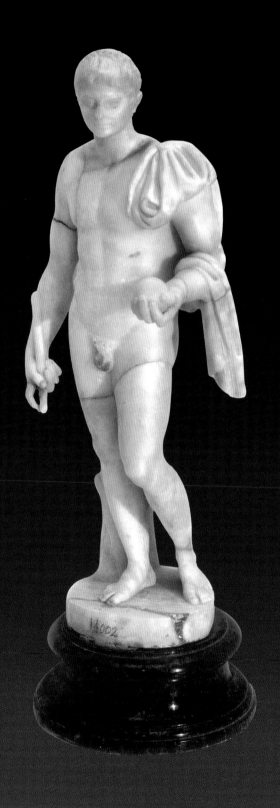

這個男性裸體的雕塑再現了希臘雕刻家波留克列特斯的風格。通過臉部和髮型特徵判斷它描繪的是克勞狄王朝的一位王子。家庭神龕通常把皇室成員和本土之神形象一起供奉。

This statuette of a nude male reproduces the style of the Greek sculptor Polykleitos. Judging by the treatment of the face and the hairstyle, it represents a prince of the Julio-Claudian dynasty. Family household shrines often included images of the Imperial family along with domestic deities.

女性肖像
Small Statue of Woman
克勞狄時期(西元前27年~西元68年)
大理石
高40公分
佛羅倫斯國家考古博物館

Julio-Claudian Dynasty (27 BCE - 68 CE)
Marble
H. 40 cm
National Archeological Museum, Florence

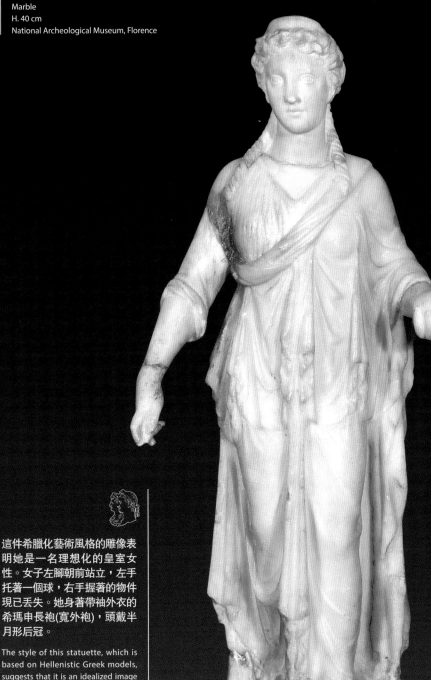

這件希臘化藝術風格的雕像表明她是一名理想化的皇室女性。女子左腳朝前站立，左手托著一個球，右手握著的物件現已丟失。她身著帶袖外衣的希瑪申長袍(寬外袍)，頭戴半月形后冠。

The style of this statuette, which is based on Hellenistic Greek models, suggests that it is an idealized image of a female member of the Imperial family. The woman stands with her left leg forward. In her left hand she holds a sphere, while the object once held in her right hand is now lost. She wears a tunic with sleeves, a long *himation* (cloak), and on her head a half-moon diadem.

有權有勢的女性
POWERFUL WOMEN

古羅馬時期人們通常希望婦女只關注家庭事務和照顧兒童。

但是也有例外。比較貧困階層的婦女由於需要出外工作，反而比那些富裕階層的婦女擁有更多的社會自由。婦女在婚姻中可以將繼承的財產和自有的財產區分開。

婦女有時也可以擔任女祭司。有權勢者的母親和妻子，特別是皇室家庭的某些婦女有時也會通過兒子和丈夫施加其影響力。皇室家庭中極具影響力的著名女性，包括奧古斯都的妻子、提比略的母親莉維亞，克勞狄皇帝的妻子和尼祿的母親小阿格麗品娜。

Women in ancient Rome generally were expected to confine their attention to running the household and caring for children.

There were exceptions, however. Women of the poorer classes, with the necessity of working outside the home, often exercised more social freedom than those of wealthy families. Women could inherit property and own property separately in a marriage.

Women served occasionally as priestesses. Also mothers and wives of powerful men sometimes exercised considerable influence through their sons and husbands. This was especially true of certain women of the Imperial household. Notable among influential women of the Imperial household were Livia, wife of Augustus and mother of Tiberius; and Agrippina the Younger, wife of Claudius and mother of Nero.

錢幣：不僅僅是貨幣 COINS: MORE THAN MONEY

錢幣除了購買物品和積累財富的功能之外，還被賦予了其它的用途。皇帝們通過發行有自己形象的硬幣，來維護他們的合法性和宣揚他們的權威。有時皇帝也利用硬幣來傳遞其它資訊，比如他們與某位特別的神祇或女神有特殊的聯繫、他們引以為榮的成就和宣告其配偶或親屬。

Coins served purposes other than purchasing goods and accumulating wealth. By issuing coins with their own image on them, the emperors were asserting their legitimacy and proclaiming their authority. Sometimes emperors used the coins to convey other messages as well—their special connection to a particular god or goddess, their pride with some achievement, their affirmation of a spouse or close relative.

奧古斯都"奧雷"金幣
Aureus of Augustus
西元前一世紀
黃金
重7.9公克
佛羅倫斯國家考古博物館

正面：奧古斯都肖像(免冠)。
反面：摩羯座。

1st century BCE
Gold
W. 7.9 g
National Archeological Museum, Florence
Obverse: Head of Augustus (uncovered).
Reverse: Capricorn.

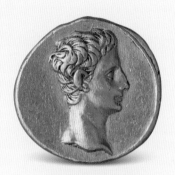

硬幣背面展示了奧古斯都皇帝的星座。硬幣有實際的經濟用途，此外，其背面的裝飾元素也說明了硬幣的紀念意義。

The coin shows on the reverse the astrological sign of the Emperor Augustus. Coins had a practical and economic usage, however the decorative element on the reverse side testifies to how this one had also a celebrative function.

奧古斯都"迪納厄斯"銀幣
Denarius of Augustus
西元前一世紀~西元11年
銀幣
直徑1.8公分
錫恩納國家考古博物館

正面：戴月桂花冠的奧古斯都肖像。
反面：身穿長袍，面蒙紗的蓋尤斯和盧修斯·凱撒(Lucius Caesar)。

1st century BCE - 11 CE
Silver
D. 1.8 cm
National Archeological Museum, Siena

Obverse: Head of Augustus with laurel wreath.
Reverse: Gaius and Lucius Caesar in togas with veiled heads.

蓋尤斯和盧修斯是奧古斯都的孫子，是其女兒茱莉亞和他的密友兼盟友阿古利巴的兒子。奧古斯都把他們列為繼承人，但均早逝。

Gaius and Lucius were Augustus' grandsons by his daughter Julia and his close friend and ally Agrippa. Augustus adopted them to be his heirs, but both died prematurely.

奧古斯都"阿斯"銅幣

As of Augustus
西元前23年
銅
直徑3公分
錫恩納國家考古博物館

正面：戴月桂花冠的奧古斯都肖像。
反面：元老院。

23 BCE
Bronze
D. 3 cm
National Archeological Museum, Siena

Obverse: Head of Augustus crowned with laurel wreath.
Reverse: S C.

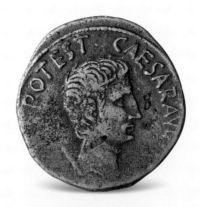

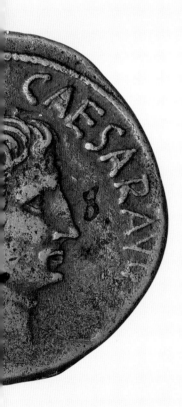

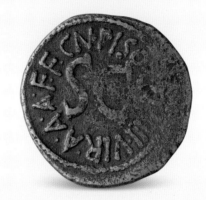

SC為"依據元老院指令"(Senatus Consulto)的縮寫，指元老院已批准發行該貨幣。

S C (*Senatus Consulto,* "By decree of the Senate") indicates that the Senate had given its approval for issuing the coin.

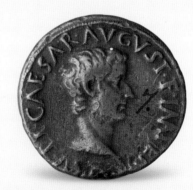

提比略"阿斯"銅幣

As of Tiberius
西元10~11年
銅
直徑2.8公分
錫恩納國家考古博物館

正面：提比略的頭像(免冠)。
反面：元老院。

10-11 CE
Bronze
D. 2.8 cm
National Archeological Museum, Siena

Obverse: Head of Tiberius (uncovered).
Reverse: S C.

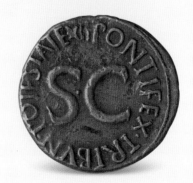

提比略"奧雷"金幣
Aureus of Tiberius
西元26~37年
金幣
直徑1.8公分
錫恩納國家考古博物館

正面：提比略肖像，頭戴月桂花冠。
反面：穿斗篷的女性坐在寶座上，左手持樹枝，右手持權杖。

26-37 CE
Gold
D. 1.8 cm
National Archeological Museum, Siena

Obverse: Head of Tiberius with laurel wreath.
Reverse: Cloaked female figure, seated on a throne, with a branch in her left hand and a long scepter in her right.

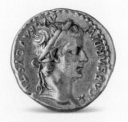
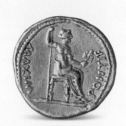

該像表現了提比略的母親莉維亞扮作和平女神潘克斯。

The figure represents Tiberius' mother Livia as the goddess Pax (Peace).

提比略"迪納厄斯"銀幣
Denarius of Tiberius
西元16~21年
銀幣
直徑1.8公分
錫恩納國家考古博物館

正面：戴月桂花冠的提比略肖像。
反面：和平女神莉維亞。

16-21 CE
Silver
D. 1.8 cm
National Archeological Museum, Siena

Obverse: Head of Tiberius with laurel wreath.
Reverse: Livia as the goddess Pax (Peace).

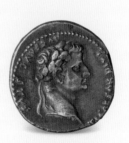
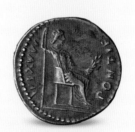
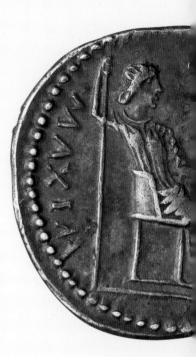

德魯蘇斯"阿斯"銅幣
As of Drusus
西元22~23年
銅
直徑2.5公分
錫恩納國家考古博物館

正面：德魯蘇斯的頭像。
反面：元老院。

22-23 CE
Bronze
D. 2.5 cm
National Archeological Museum, Siena

Obverse: Head of Drusus.
Reverse: S C.

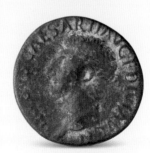
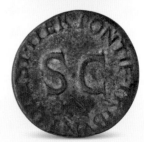

魯蘇斯是皇帝提比略的獨子，在提比略領養的兒子日耳曼尼庫斯死後，他繼承了王位。但是德魯蘇斯早於他父親去世，很有可能是被他的妻子所毒死。

Drusus was the emperor Tiberius' only son and, after the death of Germanicus whom Tiberias adopted, heir to the throne. But Dursus also died before his father, poisoned, possibly by his wife.

卡利古拉"阿斯"銅幣
As of Caligula
西元37~38年
銅
直徑2.5公分
錫恩納國家考古博物館

正面：卡利古拉頭像(免冠)。
反面：左手持託盤、右手持權杖的維斯妲登位像。

37-38 CE
Bronze
D. 2.5 cm
National Archeological Museum, Siena

Obverse: Head of Caligula (uncovered).
Reverse: Vesta enthroned with a tray in her left hand and a long scepter in her right.

如古羅馬宗教大祭司長所言，卡利古拉皇帝狂熱崇拜象徵羅馬團結和力量的灶神維斯妲。卡利古拉將賦予維斯妲的殊榮給予了祖母小安東尼亞(Antonia the Younger)和姐姐。

As *Pontifex Maximus* (chief priest), the emperor was closely bound to the cult of Vesta, goddess of the domestic hearth, and by extension, the goddess of the unity and the strength of Rome. Caligula gave the honors usually reserved for the priestesses of Vesta to his grandmother Antonia the Younger and to his sisters.

卡利古拉"塞斯特"銅幣
Sestertius of Caligula
西元37~38年
銅
直徑3.2公分
錫恩納國家考古博物館

正面：戴月桂花冠的卡利古拉頭像。
反面：三名女性人物站立於聚寶盆邊，從銘文中可識別為卡利古拉的姐姐。

37-38 CE
Bronze
D. 3.2 cm
National Archeological Museum, Siena

Obverse: Head of Caligula with laurel wreath.
Reverse: Three female figures standing by a cornucopia, identifiable from the inscription as Caligula' sisters.

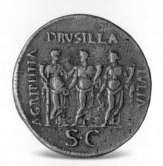

左邊的是阿格麗品娜斜靠在壁柱上；中間的是德魯西拉，手捧祭神的酒碗；右邊掌舵的是茱莉亞。她們是女神的化身。卡利古拉最喜愛的德魯西拉代表和諧，阿格麗品娜代表安全，茱莉亞代表財富(繁榮)。

Agrippina is on the left leaning on a pilaster; Drusilla in the middle holds a *patera* (shallow bowl for libations); and Julia on the right holds a ship's rudder. They are represented as the personifications of deities. Drusilla, Caligula' favorite, represents Concordia (Harmony), Agrippina represents Securitas (Security) and Julia represents Fortuna (Prosperity).

日耳曼尼庫斯"阿斯"銅幣
As of Germanicus
西元41~54年
銅
直徑2.2公分
錫恩納國家考古博物館

正面：日耳曼尼庫斯頭像(免冠)。
反面：元老院。

41-54 CE
Bronze
D. 2.2 cm
National Archeological Museum,. Siena

Obverse: Head of Germanicus (uncovered).
Reverse: S C.

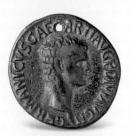

該銅幣是克勞狄皇帝為紀念其兄弟日耳曼尼庫斯而鑄。SC是"依據元老院指令" (Senatus Consulto)的縮寫，指元老院批准發行該貨幣。

The emperor Claudius minted this coin commemorating his brother Germanicus. S C (*Senatus Consulto*, "By decree of the Senate") indicates that the Senate had approved the coin's issue.

克勞狄 "阿斯" 銅幣
As of Claudius
西元42年後
銅
直徑2.2公分
錫恩納國家考古博物館

正面：克勞狄頭像 。
反面：帶有奧古斯都之名的、象徵自由的
擬人像，傳遞皇帝能捍衛自由的訊息。

After 42 CE
Bronze
D. 2.2 cm
National Archeological Museum, Siena

Obverse: Head of Claudius.
Reverse: Personification of Libertas (Freedom) with
the name Augustus, conveying the message that the
emperor could guarantee freedom.

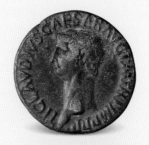

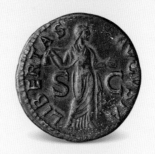

尼祿 "奧雷" 金幣
Aureus of Nero
西元54~68年
黃金
直徑1.4公分
錫恩納國家考古博物館

正面：尼祿頭像。
反面：戎裝的博洛尼亞。

54-68 CE
Gold
D. 1.4 cm
National Archeological Museum, Siena

Obverse: Head of Nero.
Reverse: Armed Virtus.

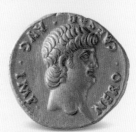

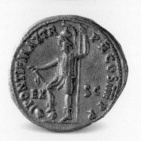

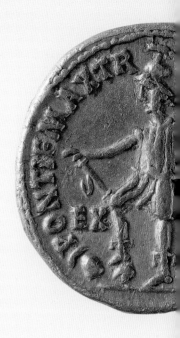

尼祿 "阿斯" 銅幣
As of Nero
西元54~68年
銅
直徑2.8公分
錫恩納國家考古博物館

正面：戴月桂皇冠的尼祿頭像。
反面：戎裝的羅馬女神坐在武器與盔甲上，
左手持勝利女神的雕像，右手持長矛。

54-68 CE
Bronze
D. 2.8 cm
National Archeological Museum, Siena

Obverse: Head of Nero crowned with laurel.
Reverse: The goddess Roma, armed and seated on weapons
and body armor, holds a statue of the goddess Nike (Victory)
in her left hand and a spear in her right.

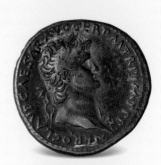

該幣鑄造的原因可能是西元
64年羅馬大火和重建。羅馬
女神被塑造成像一位坐在一
堆武器上戰鬥的女神，她左
手持勝利女神，這一形象成
為之後鑄幣的傳統。

The great fire of Rome in 64 CE and
rebuilding that followed may have
prompted the minting of this coin.
The way that Roma is depicted on
it—as a warrior goddess seated on
a pile of arms and holding Victory in
the palm of her left hand—became a
convention for coinage.

尼祿 "阿斯" 銅幣
As of Nero

西元54~68年
銅
直徑2公分
錫恩納國家考古博物館

正面：戴月桂花冠的尼祿頭像。
反面：門緊閉著的雅努斯廟。

54-68 CE
Bronze
D. 2 cm
National Archeological Museum, Siena

Obverse: Head of Nero with laurel wreath.
Reverse: Temple of Janus with closed doors.

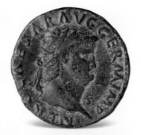

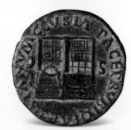

該幣發行是為了慶祝雅努斯神廟的關門(羅馬無戰事該門才關閉)，表示和平時期的到來。

The circulation of this coin celebrated the closing of the doors of the Temple of Janus (closed only when Rome fought no wars) and the beginning of a period of peace.

伽爾巴 "阿斯" 銅幣
As of Galba

西元68~69年
銅
直徑2公分
錫恩納國家考古博物館

正面：戴月桂花冠的伽爾巴肖像。
反面：自由女神。

68-69 CE
Bronze
D. 2 cm
National Archeological Museum, Siena

Obverse: Head of Galba with laurel wreath.
Reverse: The goddess Libertas.

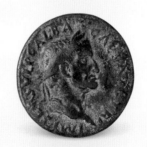

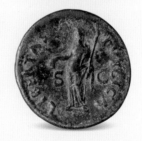

奧托 "塞斯特" 銅幣
Sestertius of Otho

西元69年
銅
直徑2.6公分
錫恩納國家考古博物館

正面：奧托頭像(免冠)。
反面：一個比其他人略大的人物，右手伸向三位武士。

69 CE
Bronze
D. 2.6 cm
National Archeological Museum, Siena

Obverse: Head of Otho (uncovered).
Reverse: One figure larger than the others, holding out his right hands toward three armed figures.

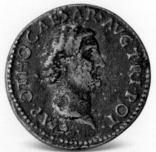

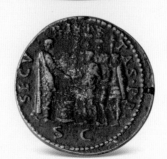

該幣代表了奧托短暫執政的重要時刻，即他的軍隊發誓對他忠誠。

This coin represents the important moment in Otho's brief reign when his troops swore their allegiance to him.

維特里烏斯 "迪納厄斯" 銀幣
Denarius of Vitellius

西元69年
銀
直徑1.1公分
錫恩納國家考古博物館

正面：戴月桂花冠的維特里烏斯頭像。
反面：站立的自由之神，右手持氈帽，左手持權杖。

69 CE
Silver
D. 1.1 cm
National Archeological Museum, Siena

Obverse: Head of Vitellius with laurel wreath.
Reverse: Libertas standing with a *pileus* (felt hat) in his right hand and a long scepter in his left.

韋斯巴薌 "迪納厄斯" 銀幣
Denarius of Vespasian

西元70年
銀
直徑1公分
錫恩納國家考古博物館

正面：戴月桂花冠的韋斯巴薌肖像。
反面：一位女人坐在勝利紀念品之下，象徵著猶太行省的化身。

70 CE
Silver
D. 1 cm
National Archeological Museum, Siena

Obverse: Head of Vespasian with laurel wreath.
Reverse: Personification of Judaea represented as a woman seated below the trophy.

該幣是以猶太行省作為戰敗者代表形象的系列之一，描繪了勝利紀念品和囚犯。

This coin, part of a series of coins showing trophies and prisoners, depicts the province of Judaea as a defeated enemy.

韋斯巴薌 "杜邦迪斯" 銀幣
Dupondius of Vespasian

西元73年
銀
直徑2公分
錫恩納國家考古博物館

正面：戴光芒皇冠的韋斯巴薌。
反面：站立著的女子右手持雙蛇杖(象徵和平)，左手持聚寶盆，象徵著幸運女神的化身。

73 CE
Silver
D. 2 cm
National Archeological Museum, Siena

Obverse: Head of Vespasian with radiant crown.
Reverse: Felicitas represented as a standing female figure with a caduceus (staff of peace) in her right hand and a cornucopia in her left.

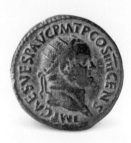
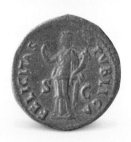

該幣傳遞了新執政家族弗拉維將帶來和平與繁榮的訊息。

The message is that the new ruling family, the Flavians, bring peace and prosperity.

提圖斯 "塞斯特" 銅幣
Sestertius of Titus
西元80年
銅
直徑2.5公分
錫恩納國家考古博物館

正面：蓄鬚的提圖斯肖像，頭戴月桂花冠。
反面：韋斯巴薌與提圖斯握手，相對而立。他們共同舉起在船舵上方的地球。

80 CE
Bronze
D. 2.5 cm
National Archeological Museum, Siena

Obverse: Head of Titus with beard and laurel wreath.
Reverse: Vespasian and Titus standing and facing each other with their right hands joined. They hold up a globe that is positioned above a ship's rudder.

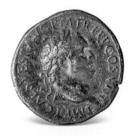

該幣展現的是西元79年韋斯巴薌死後成為神，他賦予繼任者提圖斯統治世界的權力。地球儀和船舵象徵羅馬對大地和海洋的統治。

This coin shows Vespasian, who had become divine after his death in 79 CE, offering his successor Titus the rule of the world. The globe and the ship's rudder symbolize Rome's rule over the land and sea.

圖密善 "迪納厄斯" 銀幣
Denarius of Domitian
西元93年
銀
直徑1.1公分
錫恩納國家考古博物館

正面：長鬍子的圖密善頭像，頭戴月桂花冠。
反面：圖密善的守護女神密涅瓦正用右手扔標槍。

93 CE
Silver
D. 1.1 cm
National Archeological Museum, Siena

Obverse: Head of Domitian with a beard and laurel wreath.
Reverse: Minerva, the patron goddess of Domitian, throwing a spear with her right hand.

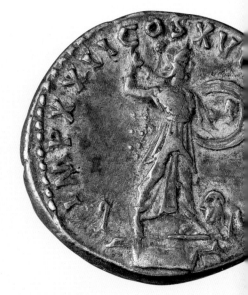

圖密善 "塞斯特" 銅幣
Sestertius of Domitian
西元92~94年
銅
直徑2.5公分
錫恩納國家考古博物館

正面：蓄鬚的圖密善肖像，頭戴月桂花冠。
反面：坐著的朱庇特，右手執勝利女神，左手持權杖。

92-94 CE
Bronze
D. 2.5 cm
National Archeological Museum, Siena

Obverse: Head of Domitian with beard and laurel wreath.
Reverse: Seated Jupiter holding a goddess Nike (Victory) in his right hand and a scepter in his left.

朱庇特的形象意味著發行該幣的人把自己置於眾神之父的保護下。勝利之神的象徵有助於政治與戰爭中獲得勝利。

The image of Jupiter on a coin meant that the person who issued the coin was placing himself under the protection of the father of the gods. This helped ensure success in politics and warfare, as symbolized by the depiction of Victory.

涅爾瓦 "阿斯" 銅幣
As of Nerva

西元96年
銅
直徑1.8公分
錫恩納國家考古博物館

正面：戴月桂花冠的涅爾瓦肖像。
反面：右手相握。

96 CE
Bronze
D. 1.8 cm
National Archeological Museum, Siena

Obverse: Head of Nerva with laurel wreath.
Reverse: Two right hands joined together.

相握的右手象徵著和諧，即
圖密善在艱難執政後重獲的
和諧。

The joined right hands symbolize
concordia, the harmony that was
regained after the difficult reign of
Domitian.

圖拉眞 "迪納厄斯" 銀幣
Denarius of Trajan

西元107~111年
銀
直徑1.4公分
錫恩納國家考古博物館

正面：頭戴月桂花冠的圖拉眞半身像。
反面：武器戰利品。

107-111 CE
Silver
D. 1.4 cm
National Archeological Museum, Siena

Obverse: Bust of Trajan with laurel wreath.
Reverse: Trophy of weapons.

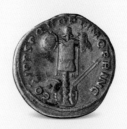

戰利品和盔甲是圖拉眞
在西元101~102年和西元
105~106年戰勝達西亞人(今
天的羅馬尼亞)的象徵。

The trophy and the armor are symbols
of Trajan's military victories over the
Dacians in 101-102 CE and 105-106 CE.

圖拉眞 "塞斯特" 銅幣
Sestertius of Trajan

西元104~111年
銅
直徑2.8公分
錫恩納國家考古博物館

正面：頭戴月桂花冠的圖拉眞肖像。
反面：達西亞人坐在武器的戰利品之下。

104-111 CE
Bronze
D. 2.8 cm
National Archeological Museum, Siena

Obverse: Bust of Trajan with laurel wreath.
Reverse: Dacian seated at the foot of a trophy of weapons.

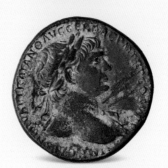
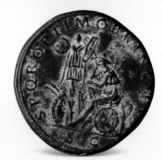

維比亞·薩比娜"塞斯特"銅幣
Sestertius of Vibia Sabina

西元132~137年
銅
直徑2.8公分
錫恩納國家考古博物館

正面：加冕的維比亞·薩比娜肖像。
反面：敬意女神的化身以女性形象坐在寶座之上，右手持祭神酒碗，左手持權杖。

132-137 CE
Bronze
D. 2.8 cm
National Archeological Museum, Siena

Obverse: Bust of Vibia Sabina with diadem.
Reverse: The goddess Pietas represented as a female figure seated on a throne, holding a patera (shallow bowl for libations) in her right hand and a long scepter in her left.

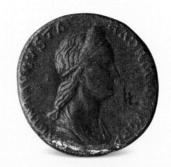

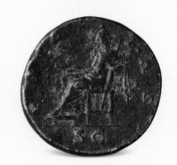

安敦尼"杜邦迪斯"銅幣
Dupondius of Antoninus Pius

西元139年
銅
直徑1.8公分
錫耶納國家考古博物館

正面：蓄鬍的安敦尼肖像，頭戴月桂花冠。
反面：站立的女性形象，右手持樹枝，左手捧聚寶盆。

139 CE
Bronze
D. 1.8 cm
National Archeological Museum, Siena

Obverse: Head of Antoninus Pius with beard and laurel wreath.
Reverse: A standing female figure with a branch in her right hand and a cornucopia in her left.

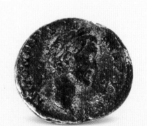

該像可能代表和平女神或是安敦尼的守護女神皮塔斯(忠實女神)。

The figure may represent the goddess Pax (Peace), or perhaps Antoninus Pius' patron goddess Pietas (Duty).

安敦尼"迪納厄斯"銀幣
Denarius of Antoninus Pius

西元161年
銀
直徑1公分
錫恩納國家考古博物館

正面：蓄鬍的安敦尼肖像。
反面：鷹。

161 CE
Silver
D. 1 cm
National Archeological Museum, Siena

Obverse: Bearded head of the divine Antoninus Pius.
Reverse: Eagle.

該幣展現了神化後的皇帝安敦尼。鷹作為朱庇特的信使，肩負著向天神貢獻世間有價值之人的使命。

This coin shows the deification of emperor Antoninus Pius. The eagle, messenger of Jupiter, had the task of carrying worthy humans from earth to the kingdom of the gods.

馬可・奧里略 "阿斯" 銅幣
As of Marcus Aurelius
西元140~143年
銅
直徑2.8公分
錫恩納國家考古博物館

正面：馬可・奧里略肖像。
反面：戎裝的密涅瓦女神，揮舞標槍。

140-143 CE
Bronze
D. 2.8 cm
National Archeological Museum, Siena

Obverse: Head of Marcus Aurelius.
Reverse: The goddess Minerva armed and brandishing a javelin.

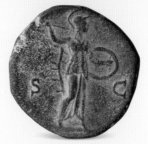

馬可・奧里略 "迪納厄斯" 銀幣
Denarius of Marcus Aurelius
西元161年
銀
直徑1.1公分
錫恩納國家考古博物館

正面：蓄鬍的馬可・奧里略肖像。
反面：站立的女性右手持地球儀，左手持聚寶盆。

161 CE
Silver
D. 1.1 cm
National Archeological Museum, Siena

Obverse: Head of Marcus Aurelius with beard.
Reverse: Standing female figure with a globe in her extended right hand and cornucopia in her left.

該女性形象被認為是上帝普羅維登斯的化身，她率先決定讓馬可・奧里略繼承帝位。該女神手持地球，象徵著羅馬在全世界的權力，聚寶盆(豐饒)象徵著新皇帝將帶來的富足。

The female figure is thought to be a personification of divine Providence, who has predetermined the succession of Marcus Aurelius. The goddess holds the globe, a symbol of Rome's universal power, and the cornucopia, a symbol of abundance brought by the new emperor.

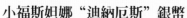

小福斯妲娜 "迪納厄斯" 銀幣
Denarius of Faustina
西元161~176年
銀
直徑1.1公分
錫恩納國家考古博物館

正面：福斯妲娜的加冕半身像。
反面：薩魯斯女神坐在寶座上。

161-176 CE
Silver
D. 1.1 cm
National Archeological Museum, Siena

Obverse: Bust of Faustina with crowned head.
Reverse: The goddess Salus (Salvation) seated on a throne.

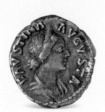

小福斯妲娜是安敦尼和福斯妲娜的女兒，皇帝馬可・奧里略的妻子。

Faustina the younger, daughter of Antoninus Pius and Faustina the elder, was the wife of the emperor Marcus Aurelius.

盧修斯・維魯斯 "迪納厄斯" 銀幣
Denarius of Lucius Verus

西元163年
銀
重24.65公克
錫恩納國家考古博物館

正面：蓄鬍的盧修斯・維魯斯肖像，頭戴月桂花冠。
反面：站立的戰神。

163 CE
Silver
W. 24.65 g
National Archeological Museum, Siena

Obverse: Bust of Lucius Verus with beard and laurel wreath.
Reverse: Standing Mars.

該幣的戰神形象是為紀念羅馬於西元163年戰勝亞美尼亞人的軍事勝利。

The figure of Mars on this coin commemorates Rome's victorious military campaign against the Armenians in 163 CE.

康茂德 "迪納厄斯" 銀幣
Denarius of Commodus

西元180年前
銀
直徑1.1公分
錫恩納國家考古博物館

正面：未蓄鬍的康茂德免冠像。
反面：奠酒祭神的容器。

Before 180 CE
Silver
D. 1.1 cm
National Archeological Museum, Siena

Obverse: Uncovered and beardless head of Commodus.
Reverse: Vessel for pouring libations.

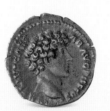

該幣的發行流通為馬可・奧里略時期，時間應在西元180年之前，此時康茂德成為皇帝繼承人。

This coin was struck and circulated by Marcus Aurelius, thus to be dated before 180 CE when Commodus became sole emperor.

康茂德 "迪納厄斯" 銀幣
Denarius of Commodus

西元186年
銀
直徑1.1公分
錫恩納國家考古博物館

正面：蓄鬍的康茂德肖像，頭戴月桂花冠。
反面：命運女神坐在寶座上，左手持聚寶盆，右手拿著在船舵上的地球儀。

186 CE
Silver
D. 1.1 cm
National Archeological Museum, Siena

Obverse: Head of Commodus with beard and laurel wreath.
Reverse: The goddess Fortuna Redux seated on a throne, holding a cornucopia in her left hand, and in her right a ship's rudder resting on a globe.

福特娜・雷德斯是幸運女神，尤其能給家庭帶來好運和平安。該幣是為了紀念羅馬軍隊從英國勝利歸來而作。

Fortuna Redux was the goddess of Fortune, particularly the good fortune that brings one home safely, and the coin commemorated the Roman army's return after victories in Britain.

克里斯碧娜 "阿斯" 銅幣
As of Crispina
西元180~183年
銅
直徑2.5公分
錫恩納國家考古博物館

正面：克里斯碧娜的半身像。
反面：站立的朱諾。

180-183 CE
Bronze
D. 2.5 cm
National Archeological Museum, Siena

Obverse: Bust of Crispina.
Reverse: Standing Juno.

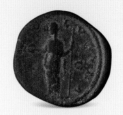

與婚姻儀式相聯繫的女神朱諾暗示該幣的內容是在皇帝馬可‧奧里略死前康茂德與年輕的克里斯碧娜舉行婚禮。

The goddess Juno, associated with the rites of marriage, suggests that this coin relates to the marriage of Commodus to the young Crispina, which took place before the death of the emperor Marcus Aurelius.

維魯斯和康茂德銅紀念章
Medallion with Lucius Verus and Commodus
西元161~180年
銅
直徑2.1公分
錫恩納國家考古博物館

正面：身披戰袍的維魯斯肖像。
反面：年輕的康茂德肖像，身披戰袍。

Reign of Marcus Aurelius (161-180 CE)
Bronze
D. 2.1 cm
National Archeological Museum, Siena

Obverse: Bust of Annius Verus in military cloak.
Reverse: Bust of young Commodus in military cloak.

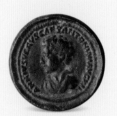

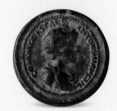

紀念章比貨幣大，用來紀念特定的政治、宗教和城邦事件。該紀念章有可能是馬可‧奧里略皇帝的兩個兒子被授予凱撒(即皇帝之意)稱號時所鑄，反映出他們對繼承皇帝的期待。

Medallions were larger than coins, in order to better render subject matter, and were struck to commemorate specific political, religious or civil events. This medallion, which represents the two sons of the emperor Marcus Aurelius, was likely struck when the two boys were given the title of Caesar, anticipating that they would succeed their father.

馬可‧奧里略和康茂德銅紀念章
Medallion with Marcus Aurelius and Commodus
西元173年
銅
直徑2.8公分
錫恩納國家考古博物館

正面：蓄鬚的馬可‧奧里略肖像，頭戴月桂花冠，身穿古羅馬護胸甲手持盾牌。
反面：年輕的康茂德肖像，身著戰袍和盔甲。

173 CE
Bronze
D. 2.8 cm
National Archeological Museum, Siena

Obverse: Bust of Marcus Aurelius with beard, laurel wreath, lorica (breast plate) and shield.
Reverse: Bust of young Commodus with *paludamentum* (military cloak) and armor.

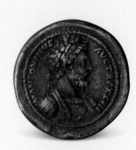

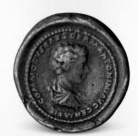

該紀念章刻畫了馬可‧奧里略皇帝和其子康茂德，在被授予凱撒(皇帝)頭銜之時的情景，預示著康茂德會成為下一任皇帝。

This medallion portrays the emperor Marcus Aurelius and his son Commodus at a time when the latter had already been given the title of Caesar, anticipating that he would become the next emperor.

塞普蒂米烏斯・塞維魯 "塞斯特" 銅幣
Sestertius of Septimius Severus

西元193年

銅

重 26.45公克

佛羅倫斯國家考古博物館

正面：塞普蒂米烏斯・塞維魯肖像，頭戴月桂花冠。
反面：位於兩個戰利品之間的軍團標誌–鷹。

193 CE
Bronze
W. 26.45 g
National Archeological Museum, Florence

Obverse: Head of Septimius Severus with laurel wreath.
Reverse: Legionary eagle between two trophies.

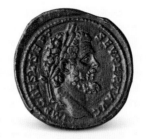
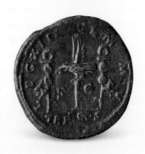
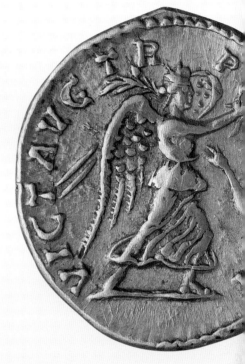

塞普蒂米烏斯・塞維魯 "奧雷" 金幣
Aureus of Septimius Severus

西元194年

黃金

直徑2公分

佛羅倫斯國家考古博物館

正面：塞普蒂米烏斯・塞維魯肖像，頭戴月桂花冠。
反面：勝利之神手持棕櫚葉樹枝與皇冠。

194 CE
Gold
D. 2 cm
National Archeological Museum, Florence

Obverse: Head of Septimius Severus with laurel wreath.
Reverse: Victory holding a palm bough and a crown.

茱莉亞・多姆娜 "塞斯特" 銅幣
Sestertius of Julia Domna

西元211~217年

銅

重27.05公克

佛羅倫斯國家考古博物館

正面：茱莉亞・多姆娜的遮蓋肖像。
反面：站立著的幸運女神在祭壇，手持神杖祭獻。

211-217 CE
Bronze
W. 27.05 g
National Archeological Museum, Florence

Obverse: Draped bust of Julia Domna.
Reverse: Standing goddess Felicitas (Good Luck) holding a *caduceus* (staff) and sacrificing at an altar.

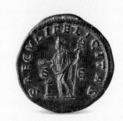

卡瑞卡拉 "奧雷" 金幣
Aureus of Caracalla
西元205年
黃金
直徑2.2公分
佛羅倫斯國家考古博物館

正面：卡瑞卡拉肖像。
反面：赤裸的戰神，左肩披斗篷，手持樹枝、權杖。

205 CE
Gold
D. 2.2 cm
National Archeological Museum, Florence

Obverse: Bust of Caracalla.
Reverse: Nude Mars with a cloak over his left shoulder, holding a tree branch and staff.

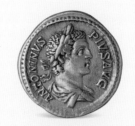
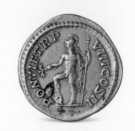

卡瑞卡拉 "塞斯特" 銅幣
Sestertius of Caracalla
西元213年
銅
直徑3公分
佛羅倫斯國家考古博物館

正面：卡瑞卡拉肖像，頭戴月桂花冠。
反面：立於戰車之上的勝利之神授予卡瑞卡拉皇冠。

213 CE
Bronze
D. 3 cm
National Archeological Museum, Florence

Obverse: Bust of Caracalla with a laurel wreath.
Reverse: Caracalla being crowned by Victory who is on a chariot.

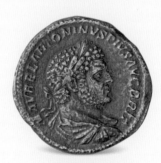

哲塔 "塞斯特" 銅幣
Sestertius of Geta
西元211年
銅
直徑3公分
佛羅倫斯國家考古博物館

正面：哲塔肖像，頭戴月桂花冠。
反面：坐姿女性手持權杖與聚寶盆。

211 CE
Bronze
D. 3 cm
National Archeological Museum, Florence

Obverse: Head of Geta with beard and laurel wreath.
Reverse: Seated female figure with a scepter and a cornucopia.

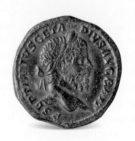

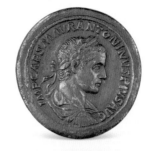

黑利阿伽‧巴盧斯 "塞斯特" 銅幣
Sestertius of Elioglabalus (Heliogabalus)
西元218~219年
銅
直徑3.5公分
佛羅倫斯國家考古博物館

正面：黑利阿伽‧巴盧斯肖像，頭戴月桂花冠。
反面：三個站立著的神祇，手持天秤、聚寶盆及腳下有一堆
錢幣，是正義女神埃奎塔斯的化身。

218-219 CE
Bronze
D. 3.5 cm
National Archeological Museum, Florence

Obverse: Draped bust of Eliogabalus with laurel wreath.
Reverse: Personifications of Aequitas (Fair Dealing): three standing deities, each
holding a balance and a cornucopia with piles of coins at their feet.

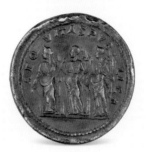

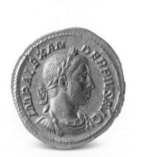

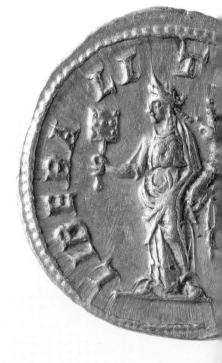

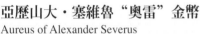

亞歷山大‧塞維魯 "奧雷" 金幣
Aureus of Alexander Severus
西元231~235年
黃金
直徑2.2公分
佛羅倫斯國家考古博物館

正面：戴月桂花冠的亞歷山大‧塞維魯肖像。
反面：拿著算盤和羊角的自由女神。

231-235 CE
Gold
D. 2.2 cm
National Archeological Museum, Florence

Obverse: Head of Alexander Severus with laurel wreath.
Reverse: Libertas with an abacus and cornucopia.

亞歷山大‧塞維魯 "塞斯特" 銅幣
Sestertius of Alexander Severus
西元222~231年
銅
重20公克
佛羅倫斯國家考古博物館

正面：戴月桂花冠的亞歷山大‧塞維魯肖像。
反面：坐姿的羅馬神祇帶著盾牌，右手執勝利
女神耐克，左手持權杖。

222-231 CE
Bronze
W. 20 g
National Archeological Museum, Florence

Obverse: Head of Alexander Severus with laurel wreath.
Reverse: Seated Roma with a shield, a Nike (Victory) in her right
hand, and a scepter in her left.

馬克西米安"塞斯特"銅幣
Sestertius of Maximus Thrax
西元235~236年
銅
重21.7公克
佛羅倫斯國家考古博物館

正面：戴月桂花冠的馬克西米安肖像。
反面：前進中的勝利之神頭戴皇冠、手持棕櫚葉樹枝。

235-236 CE
Bronze
W. 21.7 g
National Archeological Museum, Florence

Obverse: Head of Maximinus Thrax with laurel wreath.
Reverse: Advancing goddess Victory carrying a crown and a palm bough.

馬克西米安是來自希臘色雷斯的一名士兵，從輔助兵一路晉升。西元235年，亞歷山大·塞維魯被暗殺之後，他被軍隊擁護為皇帝。馬克西米安異常強大，在被刺殺以前，他捍衛王位長達三年之久。北非城市蒂斯德魯斯(現在位於突尼斯的埃爾傑姆)曾爆發了針對馬克西米安所實行政策的反叛，雖然失敗，但為他倒臺奠定了基礎。

Maximinus, a soldier from Thrace who had worked his way up from the auxiliary ranks, was acclaimed emperor by the army following the assassination of Alexander Severus in 235 CE. He was an unusually large man, and managed to survive as emperor for three years before being assassinated. A rebellion against Maximinus Thrax's policies that erupted in the North African city of Thysdrus (present-day El-Djem in Tunisia) failed, but it set the stage for his downfall.

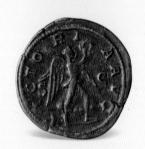

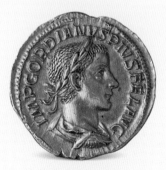

戈爾迪安三世金幣
Quinquarius of Gordianus III
西元241~243年
黃金
直徑1.8公分
佛羅倫斯國家考古博物館

正面：戴月桂花冠的戈爾迪安三世肖像。
反面：海克力斯。

241-243 CE
Gold
D. 1.8 cm
National Archeological Museum, Florence

Obverse: Head of Gordianius III with laurel wreath.
Reverse: Resting Hercules.

羅馬禁衛軍選擇由戈爾迪安三世繼承馬克西米安的皇帝職位。戈爾迪安當時年僅13歲，是阿非利加行省年邁總督的孫子，在蒂斯德魯斯抗議時期被宣佈為皇帝，直至他19歲時被暗殺。

The Praetorian Guard selected Gordian III to succeed Maximinus Thrax. Gordian was 13 years old at the time, and grandson of the elderly proconsul of the Province of Africa who had been proclaimed emperor during the failed Thysdrus rebellion. He managed to survive until he was 19 before assassination.

戈爾迪安三世"塞斯特"銅幣
Sestertius of Gordianus III

西元240年
銅
直徑3.4公分
佛羅倫斯國家考古博物館

正面：戈爾迪安三世的肖像。
反面：端坐的阿波羅右手持一根樹枝，左手握里拉琴。

240 CE
Bronze
D. 3.4 cm
National Archeological Museum, Florence

Obverse: Head of Gordanius III.
Reverse: Seated Apollo with a tree branch in his right hand and a lyre in his left.

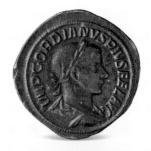
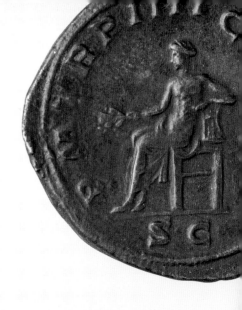
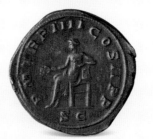

安東尼亞"阿斯"銅幣
As of Antonia

西元一世紀中期
銅
直徑2.8公分
錫恩納國家考古博物館

正面：安東尼亞的肖像。
反面：站立的男性人物。

Mid-1st century CE
Bronze
D. 2.8 cm
National Archeological Museum, Siena

Obverse: Head of Antonia.
Reverse: Standing male figure.

小安東尼亞是馬克·安東尼和屋大維的女兒，克勞狄皇帝的母親和卡利古拉皇帝的祖母。她以美貌和高尚的品德而著名，在克勞狄早期的統治時期，曾以她之名義發行貨幣。貨幣反面的男性很有可能就是克勞狄本人。

Antonia the Younger was the daughter of Mark Anthony and Octavia, mother of the emperor Claudius, and grandmother of Caligula. Renowned for her beauty and virtue, Claudius issued coins in her behalf early in his reign. The male depicted on the reverse is probably Claudius.

大阿格麗品娜"塞斯特"銅幣
Sestertius of Agrippina Major

西元37~41年
銅
直徑3.2公分
錫恩納國家考古博物館

正面：身穿披風的大阿格麗品娜肖像。
反面：由騾子拉動的戰車。

37-41 CE
Bronze
D. 3.2 cm
National Archeological Museum, Siena

Obverse: Bust of Agrippina wearing a cloak.
Reverse: Chariot drawn by mules.

據史學家蘇維托尼烏斯所述，卡利古拉每年舉辦慶典紀念他的母親大阿格麗品娜。這些慶典包括各種競賽和儀式，比如騾子拉戰車比賽。

According to the author Suetonius, Caligula held annual public festivals in honor of his mother Agrippina the Elder. These festivals included various contests and rituals, including a race of chariots drawn by mules.

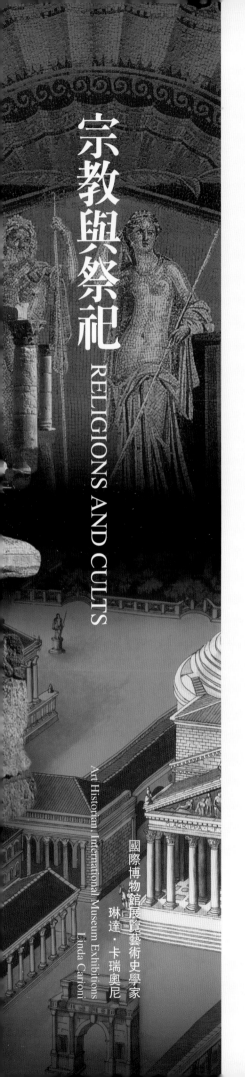

宗教與祭祀

RELIGIONS AND CULTS

國際博物館展覽藝術史學家
琳達·卡瑞奧尼
Linda Carioni
Art Historian, International Museum Exhibitions

　　早期的羅馬人和之前的希臘人一樣，信奉一些"至高神"，祭拜的儀式與他們所處的環境和農業種植週期息息相關。這些神祇未被明確地人格化，因爲他們沒有與之相關的神話故事，也沒有伴侶和子嗣，但他們擁有超能力，能夠應朝拜者的召喚造福人類。重要的神有戰神瑪斯(Mars)以及在和平年代等同於戰神的奎裡努斯(Quirinus)。羅馬神祇的首領是天神朱庇特(Jupiter)，祂如同希臘神祇中的宙斯(Zeus)。祂是掌管天氣的神祇，能爲乾旱地區帶來雨水。因此，人們在義大利的山頂祭拜祂。所有經受過閃電的地區都成了祂的領地。朱庇特也是代表著道德理念的神祇，祂帶領著各路神祇英雄履行職責。

　　羅馬帝國時代的神祇是多種宗教信仰交替混合的產物。事實上，宗教的寬容和同化正是羅馬文明的特徵。宗教信仰多是來自義大利南部的希臘殖民地，其它的則是在古伊特魯里亞或拉丁(Latin)部落中根深蒂固的宗教信仰。受到伊特魯里亞的希臘文化影響，朱庇特還被賦予了伴侶朱諾(Juno)和密涅瓦(Minerva)，即赫拉和雅典娜。供奉三位神祇的廟宇高聳於古羅馬城市廣場，並且屹立於整個帝國時期。維納斯、福耳圖那和黛安娜起源於古義大利，阿波羅則是來源於希臘神話，且沒有與之對應的羅馬神祇。酒神巴克斯及其狂歡節都具有重要的宗教意義。羅馬神祇逐漸被希臘化，並與在希臘神話中具有相同定義的神祇一一對應。

　　羅馬人對於宗教持務實的態度。繁榮、成功、勝利或失敗取決於是否嚴格遵守朝拜儀式，以祈求神祇的庇佑。信奉的目的是爲了獲得美好的願望或期待神祇將如何改變百姓的未來；因此用於供奉給神祇的祭品和用於預測未來的占卜儀式，都是羅馬人民生活中十分重要的公共儀式。這些儀式由複雜的程序組成，並接受祭司的管理。在羅馬帝國時期，君王會被授予最高神職或大祭司的頭銜。這一皇權的基本頭銜也被印刻在貨幣上。

　　當獲得勝利的屋大維被元老院授予"奧古斯都"這一尊貴的稱號時，他已爲自己死後的封號作好了準備，同時這也轉變了羅馬宗教的基礎；他已被神化，他似乎已賦予羅馬太多的福祉，足以讓羅馬視他爲神。之後這也成了一種慣例，如果一位帝王在有生之年有傑出的貢獻，那他死後便會被封作羅馬神祇。這一慣例的後果發展成了帝國的一種迷信。它們團結爲一股力量，信奉羅馬本身。從此以後，帝王被認爲是神聖不可侵犯的，並且是具有天賜神力的化身。

　　個人舉辦的宗教儀式關係到家庭生活、日常生活和商業生活的許多方面，由一家之長負責。宗教與其說是一種精神上的經歷，倒不如說是人與神祇的契約關係，它保障著人們的生活幸福安康。

　　守護家園的神祇主要有兩位，較重要的是守衛者門神雅努斯（Janus）。精靈神的中心是灶台和灶上的火，而這些通常是由房屋的女主人來照看的，因此房屋的第二位正式守衛者就是女灶神維斯妲。吃飯時，會在一旁放置些食物，或將其投入灶火，以示供奉之意。

　　家神拉爾（Lares）是祖先的靈魂，對於羅馬家庭是極其重要的。人們將家神的小雕像供奉在神龕之中。它是最重要的神祇，世代看守家族的命運。每天人們都會向其祈禱，供奉食物。在宗教日或特殊的日子，還會舉行特別的儀式。另一位家神是吉尼斯（genius），通常以一條蛇或是陽具狀符號的形式出現。某種意義上說，它意味著賦予丈夫，即孩子的生父"男子氣概"，它也可用於特定的私人儀式，以祈求繁衍子嗣。

　　禮拜儀式也用來拜祭神靈以祈求幸福安康。在農村，人們拜祭農業神對農作物的庇佑，城市中的商人拜祭墨丘利神和其他與保佑財運相關的神祇。那些代表抽象意義的神祇也為人們所拜祭，例如和平之神康考迪亞（Concordia）、健康和繁榮之神薩盧斯（Salus）、幸運之神福耳圖那和豐收之神阿班丹提亞（Abundantia）。

　　羅馬人對來世沒有過多的奢望；傳統的羅馬宗教也很少提及來世。一個人死後，他的靈魂會與其他逝者的靈魂一起成為家神之一。葬禮仍然是人生的重要部分，特別是作為財富或權利的表現形式。根據法律，墳墓必須建於城牆之外；富人通常在城市主要通路邊上建造一座陵墓，而窮人則豎立一塊刻有碑文的石柱（又叫墓碑）。

　　直到西元一世紀，火化成為了人們首選的埋葬方式，各種骨灰壇用於存放骨灰。隨後，土葬更為常見，屍體被存放于石棺之中。如果逝者是富人，石棺由昂貴的大理石製造並刻有裝飾性的圖案。如果逝者僅為小康，則採用簡單的木棺。其後，基督教徒也採用了這一種埋葬方式。

Like the Greeks before them, the early Romans worshipped of a few "high gods" and rites were closely tied to their environment and agrarian cycles. Vaguely personified, these gods had no myths, did not form married pairs, had no offspring, but possessed superhuman powers that could be called upon to intervene for the benefit of the worshipper. Important divinities were Mars, the god of war, and Quirinus, Mars' equivalent in time of peace. Chief among the Roman gods, however was Jupiter, a sky god like his Greek equivalent, Zeus. He was the god of weather, the sender of rain in drought and was worshipped on hilltops throughout Italy. All places struck by lightening were made his property. Jupiter was also the god who embodied moral concepts, who led the hero down the path of duty.

Gods and goddesses of Imperial times were a blend of religious influences; in fact, religious tolerance and assimilation was characteristic of the Roman civilization. Many were introduced via the Greek colonies of southern Italy. Others had their roots in the religious beliefs of the ancient Etruscans or Latin tribes. From Greek influence in Etruria, Jupiter was given as partners the goddesses Juno and Minerva, (identified with Hera and Athena). The temple dedicated to the three divinities dominated the Roman Forum. Such a temple was present in every settlement throughout the empire. Venus, Fortuna and Diana emerged from native Italian sources. Imported from Greece was the cult of Apollo that had no Roman equivalent. Bacchus, the god of wine, and bacchanalian festivities were also of religious importance. Gradually, a process of Hellenization took place and the Roman gods assumed the features associated with the Greek mythology of their equivalents.

The Romans had a practical attitude to state religion. Prosperity, success, victory or defeat depended on the strict performance of rituals intended to guarantee the favour of the Gods. The purpose of worship was to obtain their good will or to discover how the gods might influence the future; hence sacrifice, intended to please the gods, and divination rites, used to foretell the future, were very important public ceremonies in Roman life. Composed of complicated rituals, these ceremonies were regulated by an elaborate priesthood. In Imperial Rome, the Emperor was given the title of supreme priest or *pontifex maximus*. A fundamental definition of Imperial power, the title was often inscribed on coinage.

When the victorious Octavian assumed the name of Augustus, a term implying reverence, he prepared the way for his own posthumous deification and a transformation of the Roman religious foundation; he was deified because he seemed to have given Rome gifts worthy of a god. It then became customary for emperors, if they were worthy in their lifetimes, to be elevated to divinity upon their deaths. The ramification of this was the Imperial cult that developed throughout the empire. Encouraged as a unifying force, the cult included worship of Rome herself. Overtime, the emperors were treated as divine and seen as the selected representation of divine powers.

Private religious rituals, overseen by the head of the family, the *pater familias*, related

to various aspects of family life, daily life and work or business life. Religion was less a spiritual experience than a contractual relationship between man and the gods that were believed to control one's existence and well-being.

Two main gods protected the home. Chief guardian was Janus, the god of doorways and beginnings. The spiritual center however was the hearth and the fire of the hearth was an element tended to by the woman of the house, so the second official deity of the home was Vesta, the goddess of the hearth. During meals, food might be set aside and passed into the fire as an offering.

The spirits of the ancestors, the *Lares*, were extremely important to Roman families. They were represented by small figurines that were kept in their own shrine, the lararium. The Lar familiaris, the benevolent god that watched over the family's fortunes from generation to generation was the most important. On a everyday basis, short prayers and small offerings were made to the Lares. On sacred days or on special occasions, more elaborate rituals were held in their honour. Another household spirit was the genius, often represented in the form of a snake or phallic symbol. This was in a sense the 'manhood' of the family, which empowered the husband to father children and an important function of certain private rituals was to insure fertility.

Devotional rites were also rendered to deities that affected the individual's livelihood and well-being. In rural villages, great care was taken to honour the agrarian deities that watched over the crops just as merchants in the city honoured Mercury and other gods associated with trade. The divine personifications of abstract concepts such as Concordia (peace), Salus (health and prosperity), Fortuna (fortune) and Abundantia (abundance) were also honoured.

The Romans had an uncomplicated view of the afterlife; traditional Roman religion offered little hope of eternal life. The spirit of the deceased joined all the other spirits of the dead and became one of the family lares. Still, funeral rites were an important part of life, especially as a social affirmation of wealth or power. By law, tombs had to be built outside city walls; the wealthy often built mausoleums along the main access roads of the city while the less fortunate erected an inscribed stele (tombstone) to mark the grave site.

Until the I century CE, cremation was the preferred burial practice and a variety of urns were used to hold the ashes. Subsequently, when internment became the more common practice, the body would be placed in a sarcophagus. If the deceased was wealthly, the sarcophagus would be made of expensive marble and incised with decorative motifs. Simple wood coffins were used for the less well-to-do, and this type of burial was later adopted by the Christians.

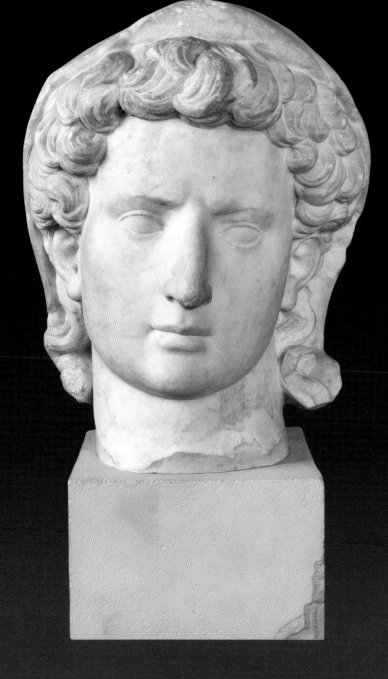

奧古斯都的這尊肖像(apite velato)，全然一幅大祭司的模樣(Pontifex Maximus)。這個未來的皇帝以年輕男子的形象示人，捲曲的短髮襯托出他瘦削的臉龐。事實上，奧古斯都在很年輕的時候就已經加入了最高祭司團。

Here the Emperor Augustus is depicted *capite velato* (the head is veiled) that is to say as Pontifex Maximus. The future emperor is portrayed in this statue as a young man, whose oval face is framed by wavy locks. Indeed, Augustus became a member of the Pontifical College when he was very young.

密特拉殺牛浮雕
Relief with Mithras Killing a Bull
羅馬帝國時期
大理石
高70公分
佛羅倫斯國家考古博物館

Imperial Age
Marble
H. 70 cm
National Archeological Museum, Florence

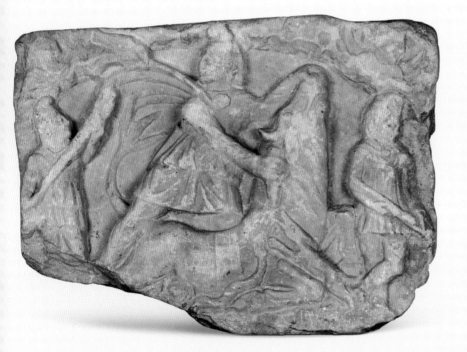

東方諸神及異教傳播至發源地之外常常被賦予了其他的特質，比如早期的異教和儀式通常與農業相關，但之後就作為個人救贖的方式。異教之神或女神的崇拜者借助入門式得以與神分享克服逆境的勝利。被冠以"神秘宗教"之名的"入門式"(initiation)是源自希臘術語奧秘(mysteria)。密特拉教是其中最受歡迎的一種。

密特拉是波斯神，其信仰在一到二世紀傳播至整個帝國，在三世紀尤為強盛。密特拉教排斥女性，在羅馬軍隊中非常流行，被認為具有非常高的靈性。密特拉教的入門式通常在洞穴或仿照洞穴建造的地下室進行。儀式中殺牛的象徵意義還不為人知，或許代表著密特拉教的崇拜者以參與祭祀活動實現自我救贖。

As oriental gods and cults spread beyond their lands of origin, they often took on a different character-cults and rituals that earlier might have had to do with agriculture, for example, came to be understood as paths to personal salvation. By means of initiation rituals, worshippers identified with the god or goddess of the cult, and thereby shared in the god's victory over adversities. These are called "Mystery Cults" after the Greek term for "initiation" (*mysteria*). One very popular mystery cult was Mithrism.

Mithrus was Persian god whose cult spread throughout the empire during the 1st and 2nd centuries CE, and was especially strong during the 3rd century. It was for men only, very popular among Roman soldiers, and characterized by a high level of spirituality. Mithraic initiation rituals were celebrated in caves or in underground chambers constructed to resemble caves. The symbolism of slaying of a bull is unclear, but somehow it was understood to be an act of salvation in which the worshippers participated directly with the sacrificial act.

主神朱庇特雕像
Head of Jupiter
羅馬帝國時期
大理石
高39公分
佛羅倫斯國家考古博物館

Imperial Age
Marble
H. 39 cm
National Archeological Museum, Florence

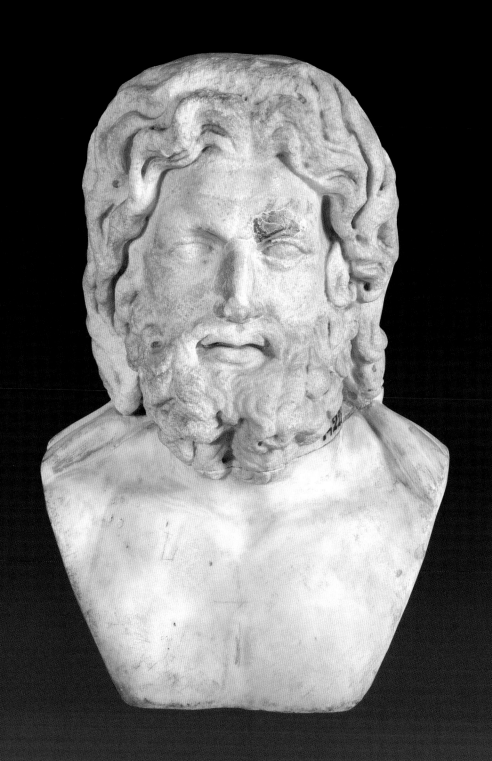

羅馬的朱庇特與希臘的宙斯一樣被認為是眾神的父親，所以他們的形象也相似，留著鬍子，臉上垂著捲曲的長髮。

Roman Jupiter was identified with Greek Zeus, the father of many gods, and he is depicted accordingly—bearded, with his face framed by long, wavy hair.

羅馬帝國的諸神
THE MANY GODS AND GODESSES OF THE ROMAN EMPIRE

隨著帝國的擴張，羅馬人接觸了外國的神祇和女神，羅馬的宗教變得日益國際化。

羅馬人經常將他們自己的神祇與外國的神祇等同化，特別是希臘的神祇，認為祂們有相似的性格和作用，羅馬宗教由此融合了"奧林匹亞"的神話。羅馬的朱庇特相當於希臘的宙斯，羅馬的朱諾相當於希臘的赫拉，羅馬的維納斯相當於希臘的阿佛洛狄特等等。

羅馬的神祇也對應於東方的神祇。朱庇特·塞拉皮斯是羅馬朱庇特、希臘宙斯–哈得斯和埃及的奧西瑞斯、阿比斯的結合體。福耳圖那–伊希斯是羅馬的福耳圖那和埃及的伊西斯的結合體。

As the Empire expanded and Romans encountered foreign gods and goddesses, Roman religion became increasingly international.

The Romans often equated their own gods with foreign gods that had similar characteristics and functions. This was especially true of Greek gods, and in this way Roman religion incorporated the stories of "Olympian" mythology. Roman Jupiter came to be equated with Greek Zeus, Roman Juno with Greek Hera, Roman Venus with Greek Aphrodite, and so on.

Roman gods were equated with oriental gods as well. Jupiter Serapis was a combination of Roman Jupiter, Greek Zeus-Hades, and Egyptian Osiris Apis. Fortuna-Isis combined Roman Fortuna with Egyptian Isis.

朱庇特·塞拉皮斯雪花石膏雕像
Small Bust of Jupiter Serapis

羅馬帝國時期
雪花石膏
高35公分
佛羅倫斯國家考古博物館

Imperial Age
Alabaster
H. 35 cm
National Archeological Museum, Florence

朱庇特·塞拉皮斯由埃及國王托勒密一世(西元前305~282年)引入，用來吸引希臘和埃及的國民。它結合了希臘的宙斯–哈得斯和埃及的奧西瑞斯神–阿比斯神，塞拉皮斯從亞歷山大港傳播至地中海東部和義大利南部，最後傳遍整個羅馬世界。

Serapis was introduced by Ptolemy I of Egypt (305-282 BCE) and intended to appeal to both his Greek and Egyptian subjects. A combination of Greek Zeus-Hades and Egyptian Osiris-Apis, Serapis spread from Alexandria to the eastern Mediterranean, southern Italy and eventually throughout the Roman world.

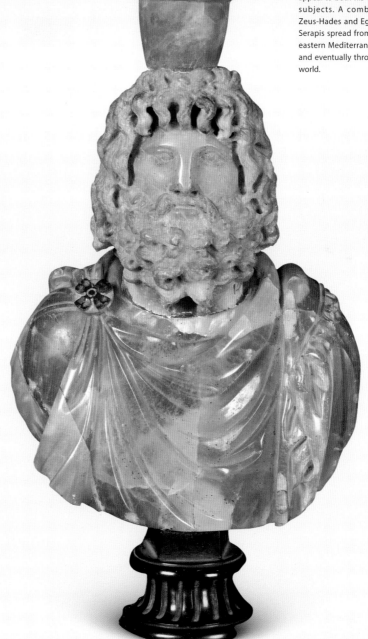

智慧女神密涅瓦雕像
Head of Minerva

西元二世紀
大理石
高27公分
佛羅倫斯國家考古博物館

2nd century CE
Marble
H. 27 cm
National Archeological Museum, Florence

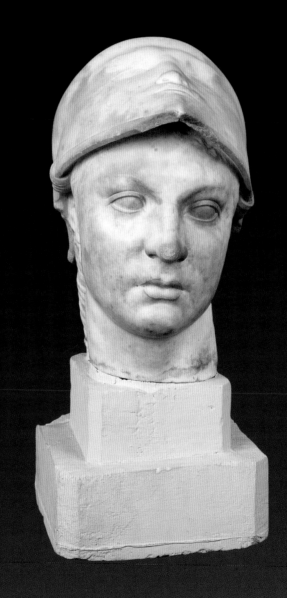

密涅瓦女神雕像戴有頭盔，頭髮從大護頸下垂落。雕像的一大特色是有帽沿的頭盔襯托了女神的面龐。

The head portrays Minerva wearing a helmet while her hair falls down from the large neck shield. The visor of her helmet, replicating the face of the goddess, is an extraordinary feature of this statue.

小型諸神雕像　Small bronze figurines of gods and goddesses

小型銅質神像和女神雕像皆作為願望實現後，供奉給神祇的祭祀品，也可作為家中的宗教供奉神像。

　　Small bronze figurines of gods and goddesses used both as votive offerings—gifts to the gods in fulfillment of vows—and as cult figurines in household shrines.

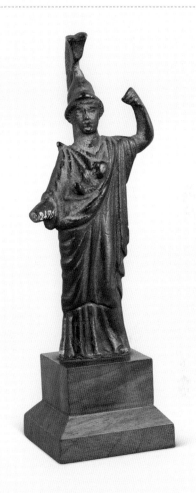

智慧女神密涅瓦銅像
Small Statue of Minerva
羅馬帝國時期
銅
高10.5公分
佛羅倫斯國家考古博物館

Imperial Age
Bronze
H. 10.5 cm
National Archeological Museum, Florence

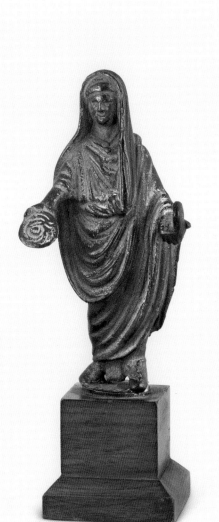

祭祀銅像
Small Bronze Statue of Sacrificer
羅馬帝國時期
銅
高10.1公分
佛羅倫斯國家考古博物館

Imperial Age
Bronze
H. 10.1 cm
National Archeological Museum, Florence

幸運女神福耳圖那–伊西斯雕像
Statue of a Woman Portrayed as the Goddess Fortuna-Isis

圖拉眞時期(西元98~117年)
大理石
高130公分，寬45公分，重130公斤
佛羅倫斯國家考古博物館

Reign of Trajan (98-117 CE)
Marble
L. 130 cm, W. 45 cm, D. 130 kg
National Archeological Museum, Florence

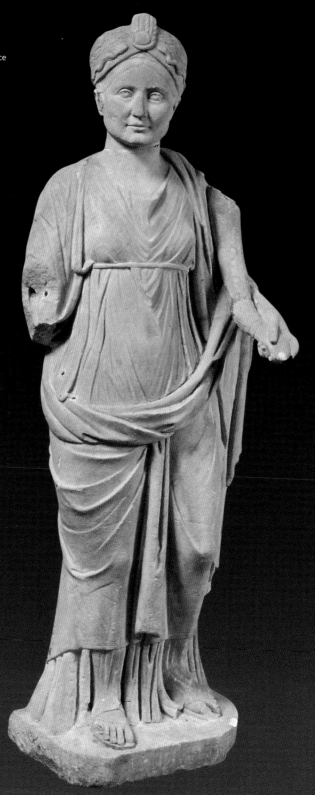

幸運女神福耳圖那–伊西斯的右臂低垂，左臂彎曲，手裡端著以棕櫚葉圖案為裝飾的聚寶盆(象徵豐饒的羊角)。她的頭上盤著髮辮並在腦後連接。這樣的髮型說明雕像是在圖拉眞統治時代(西元98~117年)製造的。雕像的頭上還佩戴鑲有兩條蛇盤踞於中央的長方形髮夾。

幸運女神是早期很受歡迎的羅馬女神，她能帶來繁衍和財富。伊西斯則是埃及女神，奧西瑞斯的妻子。西元二世紀中期，伊西斯的異教影響傳遍了羅馬世界。福耳圖那和伊西斯合二為一成為福耳圖那–伊西斯，被認為是能夠掌管命運，並給人們帶來財富的女神。聚寶盆是其象徵。

The goddess Fortuna-Isis' right arm is lowered and the left is bent, holding a cornucopia decorated with palm leaves. Her hairstyle, with a series of braids around the head and joined at the back, suggests that the statue was made during the reign of Trajan (98-117 CE). She also wears a hair band decorated with two snakes converging at a central, rectangular ornament.

Fortuna was a Roman goddess popular from earliest times, bringer of fertility and increase. Isis was an Egyptian goddess, consort of Osiris, whose cult had spread throughout the Roman world by the middle of the 2nd century CE. The two were fused as Fortuna-Isis, believed to determine fate and provide wealth, as symbolized by the cornucopia.

幸運女神福耳圖銅像
Small Statue Representing the Goddess Fortuna

羅馬帝國時期
銅
高15.3公分
佛羅倫斯國家考古博物館

Imperial Age
Bronze
H. 15.3 cm
National Archeological Museum, Florence

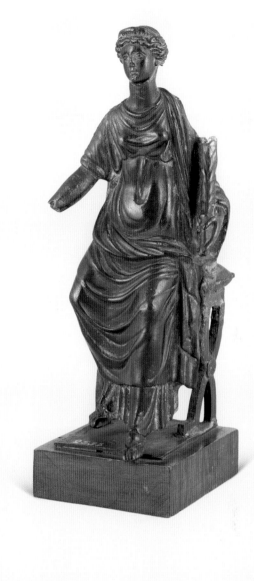

幸運女神福耳圖那左手拿著象徵著財富的聚寶盆。福耳圖那也稱作福斯‧福耳圖那，與希臘女神堤喀一樣是掌管命運、機遇和幸運的女神。

Fortuna sits with a cornucopia in her left hand, the symbol of abundance. Also known as Fors Fortuna, and identified with the Greek goddess Tyche, she was the goddess of fate, chance, and luck.

月亮女神赫卡忒雕像

Hecateion (Stand with the Goddess Hecate)/ Hecateion

西元一世紀晚期

大理石

高53公分，寬30公分

佛羅倫斯國家考古博物館

second half of the 1st century
Marble
H. 53 cm, W. 30 cm
National Archeological Museum, Florence

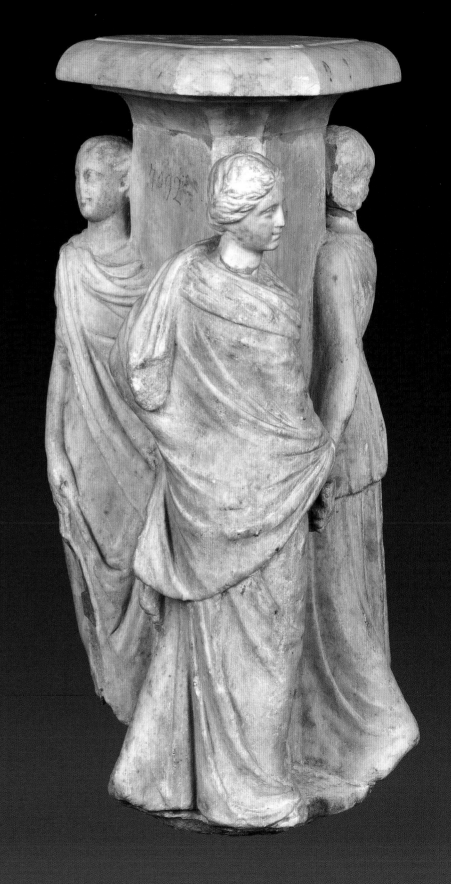

赫卡忒是色雷斯人的月亮女神，通常為三位身著長衣手拿火把的女人。赫卡忒原有的信奉區集中在小亞細亞，但是之後常常與相似的神祇阿耳特彌斯和珀爾塞福涅相混淆。

Hecate was a Thracian moon goddess often shown as three women dressed in long tunics and with torches in their hands. She originally had her own cult, concentrated especially in Asia Minor, but later was often confused with similar deities such as Artemis and Persephone.

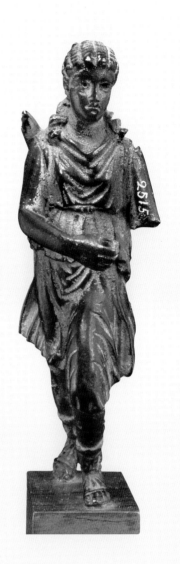

月亮女神黛安娜銅像
Small Statue of Diana
羅馬帝國時期
銅
高12.4公分
佛羅倫斯國家考古博物館

Imperial Age
Bronze
H. 12.4 cm
National Archeological Museum, Florence

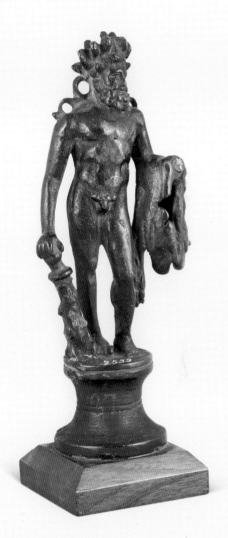

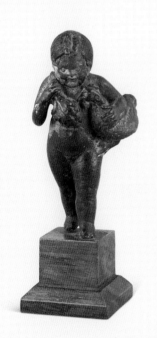

愛神丘比特銅像
Small Statue of the Eros
羅馬帝國時期
銅
高6.4公分
佛羅倫斯國家考古博物館

Imperial Age
Bronze
H. 6.4 cm
National Archeological Museum, Florence

大力神海克力斯銅像
Small Statue Representing Hercules
羅馬帝國時期
銅
高12.4公分(連底座)
佛羅倫斯國家考古博物館

Imperial Age
Bronze
H. 12.4 cm (with the base)
National Archeological Museum, Florence

裸體英雄肖像
Small Statue of Naked Hero with the Horne on the Right Hand

羅馬帝國時期
大理石
高72公分
佛羅倫斯國家考古博物館

Imperial Age
Marble
H. 72 cm
National Archaeological Museum. Florence

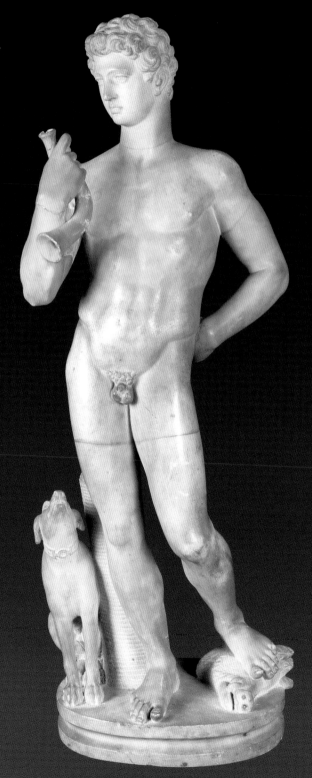

這件波利克里特斯風格的雕塑表現了一個年輕的裸體男子。事實上，它是波利克里特斯的戰神海克力斯系列複製品中的一件，與其傳統有關聯。此尊仿雕像證明了這類小雕像在羅馬悠久的藝術傳統中廣受歡迎。

The sculpture represents a young naked man in the style of Policleto; as a matter of fact, it has been included in the series of replicas of Policleto's Hercules, and it still remains associated to that tradition. However, the high quality of the modelling of the bust proves that the series of small statues such this one had an important success and long time tradition in the Roman art.

愛神丘比特雕像

Small Statue of Amor

西元二世紀初期
大理石
高102公分
佛羅倫斯國家考古博物館

First half of the 2nd century CE
Red-grained marble; some reconstruction with fine-grained. white marble
H. 102 cm
National Archeological Museum, Florence

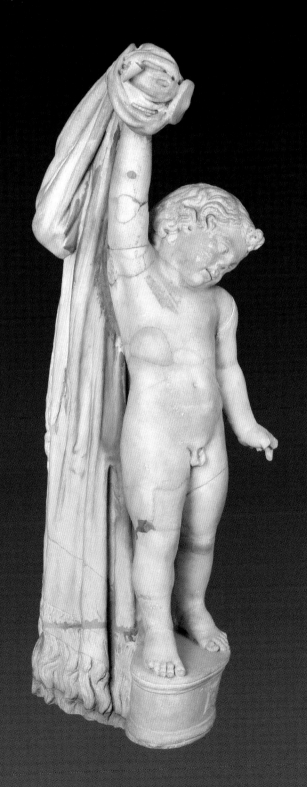

雕像中的丘比特(Amor是古羅馬愛神丘比特的別名,相當於希臘的厄洛斯)長著翅膀,頭偏向左肩,右手高拿斗篷,斗篷上有插入多層褶皺中的圓形搭扣。此作品由同類大理石的碎片塑成,很難判斷是原作品和複製品,但軀幹和頭部確為原作。

This statue represents a winged Amor with his head bent on the left shoulder and the right arm raised. The arm holds a cloak with a circular *fibula* (buckle) inserted into the heavy folds. Because this piece has been reconstructed from numerous fragments of similar types of marble, it is difficult to distinguish between the original sculpture and the reconstruction. The torso and the head are certainly original to the piece.

沉睡中的丘比特雕像
Statue of Sleeping Eros
羅馬帝國時期
大理石
高23公分，長48公分，寬45公分
佛羅倫斯國家考古博物館

Imperial Age
Fine-grained. white marble
H. 23 cm, L. 48 cm , W. 45 cm
National Archeological Museum, Florence

年輕的帶著翅膀的丘比特睡在橢圓形基座上，基座明顯覆蓋著獅皮。獅頭的下方可見箭袋的下部。丘比特的左邊是一個火把。丘比特沉睡的姿勢有其他例子的記載，通常基於希臘化晚期的原型。除了丘比特右腳大腳趾外，此雕像完好無損。

A young winged Eros sleeps on an oval base, apparently a rock covered by a lion skin. The lower part of a quiver is visible under the lion's head, and there is a torch near Eros' left. The sleeping Eros in this position is documented by other examples, all probably based on a late Hellenistic prototype. The statue is intact except for a part of the big toe on the right foot.

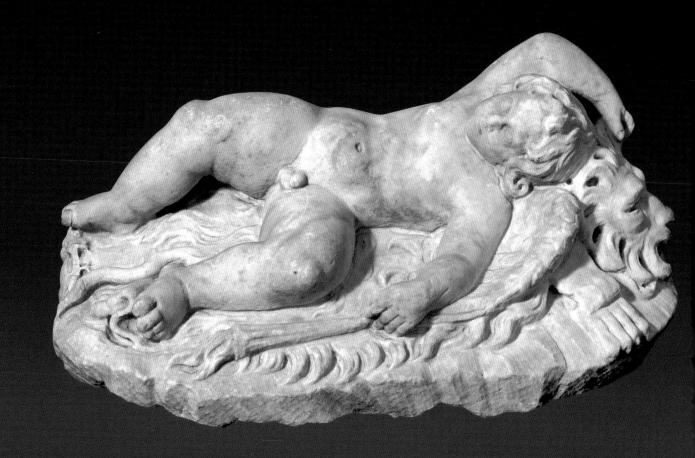

牧神潘雕像
Herm of the God Pan

羅馬帝國時期
大理石
高153公分
佛羅倫斯國家考古博物館

Imperial Age
Marble
H. 153 cm
National Archeological Museum, Florence

自然田園之神潘與酒神巴克斯
(希臘酒神戴‧尼索斯)關係密
切。祂通常為半人半羊的形
象，但這尊雕像幾乎完全為人
形。祂身穿鹿皮，頭戴尖帽，
是典型的牧羊人形象。祂的右
肩扛著一隻小山羊，左手拿著
一個桶狀容器。

Pan was a god of pastoral life and
nature, closely associated with
Bacchus (Greek Dionysus), and often
depicted as half-man and half-goat.
Yet this statue depicts him as almost
completely human. He is wearing a
deerskin and pointed hat typical of
shepherds. He carries a small goat
on his right shoulder and has a *situla*
(bucket) in his left hand.

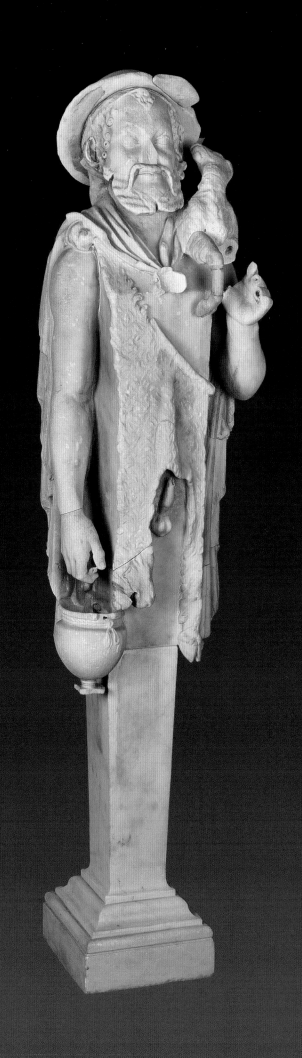

森林之神賽提雕像

Head of Satyr

西元一~二世紀
大理石
高27公分
佛羅倫斯國家考古博物館

1st - 2nd century CE
Marble
H. 27 cm
National Archeological Museum, Florence

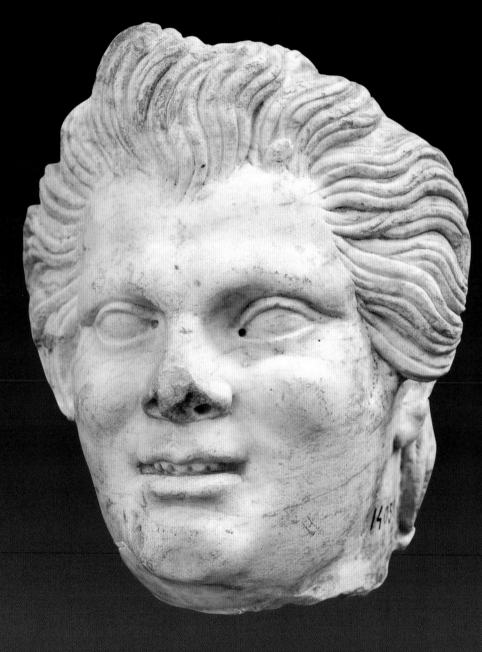

賽提是與酒神巴克斯、自然之
神潘有關的森林之神，代表著
大自然孕育的力量。通常為半
人半羊形象。

Satyrs were gods of the woods tied
to Bacchus and Pan and symbolized
the fertility forces of nature; they are
represented by half-man, half-goat
figures

森林之神西勒努斯雕像
Statue of Silenus

羅馬帝國時期
大理石
高95公分
佛羅倫斯國家考古博物館

Imperial Age
Marble
H. 95 cm
National Archeological Museum, Florence

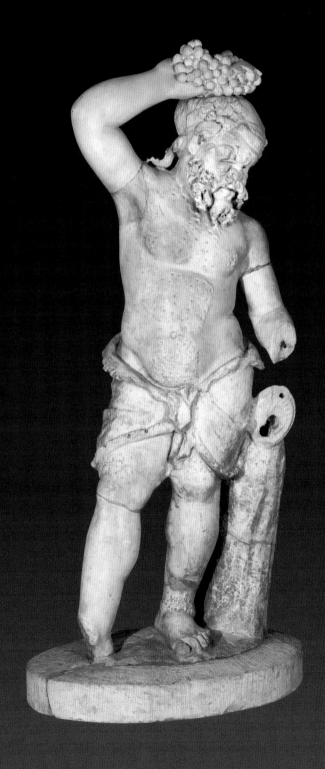

留著鬍子的西勒努斯(森林之神賽提的別稱)頭戴常春藤和藤葉編制的冠冕，身穿獸皮衣服。這種類型的人物肖像雕塑最初起源於羅馬共和晚期，直到帝國時期中期才廣為流行。此後，人們常用此類雕塑裝點花園和噴泉。

The statue represents a *silenus* with beard, crowned with ivy or vine leaves and dressed with an animal-skin. The origin of this type of representation can be dated to the Late Hellenistic period, and it had a great success until the Mid Imperial Age, as it was used to decorate gardens and fountains.

農神西瓦努斯銅像
Small Statue of Silvanuss
羅馬帝國時期
銅
高13.4公分
佛羅倫斯國家考古博物館

Imperial Age
Bronze
H. 13.4 cm
National Archeological Museum, Florence

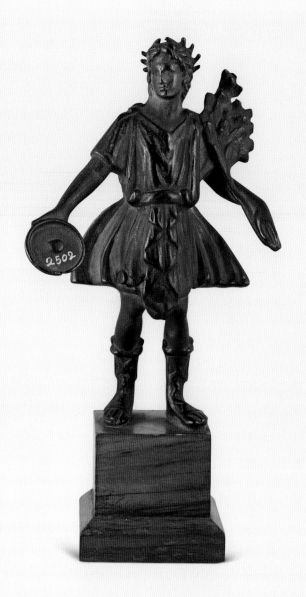

西瓦努斯是森林和放羊人之神。祂也供奉於民間神龕，尤其流行於社會地位低下的奴隸階層。

Silvanus was the god of the woods and of shepherds. He was also honored in domestic shrines, and was especially popular with slaves of low social standing.

商業之神墨丘利銅像
Small Statue of Mercury
羅馬帝國時期
銅
高12公分
佛羅倫斯國家考古博物館

Imperial Age
Bronze
H. 12 cm
National Archeological Museum, Florence

墨丘利與希臘的赫耳墨斯一樣是商業貿易之神。

Mercury, identified with Greek Hermes, was a god of trade and commercial success.

醫神埃斯庫拉庇俄斯雕像
Small Statue of Aesculapius

羅馬帝國時期
大理石
高30公分
佛羅倫斯國家考古博物館

Imperial Age
Marble
H. 30 cm
National Archeological Museum, Florence

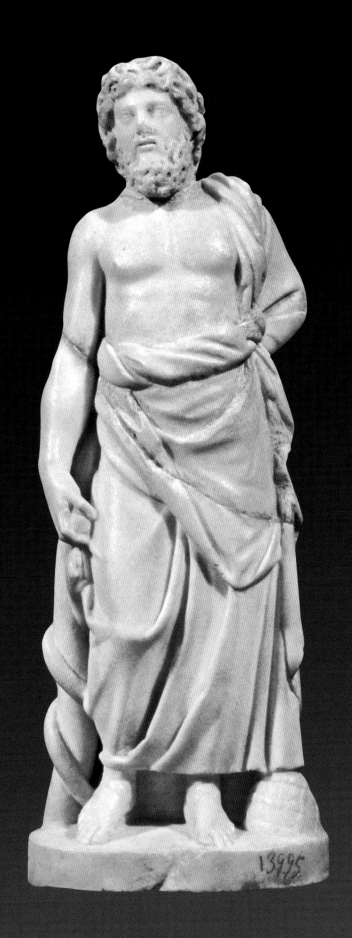

埃斯庫拉庇俄斯是醫神，在所
信奉的地區要舉行該神崇拜的
治療儀式。祂的形象與朱庇特
類似。這尊雕像祂站立著，手
拿纏蛇的棍棒緊靠右腿邊。

Asclepius was the patron god of
medicine and the god of cult places
where healing rites were practiced. He
is depicted similarly to Jupiter. Here he
stands with a club, around which coils
a snake, held next to his right thigh.

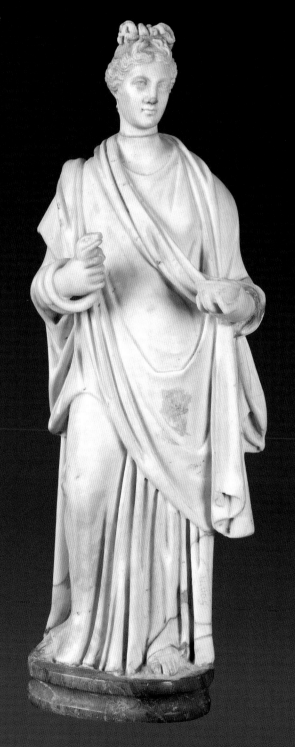

健康女神海吉爾雕像
Small Statue of Hygeia

羅馬帝國時期
大理石
高50公分
佛羅倫斯國家考古博物館

Imperial Age
Marble
H. 50 cm
National Archeological Museum, Florence

海吉爾源自希臘的健康女神，與之等同的羅馬女神有薩盧斯。海吉爾通常與醫術之神埃斯庫拉庇俄斯相聯繫，共同代表著均衡健康的概念。

Hygeia was a healing goddess of Greek origin whom the Romans equated with their goddess Salus. Often associated with Asclepius, Hygeia represented the abstract ideas of health and the equilibrium of physical well-being.

家神拉爾銅像
Small Statue of a Lar God
西元一世紀
銅
高10公分
佛羅倫斯國家考古博物館

1st century CE
Bronze
H. 10 cm
National Archeological Museum, Florence

拉爾是起源義大利的鄉村神
祇，供奉於曠地，之後作為
家庭的守護神。拉爾神龕通
常樹立在曠地或交叉路口。
每家都可用小神龕供奉拉爾
神、貝拿特和祖先神靈。

The *Lares* were divinities of Italic
origins originally related to rural
properties and venerated in open
spaces. Later they came to be
understood as protectors of home and
family. Shrines for Lares stood in open
spaces and at crossroads. Also each
family would have a small household
shrine for its Lares, Penates (other
domestic deities) and ancestral spirits.

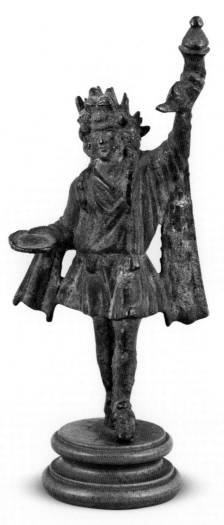

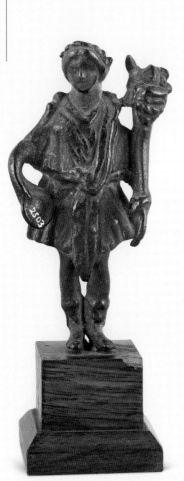

家神拉爾銅像
Small Statue of a Lar God
西元一世紀
銅
高8公分
佛羅倫斯國家考古博物館

1st century CE
Bronze
H. 8 cm
National Archeological Museum, Florenc

生育之神普利阿普斯銅像
Small Statue of Priapus
羅馬帝國時期
銅
高6.7公分
佛羅倫斯國家考古博物館

Imperial Age
Bronze
H. 6.7 cm
National Archeological Museum, Florence

普利阿普斯是自然界繁殖力
之神，祂的形象特點是一個
大型的生殖器，象徵著繁衍
興旺。他也代表著人們對於
酒神載奧尼索斯(巴克斯)的崇
拜。普利阿普斯的雕像可作
為花園的裝飾或家庭神龕。

Priapus was a god of the regenerative
forces of nature and his image,
characterized by a large sexual organ,
symbolized fertility and prosperity. He
also figured in the worship of Dionysus-
Bacchus. Statues of Priapus decorated
gardens and were included in the
household shrines.

智慧之神赫耳墨銅像
Small Statue of a Herm
羅馬帝國時期
銅
高5.6公分
佛羅倫斯國家考古博物館

Imperial Age
Bronze
H. 5.6 cm
National Archeological Museum, Florence

赫耳墨代表的是男性生殖神普
利阿普斯。典型的赫耳墨像為
頂部有人頭像的立石，下方鑲
嵌著男性生殖器，有時石碑兩
邊會有小的殘臂。赫耳墨通常
放置于街邊、十字路口、門前
等交通要道。這種小型雕像也
會在家中供奉。

This miniature Herm apparently
represents Priapus, the phallic divinity.
Herms typically consisted of a vertical
pillar of stone with a human head on top,
a phallus below, and sometimes small
stumps of arms on either side. Herms
were placed along streets, at crossroads,
in front of doors and anywhere there was
a place of transition. A small one such
as this may have stood in a household
shrine.

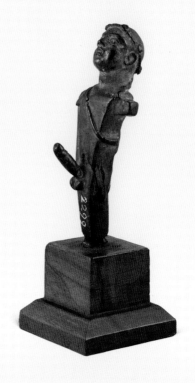

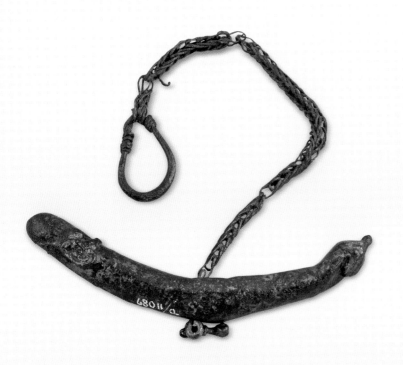

陽具護身符掛件
Pendant Amulet in the form
of a Phallus
羅馬帝國時期
銅
器長9.5公分，鏈長16.5公分
錫恩納國家考古博物館

Imperial Age
Bronze
L. (body) 9.5 cm, L. (chain) 16.5 cm
National Archeological Museum, Siena

考古學家在羅馬地區發現了許
多形狀、大小不同的陽具護身
符，佩戴這些護身符可以驅趕
邪惡，增強男子氣概，提升戰
鬥力。

Many phallus amulets of different
shapes and sizes have been discovered
by archaeologists at Roman sites. They
were worn to ward off evil, enhance
virility, and increase strength in battle.

陽具護身符
Amulet in the form of a Phallus
羅馬帝國時期
銅
長4 公分，寬3.6公分
錫恩納國家考古博物館

Imperial Age
Bronze
L. 4 cm , W.3.6 m
National Archeological Museum, Siena

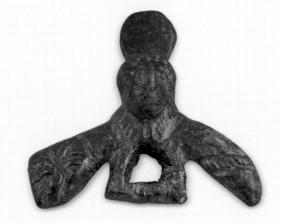

陽具護身符
Amulet in the form of a Phallus
羅馬帝國時期
銅
長5.2公分
錫恩納國家考古博物館

Imperial Age
Bronze
L. 5.2 cm
National Archeological Museum, Siena

陽具護身符
Amulet in the form of a Phallus
羅馬帝國時期
銅
長4公分
錫恩納國家考古博物館

Imperial Age
Bronze
H. 4 cm
National Archeological Museum, Siena

神諭
Oracle
羅馬帝國時期
銅
長14.8公分，寬2公分
佛羅倫斯國家考古博物館

Imperial Age
Bronze
L. 14.8 cm, W. 2 cm
National Archeological Museum, Florence

Sorti Oracolari (玄妙的命運)
是銅或石製的小器物，通常在
命運女神的廟宇中可以找到。
膜拜者從刻有女巫預言的幾個
神諭中挑選一個，祭司則從中
解讀膜拜者的命運。該神諭上
的刻文難以辨認，大意是：
"遵守女巫的指示就能成功。

Sorti Oracolari were small bronze or
stone objects usually found in temples
dedicated to Fortuna. Worshippers
would choose from several such oracles,
each inscribed with a prophecy of the
Sibyl, and a priest would then interpret
the prophecy as it related to the
worshipper's future. The inscription on
this oracle is illegible, but the meaning
seems to be: "if you will follow the Sibyl's
indications, you will be successful".

向死者致敬
HONORING THE DEAD

羅馬宗教不支持永生的理論。人死後進入黑暗的冥界不能轉世，但是喪葬儀式和對祖先的崇拜是生活中非常重要的部分。

帝國初期火葬很流行，死者被放置在柴堆上燃燒，骨灰被放進一個火葬甕裡(骨灰罐)，骨灰盒放在公墓或者家族墓地裡。羅馬帝國後期也有不施行火葬(土葬)的，而且越來越盛行，富有的羅馬人把死者放置在有精美雕刻的石棺裡。

公墓通常在城外，沿著大路，路過的人就可以看到墓碑和精美的墳墓。

Roman religion offered little hope for eternal life, just the dark underworld from which there was no return. Yet funerary rites and the veneration of ancestors were very important parts of life.

Cremation was favored during the early Imperial Period—the dead burned on a pyre, the ashes and bones placed in a cremation urn (*cinerarium*), and the container buried in a cemetery or family tomb. Burial without cremation (inhumation) was practiced also and became increasingly popular during the later Imperial Period, with the bodies of wealthy Romans placed in elaborately carved stone sarcophagi.

Cemeteries were outside the cities, often along a main road, where tombstones and more elaborate funerary monuments could be seen by passers-by.

Sarcophagus Side with Scene of Mourners
西元二世紀
大理石
長80公分，寬70 公分，厚12公分
佛羅倫斯國家考古博物館

2nd century CE
Marble
L. 80 cm, W. 70 cm, Th. 12 cm
National Archeological Museum, Florence

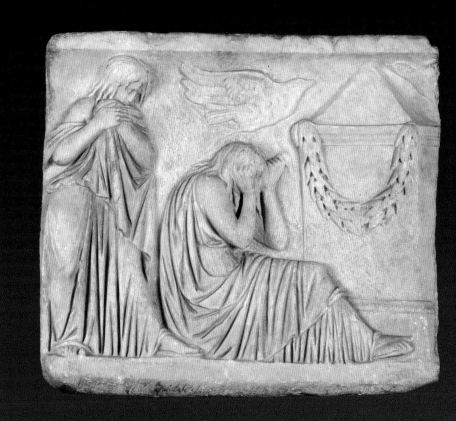

此浮雕石棺上裝飾的是墨勒阿格神話的一幕，其中墨勒阿格的母親愛菲亞和妻子克列奧帕特拉在他的墓前哭泣。

This fragment belongs to a sarcophagus decorated with scenes from the myth of Meleager. Meleager's mother Althaea and his wife Cleopatra weep at his tomb.

神話浮雕石棺殘件
Sarcophagus Side with Mithologic Scene

西元二世紀
大理石
長80公分，寬70 公分，厚12公分
佛羅倫斯國家考古博物館

2nd century CE
Marble
L. 80 cm, W. 70 cm, Th. 12 cm
National Archeological Museum, Florence

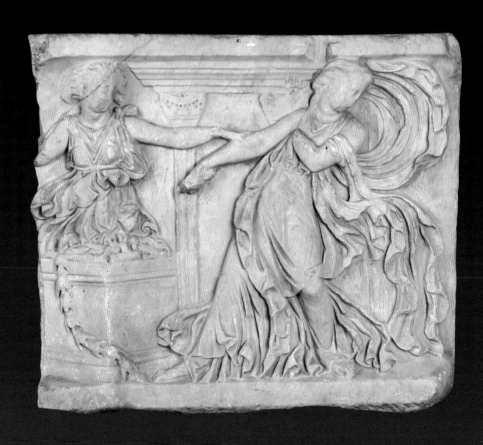

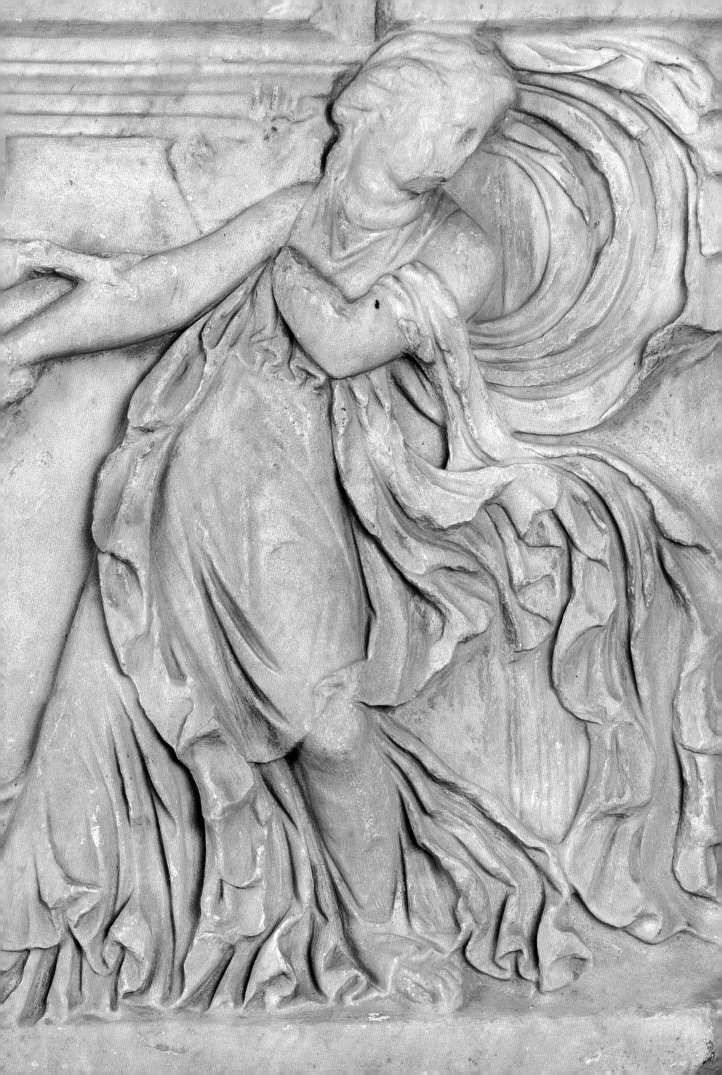

骨灰甕
Urn with Raised Stripes on Body
奧古斯都時期(西元前27年~西元14年)
大理石
高35公分，寬30公分
佛羅倫斯國家考古博物館

Reign of Augustus (27 BCE - 14 CE)
Marble
H. 35 cm, W. 30 cm
National Archeological Museum, Florence

此骨灰甕代表方形建築物，
甕蓋呈屋頂形狀，邊緣上
揚。正面銘文上方是卡皮托
勒母狼正在餵養羅慕洛斯和
勒莫斯的圖案。

This cinerarium represents a square
building, the lid in the shape of a roof
with raised edges. The front has an
inscription under which the Capitoline
wolf nurses Romulus and Remus.

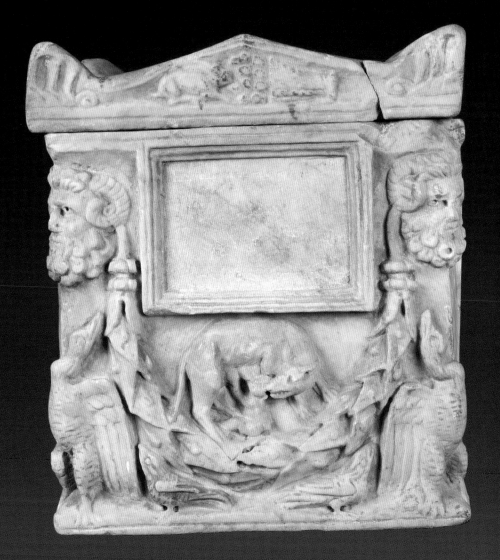

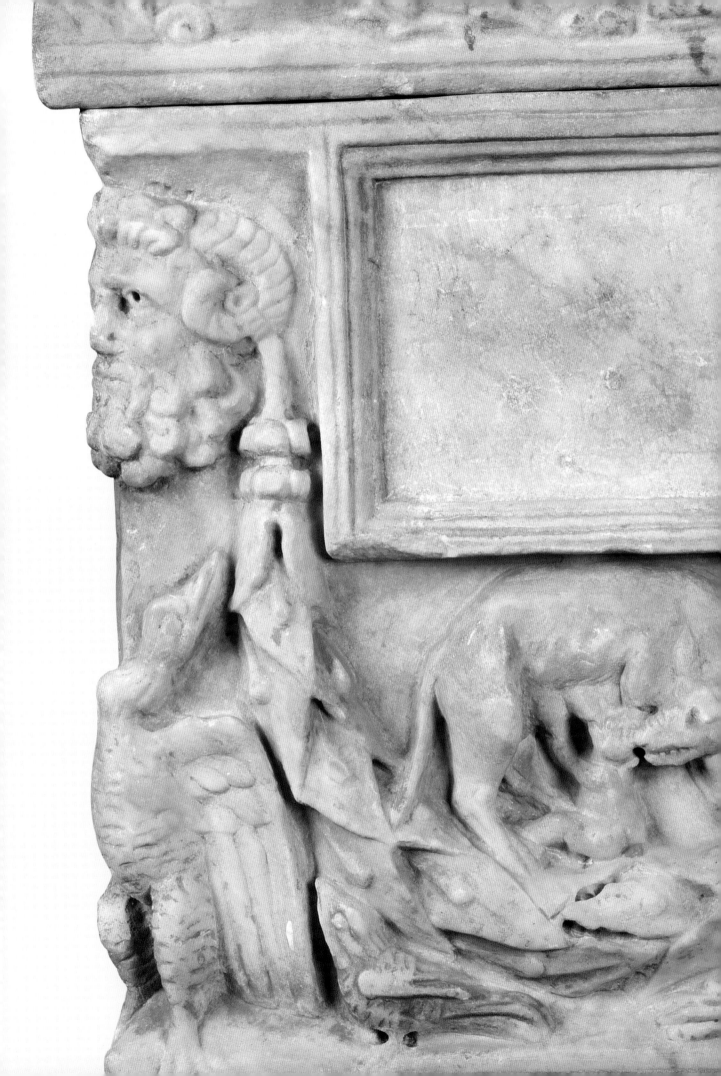

西元一世紀初期
大理石
高35公分，寬30公分
佛羅倫斯國家考古博物館

First half of the 1st century CE
Marble
H. 35 cm, W. 30 cm
National Archeological Museum, Florence

此方形骨灰甕呈房屋形狀，用
來裝已故者火葬後的骨灰。甕
蓋為屋頂，裝飾著劇院屋頂的
兩個人面雕塑，銘文上方躺著
一位赴宴的客人。

This squared urn, meant to hold the
ashes of the deceased after cremation,
is in the shape of a building. The lid
represents the roof and is decorated
with two angular *acroteria* (roof
sculptures) in the shape of theater
masks. Above the inscription is a
reclining banqueter.

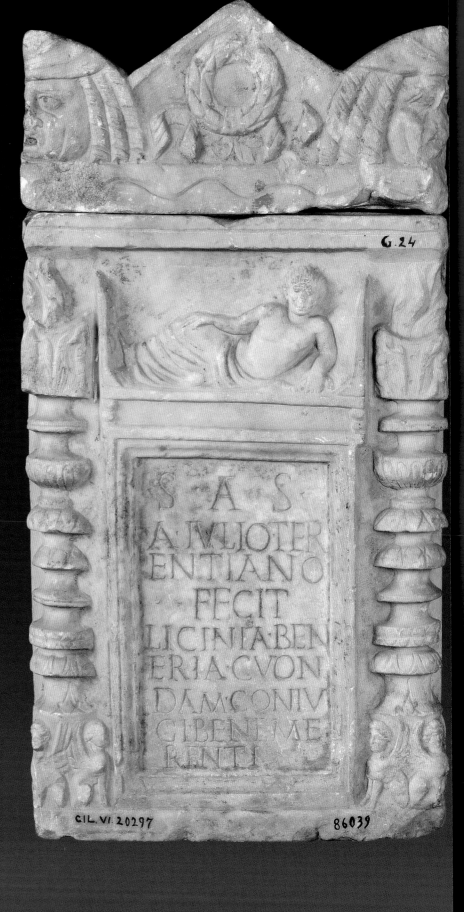

G.24

S · A · S
A·IVLIO·TER
ENTIANO
FECIT
LICINIA·BEN
ERIA·C·VON
DAM·CONIV
GI·BENE·ME
RENTI

CIL.VI.20297

86039

圓柱形骨灰甕
Cylindrical Urn
奧古斯都時期(西元前27年~西元14年)
大理石
高42公分，寬34公分
佛羅倫斯國家考古博物館

Reign of Augustus (27 BCE - 14 CE)
Marble
H. 42 cm, W. 34 cm
National Archeological Museum, Florence

骨灰甕通常是用貴重的材質製成，比如大理石、雪花石膏、玻璃和陶。甕身由小愛神丘比特手舉著花環，甕蓋的紐作成叼蛇的鷹。

Funerary urns often were made of valuable materials such as marble, alabaster, glass and ceramic. The body of this one is decorated with garlands held up by small Eros figures. The handle of the lid is in the shape of a hawk that holds a snake in its beak.

雪花石膏骨灰甕
Urn
西元一世紀
雪花石膏
高39公分
佛羅倫斯國家考古博物館

1st century CE
Alabaster
H. 39 cm
National Archeological Museum, Florence

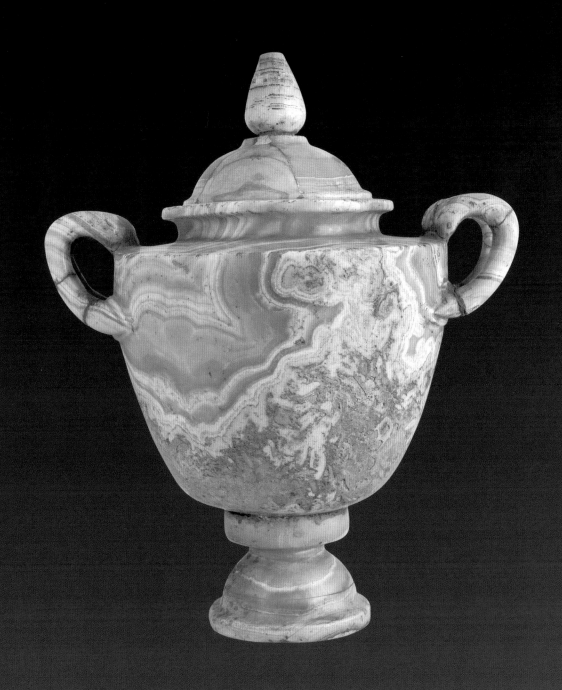

公共生活

PUBLIC LIFE

Art Historian, International Museum Exhibitions
Linda Carioni

國際博物館展覽藝術史學家
琳達‧卡瑞奧尼

在羅馬社會中，市民生活是多元化的。羅馬人不論其身份地位大都樂於參與各式各樣的娛樂活動。

羅馬浴場的考古遺址是最能體現羅馬市井生活的美好和複雜的一面。只有羅馬人才能把浴池提升成一門建築藝術，也只有帝王浴池最能體現其細緻和奢華。

每天會有各種階層的人出入浴場，洗浴儼然成為了社會生活中十分重要的一部分。浴場除了提供滿足個人衛生和護理的需求設備外，也是交友、談生意、辯論、交流資訊，以及得到友誼和社區感的場所。

人們通常會在午後去浴場。在更衣室更衣後就可踏入一個有溫水浴池(tepidarium)的暖房，再去熱水浴池(caldarium)。在熱水浴池隔壁有桑拿間和蒸汽室。通常旁邊還有與露天游泳池相連的冷水浴池(frigidarium)。去浴場還意味著可以去健身房從事些體育活動。選擇如跑步、拳擊、摔跤、擲鐵餅還有各式球類遊戲。最後人們會選擇用豐富的橄欖油和芳香油來做全身按摩從而結束一場洗浴。在浴場幾個小時的放鬆過後，羅馬人接著會去馬戲團，圓形露天競技場或戲院玩個盡興。

娛樂活動充滿了活力，是羅馬公共生活不可分割的一部分。在宗教節日或政治軍事慶典中，經常安排的慶祝活動有：戰車比賽、角鬥士競賽、劇院演出和音樂會。

在整個羅馬帝國，戰車比賽非常流行。競技場長800公尺，寬80公尺，沿其長軸劃分而成橢圓形。每一場比賽需要四輛戰車參賽(有雙馬式戰車或四馬式戰車)，且每位參賽者必須對抗其餘所有參賽者。參賽者按照亢奮的擁護者(他們通常會賭勝負結果)分類。羅馬的馬克西姆賽車場一次可容納二十五萬觀眾，全天可以觀摩多達24場比賽。然而，作為一名戰車參賽者。這是一項非常冒險的賭博，只有他們中最傑出的人可以得到大量金錢和巨大聲望。

在競技場舉辦的角鬥士格鬥和鬥獸表演是羅馬帝國最流行也是最惡名昭著的一種娛樂方式。西元80年，從韋斯巴薌皇帝到他兒子提圖斯統治時期，羅馬競技場成為了家喻戶曉的地方。橢圓形的競技場其結構複雜，由實木和水泥構成，周圍的座位嚴格按照觀眾的不同社會階級而被分成不同段區。競技場下面連接著一個龐大複雜的地下室，活板門裡關押著角鬥士和獅子老虎等野獸，也存放著一些武器和裝備。

　　羅馬帝國的一些節日慶祝可長達175天，成千上萬的角鬥士和野獸面臨著生死角逐。比賽中，既可讓人（或獸）直接攻擊對方直到死亡，也可等對抗到某種程度讓遊戲的贊助人，或是皇帝或其代表決定生死。

　　觀眾可以通過揮動衣物，同時舉起右手大拇指朝上為技巧高超的角鬥士請求活命。如果敗者表現的過於懦弱或不討人喜愛，觀眾會把拇指朝下以示處死。

　　眾多角鬥士都是有技巧的格鬥者，他們之中有戰俘、奴隸和死刑犯。角鬥士也有許多類別，他們用出生地的地名，或者用過的武器來命名。按照現代標準，這些競技場面極其殘忍。有時判刑的罪犯被直接扔進競技場被猛獸撕成碎片。此外，成千上萬的基督徒也因這種方式喪命。

　　在白天，劇場提供多樣化的悲劇、喜劇和默劇演出，觀眾可以大聲呼喊、發洩或開開玩笑。表演卻不是一個受人尊重的職業，男演員一般都是無公民權和社會地位的男性奴隸或是已被解放的男性奴隸，他們被稱為默劇表演者。他們頭頂假髮，臉戴張著大嘴的悲喜假面具，連接假面的是個金屬漏斗以用作演員擴聲。情色默劇是最炙手可熱的風格。不戴假面具的男演員嘲諷著愛情、婚姻和通姦。大多數劇院有騎樓，外觀呈半圓形，且都配備了舞臺機械設備，一般可以容納一萬五千名，甚至更多的觀眾。

　　到西元一世紀，羅馬儼然成為了一座擁有一百萬人口的大型城市，並且許多商業行為融入了市民日常生活中。市民們經常光臨工匠作坊或逛烘烤麵包和買賣蔬菜瓜果鮮肉這樣的零售攤位。在街道上擺攤的生意可以讓家人和他們的奴隸一起經營。這些市民生活中最重要的雞毛店遍佈羅馬的大街小巷，許多壁畫和大理石浮雕上均有呈現這樣的畫面。

　　一些早期的小店逐漸演變成了一些專業銷售葡萄酒和食物的酒館。它們通常由一個或多個房間組成，有一個底部為烤箱的石器檯面，及用來存放食物和飲料的幾個瓶罐。傢俱僅限於最基本的需求：一張桌子，或一些椅子，但更多地是一條長凳。羅馬人在這裡能買到便宜的食物和葡萄酒，它也為顧客提供賭博和賣淫這類常見活動。

In Roman cities, public life was multi-faceted and most Romans, regardless of status, interacted with a variety of its manifestations.

Archaeological ruins of Roman baths represent one of the most common, beautiful and sophisticated expressions of Roman public life. It was the Romans who elevated the act of bathing to a form of art in architecture, and it is the baths of the emperors that best represent the luxurious refinement attained.

Attended daily by people from all classes, the baths were a fundamental part of social life. Besides providing all the facilities needed for personal care and hygiene, they were considered as a place to meet friends, do business, debate, exchange news and receive a sense of companionship and community.

A visit to the baths usually occurred in the afternoon. After undressing in the changing room (apodyterium), one would enter the warm room (tepidarium) and from there, the calidarium where pools of hot water were located. In the calidarium, or in adjacent rooms, there were the laconicum (sauna) and the sudatorium (steam room). Next was a plunge into the cold water of the frigidarium, followed by a swim in the pool (natatio), usually located in the open air.

A visit to the baths included sporting activities in the gymnasium. Among the choices were running, boxing, wrestling, the discus throw and ball games. Delicate massage, with abundant use of olive oil and perfumed oils, completed the visit. Rejuvenated by a few hours at the baths, Romans were then ready to enjoy themselves at the circus, at the amphitheatre or at the theatre.

Entertainment was a vibrant and integral part of Roman public life. Chariot races, gladiator contests, theatre presentations and musical concerts were often organized in connection with religious festivals or celebrations of political and military events.

Throughout the empire, chariot races were very popular events. The track of a hippodrome (circus) was 800 meters long, 80 meters wide, divided along its major axis to form an oval shape. Four chariots (either a biga, a two-horse chariot, or quadriga, four-horse chariot) participated in each race; each against all others. Contestants were divided into factions supported by excited fans who would usually bet on the outcome. The hippodrome in Rome, the Circus Maximus, could hold 250,000 spectators who watched as many as 24 races per day. To be a charioteer was a dangerous trade, but the best of them earned a great deal of money and enjoyed enormous popularity.

Gladiator combat and pitting men against wild beasts were the most popular and ultimately, infamous forms of entertainment held at amphitheatres throughout the Empire. The most famous amphitheatre was the Colosseum in Rome, begun by the Emperor Vespasian and inaugurated by his son Titus in 80 CE. Complicated in structure, an oval arena, constructed of wooden planks covered with sand, was surrounded by seats grouped into sections that strictly corresponded to the social ranking of the spectators. Underneath, there was a vast complex of underground chambers connected to the arena by trapdoors where gladiators, beasts, captives, arms and machinery were kept.

During some festivals that could last for one hundred days, thousands of gladiators and beasts met their deaths. Men (or beasts) fought against each other until death or defeat at which point the decision of life or death was given to the patron of the games, either the emperor or one who represented him.

For bravery or skill, the crowd could ask for a life to be spared by waving pieces of cloth in the air while holding their right thumbs in the air. But if the defeated had acted cowardly or was disliked, the crowd could condemn him by pointing their thumbs to the ground.

Most gladiators were skilled combatants who were prisoners of war, slaves or those condemned to death. There were many categories of gladiators; some took their names from their place of birth, others from the types of weapons they used. By modern standards, these spectacles were extremely cruel. At times, criminals condemned to execution were thrown into the arena where they were torn apart by vicious animals. Thousands of Christians also died this way.

During the daytime, theatres offered a varied program of tragedies, comedies, mimes and pantomimes to which the audience reacted loudly with yells, outbursts and jokes. Acting was not an esteemed profession; actors called histriones or cantares were generally male slaves or freed slaves, without civil rights or social status. They wore wigs and tragic or comic masks with a large mouth opening and metal funnel attached that amplified the actor's voice. Mime with erotic themes, however was the most popular genre; love, marriage and adultery were ridiculed by unmasked actors. Most theatres were semicircular in shape with arcaded facades and equipped with theatrical machinery. Capacity could be 15,000 spectators or more.

By the 1st Century CE, Rome had become a very large city with a population of about one million and there were many commercial activities woven into the fabric of public life. Citizens interacted daily with artisan workshops and retail stalls dedicated to the baking of bread or the sale of vegetables, fruit or meat. Opening onto the streets, these businesses were run families and their slaves. These were the original tabernae, small shops lining the streets of Rome, whose importance in daily life is represented in many frescoes and marble reliefs.

The early tabernae evolved into taverns (vinaria) specialized in the sale of wine and food. They usually consisted of one or more rooms; in the first was a stone countertop, with an oven underneath, and many large vases for storing food and beverages. Furnishings were limited to the barest essentials; a table, perhaps some chairs, but more often, a bench. Here, Romans could find inexpensive food and even cheaper wine. Both gambling and prostitution were among the common activities available for patrons.

浮雕石棺殘件
Sarcophagus Fragment with Portrait of a Woman
西元三世紀初期
大理石
長75公分
佛羅倫斯國家考古博物館

First half of the 3rd century CE
Marble
L. 75 cm
National Archeological Museum, Florence

這塊殘件是石棺蓋的一部
分，採用的是自西元二世紀
最後幾十年到西元三世紀初
期頗為常見的樣式。石棺蓋
的四角應該刻有表現舞臺面
具的裝飾圖案，前方的正
中間刻有提及死者名字的銘
文。若死者為女性，在碑文
左邊會鑲有該女子的肖像。

This fragment belongs to the cover
of a sarcophagus, of a type that was
common from the last decades of
the 2nd century CE through the first
half of the 3rd century. It would have
had decorative motifs engraved at
the corners of its lid depicting stage
masks, and in the middle of its front
the sarcophagus might have borne
an inscription with the name of the
deceased. The female bust engraved
to the left of the tablet suggests this
sarcophagus contained the remains of
a woman.

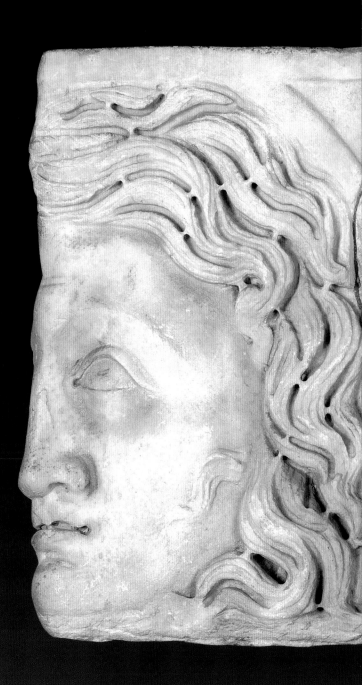

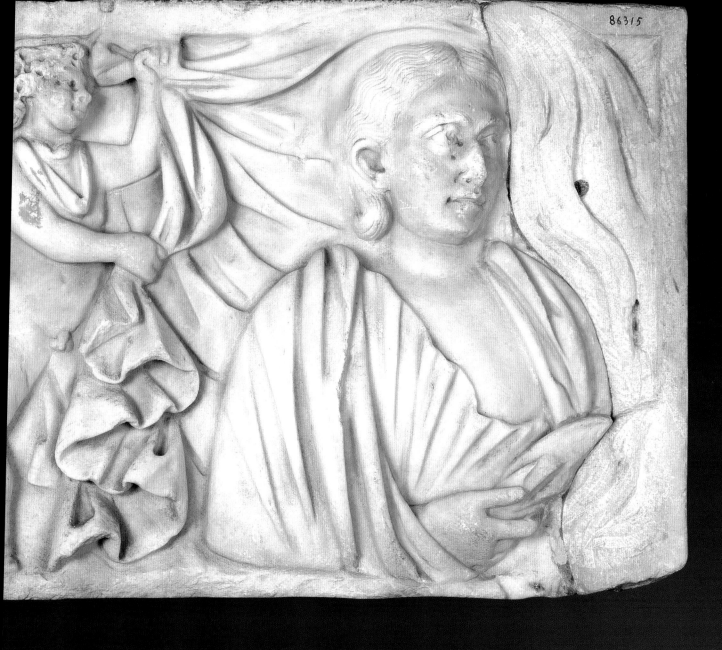

劇場面具
Theater Mask
西元二世紀
大理石
高29公分
佛羅倫斯國家考古博物館

2nd century CE
Marble
H. 29 cm
National Archeological Museum, Florence

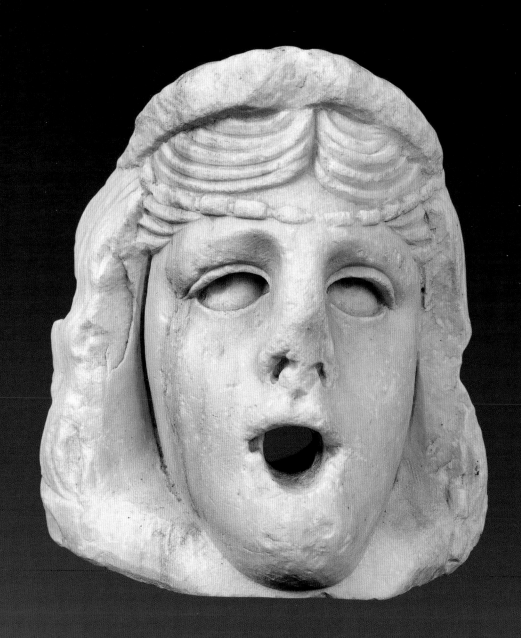

它可能用於裝飾石棺蓋的角落。

This piece probably decorated the corner of a lid to a sarcophagus.

劇場面具圖陶燈
Lamp with Theater Mask
羅馬帝國時期
陶土
最長9.5公分，直徑6.4公分
錫恩納國家考古博物館

Imperial Age
Terracotta
L. (max) 9.5 cm, D. 6.4 cm
National Archeological Museum, Siena

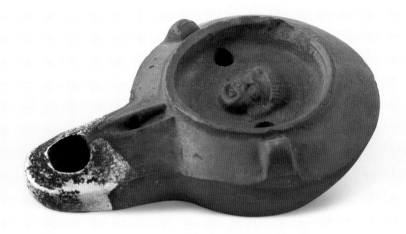

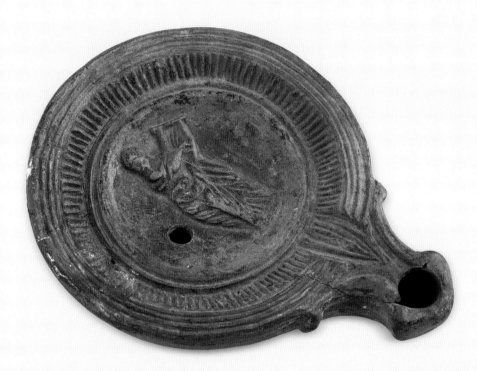

彈奏豎琴圖陶燈
Theater Mask
西元一~二世紀
陶土
長11公分，直徑8.5公分
佛羅倫斯國家考古博物館

1- 2 century CE
Terracotta
L. 11 cm, D. 8.5 cm
National Archeological Museum, Florence

個人肖像
PRIVATE PORTRAITURE

　　肖像是羅馬藝術門類中高度發達的一類，個人肖像尤其反映出現實主義的意味。

　　很多流傳下來的個人肖像的對象是男性老者—他們無疑是傑出和富有的公民，但也有端莊的女子甚至兒童。人物極微小的細節也刻畫了出來，毫不避諱地反映其真實面貌。雕塑家也竭力去表達對象諸如聰明、智慧、堅定、甚至無情的人格特質。

　　羅馬肖像的現實主義風格可能與其葬俗緊密相關，家庭神龕裡也保存有祖先的面模和半身像。

Portraiture was a highly developed aspect of Roman art, and especially private portraits reflect a taste for realism.

Many of the private portraits that have survived are of older men—prominent and wealthy citizens no doubt—but there are stately women as well and even children. Subjects are depicted with attention to the smallest details, including unflattering features. The sculptors managed to convey personality traits as well—intelligence, wisdom, firmness, and even ruthlessness.

Roman portraiture seems to have been closely associated in its origins with funerary customs, which helps explain the taste for realism. Also masks and busts of ancestors were kept in household shrines.

默劇小丑銅像
Small Statue of a Mime
羅馬帝國時期
銅
高9公分
佛羅倫斯國家考古博物館

Imperial Age
Bronze
H. 9 cm
National Archeological Museum, Florence

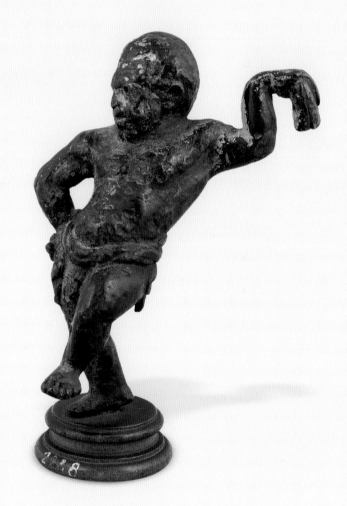

羅馬人所見到的各種場面在他們的社會生活中發揮著重要的作用。因此，默劇演員、雜技演員和戲劇演員通常作為銅小型雕像的主題。

The various types of spectacles viewed by the Romans played an important role in their social life. As a result, mimes, acrobats and actors were often the subject of small bronze figurines.

娛樂
ENTERTAINMENT

羅馬劇院最大特別之處在於僅使用男演員。他們戴著不同角色的面具,以區分男女。默劇很流行。羅馬社會生活的另一個方面,也是和我們當代社會緊密相關的,是體育賽事吸引了大量的公眾。

戰車競賽非常流行。羅馬的馬克西姆賽車場,可容納二十五萬觀眾,一天可以進行24場比賽。更加盛行的可能是角鬥士競賽—男人對男人(有時是女人)、男人對野獸。絕大部分角鬥士是奴隸、犯人或者死刑犯。少部分是自願成為角鬥士的人,這個職業在競技場不一定都意味著最後走向死亡。

Roman theater featured only male actors, who wore masks to distinguish their roles, male or female. Pantomime and mime were popular as well. Another characteristic aspect of Roman social life, and one that finds a close parallel in our society today, was the large number of public spectator sporting events.

Chariot racing was very popular. Rome's race track, the *Circus Maximus*, could hold 250,000 spectators who might watch as many as 24 races in a day. Gladiatorial combat—men (and occasionally women) against each other, and men against wild beasts—was perhaps even more popular. Most gladiators were slaves, prisoners, or criminals condemned to execution. Others became gladiators voluntarily, and the profession did not necessarily lead to eventual death in the arena.

演員銅像
Statue of an Actor
羅馬帝國時期
銅
高4.5公分
佛羅倫斯國家考古博物館

Imperial Age
Bronze
H. 4.5 cm
National Archeological Museum, Florence

該演員戴的喜劇面具是張大嘴巴、蓄著短鬍子的樣子。

The actor wears a comedy mask whose mouth is wide open and framed by a short beard.

角鬥士銅像
Statue of a Gladiator
羅馬帝國時期
銅
高9.2公分
佛羅倫斯國家考古博物館

Imperial Age
Bronze
H. 9.2 cm
National Archeological Museum, Florence

這位角鬥士戴著頭盔,手持盾牌和刀劍,頭盔頂部還高聳著羽冠。

The gladiator is fully armed with a helmet, shield and sword, and his helmet is topped with a high crest.

角鬥士銅像
Small Statue of Gladiator
羅馬帝國時期
銅
高16.7公分
佛羅倫斯國家考古博物館

Imperial Age
Bronze
H. 16.7 cm
National Archeological Museum, Florence

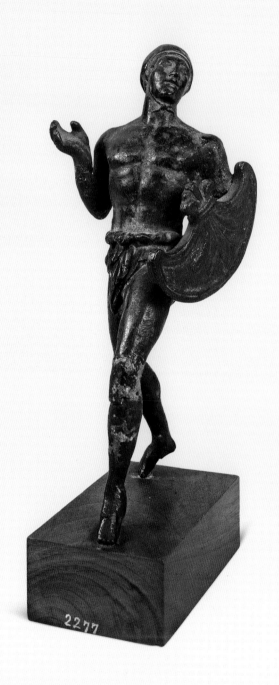

該銅像刻畫了角鬥士向後跌倒的瞬間，此時他不得不屈服於對手。

The gladiator is depicted here falling over backwards, apparently at the moment he succumbs to his adversary.

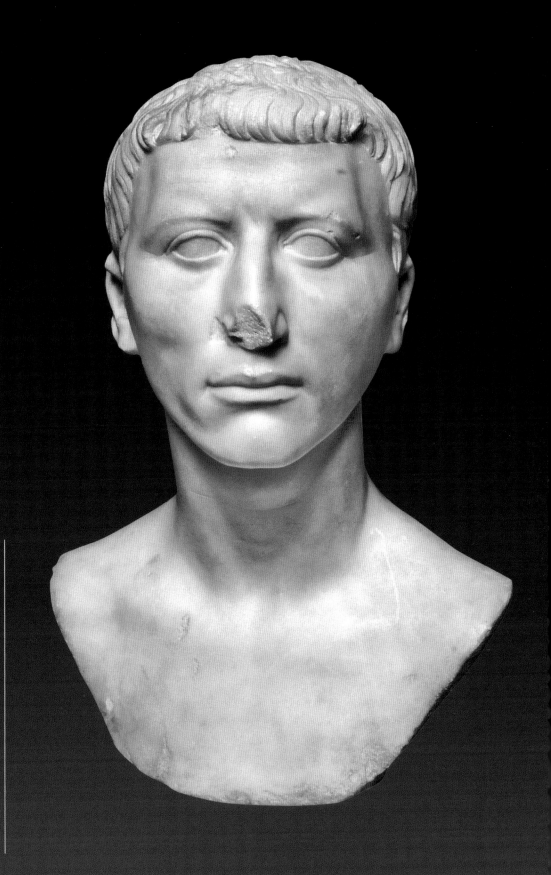

男性肖像
Portrait of Unknown Man
提比略時期(西元14~37年)
大理石
高39.4公分
佛羅倫斯國家考古博物館

Reign of Tiberius (14 - 37 CE)
Italian marble
H. 39.4 cm
National Archeological Museum, Florence

該肖像刻畫的是一名體貌獨特的中年男子，帶有淺淺皺紋的方額頭，鬢骨凹陷，顴骨高聳，長長的鷹鉤鼻，嘴唇肥厚，寬圓的下顎。與其他肖像相比，這尊肖像顯然更為上乘，估計是出自提比略統治後期。

This portrait shows a middle-aged man with very individual physical characteristics. He has a squared forehead with some shallow lines and his temples have deep grooves. His cheekbones are very pronounced, his nose is long and hooked, and he has large lips and a wide, rounded chin. This is undoubtedly a work of high quality and, based on comparison with other portraits, can be dated to the late years of the reign of Tiberius.

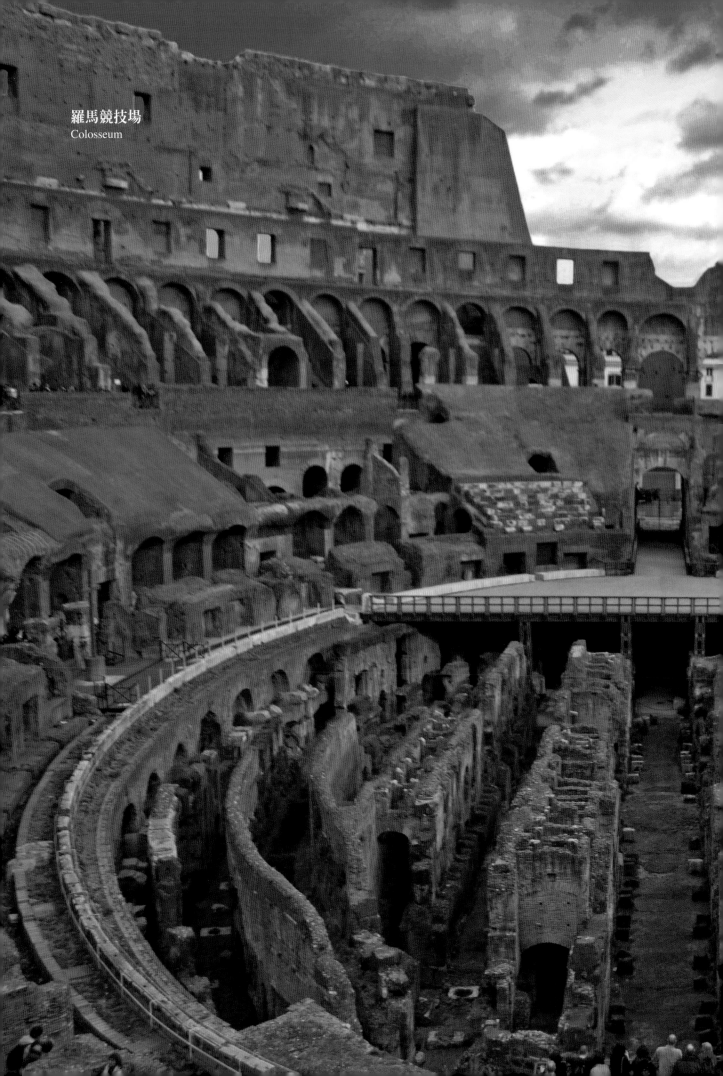

羅馬競技場
Colosseum

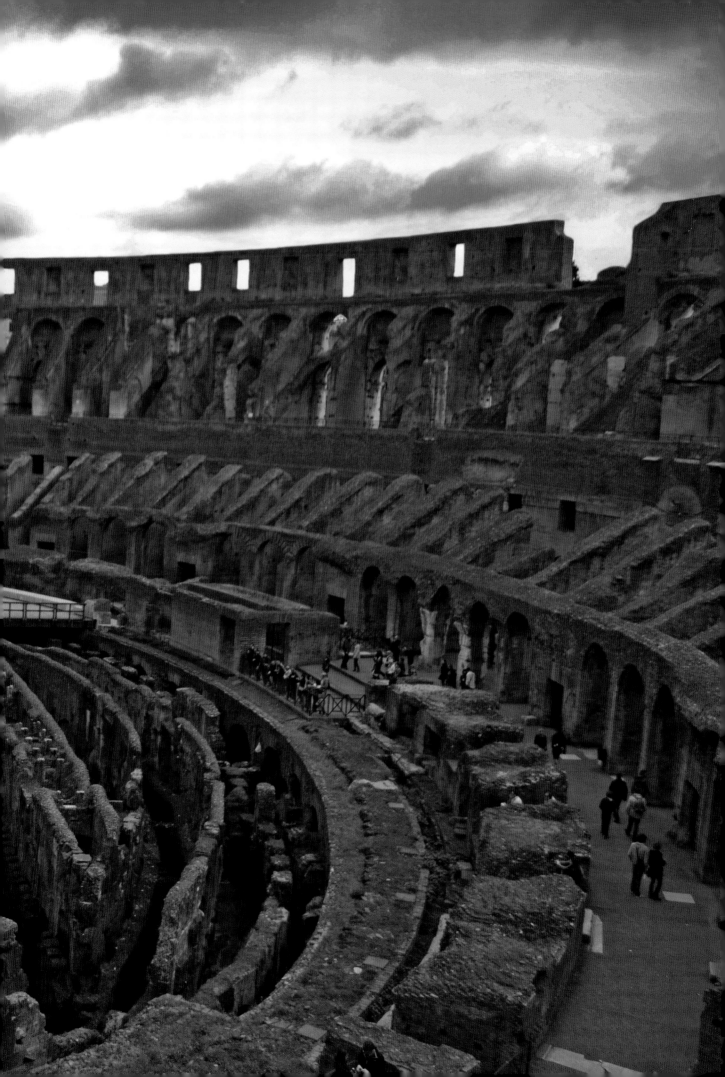

奏樂者陶板
Fragment of Slab with Figures Playing Musical Instruments
西元前一世紀
陶土
最高33公分，長44公分
佛羅倫斯國家考古博物館

1st century BCE
Terracotta
H. (max) 33 cm, L. 44 cm
National Archeological Museum, Florence

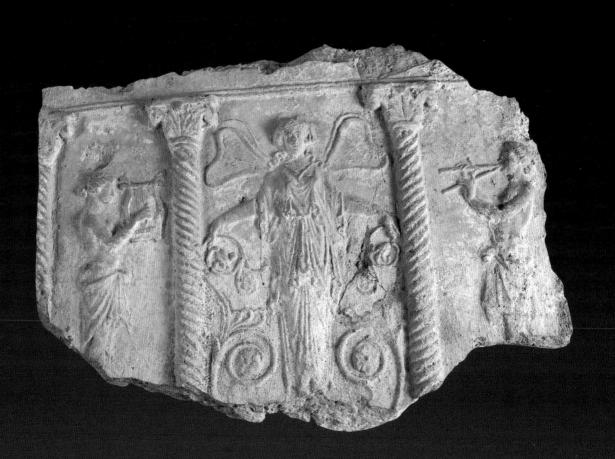

左邊的女人在彈奏里拉琴，右邊的男子在吹奏長笛。

A woman on the left plays a lyre while a man on the right plays a flute.

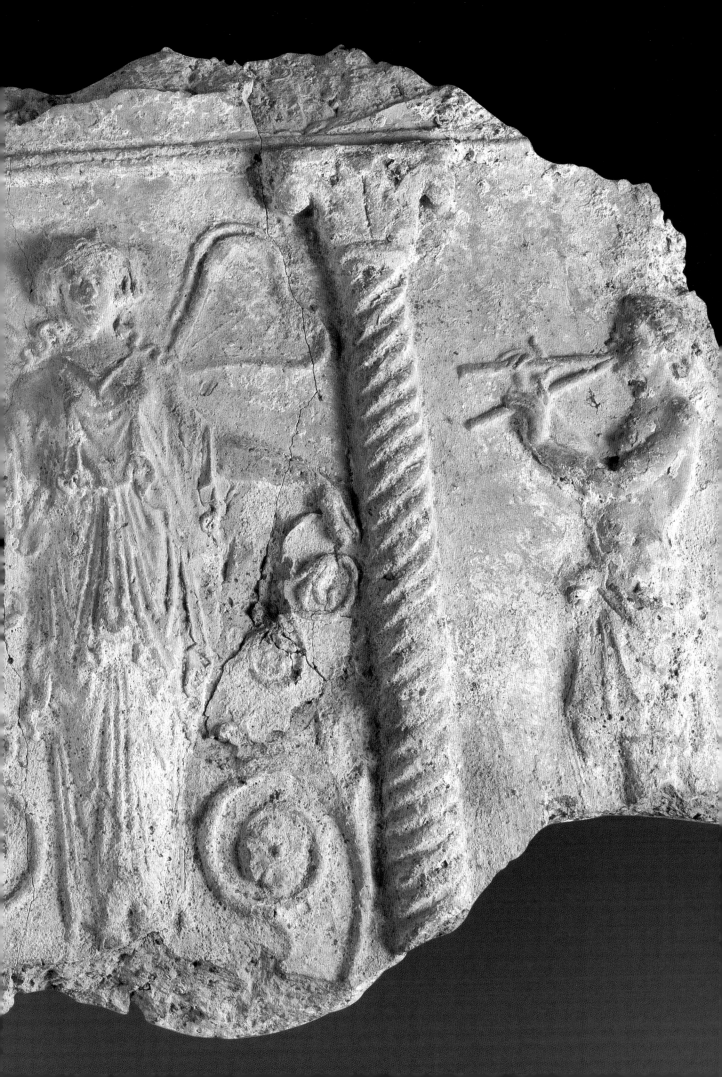

市場圖石棺殘件
Fragment of a Sarcophagus Front with Market

西元二世紀初期
大理石
長83公分，寬26公分
佛羅倫斯國家考古博物館

First half of the 2nd century CE
Marble
L. 83 cm, W. 26 cm
National Archeological Museum, Florence

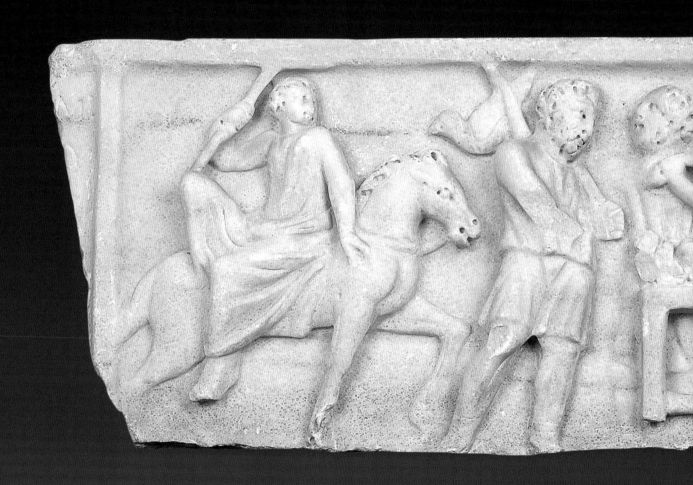

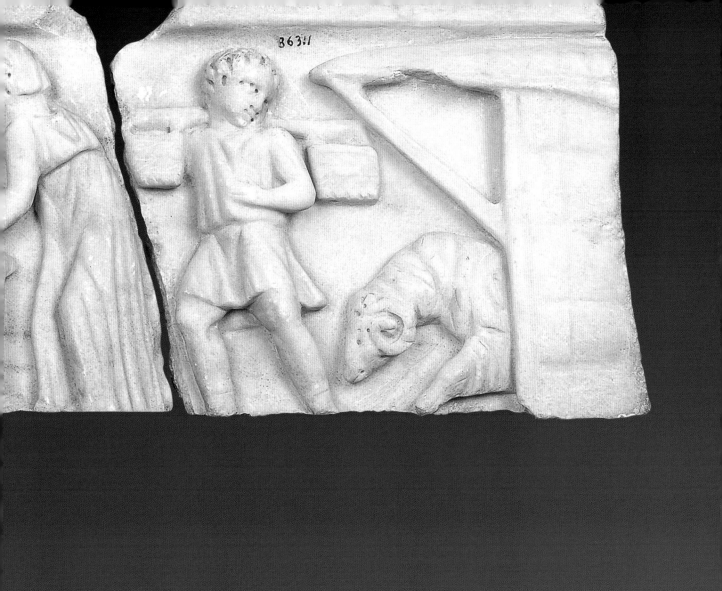

古羅馬市場遺跡(羅馬廣場)
Ancient Rome Market(FORO ROMANO)

羅馬人的飲食　THE ROMAN DIET

羅馬人的食物主要依賴於糧食，而下層人民的主食是一種叫 "普爾" (puls)的粥。

普爾一般是小麥或大麥做成，用橄欖油和植物調料來調味，同各種蔬菜或山羊乳酪一起食用。富裕的羅馬人享用各種食物：水果、雞蛋、肉、魚和甜糕點。富人吃的更加奢侈，有時宴饗各種令人難以置信的食物。

人們根據不同季節食用蔬菜和水果，肉類和魚。吃新鮮食物，也吃煙燻、鹽漬或者醃製品。葡萄酒必須經過稀釋，通常再用蜂蜜增甜，用苦艾酒、玫瑰花瓣、肉桂或者藏紅花來調味。一種很受歡迎的經過發酵及鹽漬的魚(一種伍斯特醬)出口到帝國的不同地區。

The Roman diet depended heavily on grains, and a mainstay for lower classes was a kind of porridge called puls.

Puls could be made from wheat or barley, flavored with olive oil and herbs, and served with vegetables or goat cheese. Affluent Romans could afford a variety of foods—fruit, eggs, meat, fish and sweet pastries. The wealthy ate lavishly, sometimes feasting on a staggering variety of foods.

Vegetables and fruits were eaten in season. Meat and fish had to be eaten fresh as well unless smoked, salted or pickled. Wine was always diluted, often sweetened with honey, and flavored with absinthe, rose petals, cinnamon or saffron. A popular condiment of fermented, salted fish (a type of Worchester sauce!) was exported throughout the empire.

球形油瓶
Spherical Oil Holder
羅馬帝國時期
玻璃
高3.8公分
錫恩納國家考古博物館

Imperial Age
Glass
H. 3.8 cm
National Archeological Museum, Siena

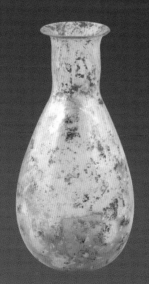

短錐形油瓶
Tronco-Conic Oil Holder
羅馬帝國時期
玻璃
高6公分
錫恩納國家考古博物館

Imperial Age
Glass
H. 6 cm
National Archeological Museum, Siena

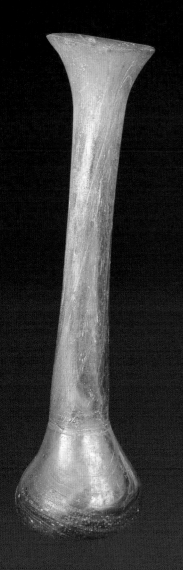

管狀油瓶
Tubular Oil Holder
羅馬帝國時期
玻璃
高13公分
佛羅倫斯國家考古博物館

Imperial Age
Glass
H. 13 cm
National Archeological Museum, Florence

細長型油瓶起源於西元一世紀初期。

The elongated pyriform shape can be dated to the first half of the 1st century CE.

細長型油瓶
Elongated Oil Holder
西元一世紀初期
玻璃
高9.2公分
錫恩納國家考古博物館

First half of the 1st century CE
Glass
H. 9.2 cm
National Archeological Museum, Siena

管狀油瓶
Tubular Oil Holder

羅馬帝國時期
玻璃
高10.2公分
佛羅倫斯國家考古博物館

Imperial Age
Glass
H. 10.2 cm
National Archeological Museum, Florence

球形油瓶
Spherical Oil-Holder

西元一世紀初期
黃色玻璃
高4公分
錫恩納國家考古博物館

First half of 1st century CE
Yellow glass
H. 4 cm
National Archeological Museum, Siena

這種油瓶特徵是口緣有三個瓣，短頸，幾乎很難與圓形的瓶身區分開來。這種油瓶十分罕見，曾在義大利東北地區出現過。

This unguentary is characterized by a *trliobate* (three-mouthed) rim and a short neck, hardly discernable from the spherical belly. This kind of unguentary is quite rare, but similar examples have been found at northeastern Italian sites.

陶油罐
Oil Jar
羅馬帝國時期
陶土
高7.5公分，寬 5公分
佛羅倫斯國家考古博物館

Imperial Age
Terracotta
H. 7.5 cm , W. 5 cm
National Archeological Museum, Florence

陶油罐
Oil Jar
羅馬帝國時期
陶土
高12公分，寬8公分
佛羅倫斯國家考古博物館

Imperial Age
Terracotta
H. 12 cm, W. 8 cm
National Archeological Museum, Florence

陶盤

Plate

西元前一世紀

陶土

直徑18公分

佛羅倫斯國家考古博物館

1st century BCE

Terracotta

D. 18 cm

National Archeological Museum, Florence

陶盤

Plate

西元前一世紀

陶土

直徑18公分

佛羅倫斯國家考古博物館

1st century BCE

Terracotta

D. 18 cm

National Archeological Museum, Florence

陶盤
Plate
西元前一世紀
陶土
直徑18公分
佛羅倫斯國家考古博物館

1st century BCE
Terracotta
D. 18 cm
National Archeological Museum, Florence

陶杯
Cup
羅馬帝國時期
陶土
最大直徑12公分
佛羅倫斯國家考古博物館

Imperal Age
Terracotta
D. (max) 12 cm
National Archeological Museum, Florence

薄胎陶罐
Thin Walled Vase
西元前一世紀~西元一世紀
陶土
高8公分
佛羅倫斯國家考古博物館

1st century BCE -1st century CE
Terracotta
H. 8 cm
National Archeological Museum, Florence

西元前一世紀末，一種模仿玻璃厚度的薄胎陶器開始出現。這也許是該時期出土器皿中最具價值的陶器餐具。

Towards the end of the 1st century BCE, a type of thin walled pottery was produced that imitated the thickness of glass. It was perhaps among the most valuable ceramic tableware produced during this period.

薄胎雙耳陶杯
Thin Walled Double-Handled Cup
西元前一世紀~西元一世紀
陶土
高9公分
佛羅倫斯國家考古博物館

1st century BCE - 1st century CE
Terracotta
H. 9 cm
National Archeological Museum, Florence

薄胎雙耳陶瓶
Thin Walled Double-Handled Vase(Olla)
西元前一世紀~西元一世紀
陶土
高10公分
佛羅倫斯國家考古博物館

1st century BCE - 1st century CE
Terracotta
H. 10 cm
National Archeological Museum, Florence

陶杯
Poculo
西元前一世紀~西元一世紀
陶土
高10公分
佛羅倫斯國家考古博物館

1st century BCE - 1st century CE
Terracotta
H. 10 cm
National Archeological Museum, Florence

陶罐
Pitcher
西元前一世紀~西元一世紀
陶土
高7公分
佛羅倫斯國家考古博物館

1st century BCE - 1st century CE
Terracotta
H. 7 cm
National Archeological Museum, Florence

這是羅馬粗陶典型器皿的形狀，可能用於盛放酒類。

This piece is a typical Roman coarse ware shape, probably used as a container for wine.

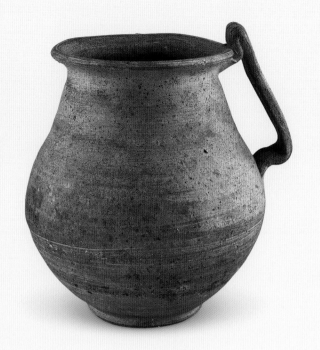

刮身板
Strigil
西元一世紀
銅
長23公分
佛羅倫斯國家考古博物館

1st century CE
Bronze
L. 23 cm
National Archeological Museum, Florence

刮身板用於運動後清除身上的油脂和汗水。

The strigil was used to clean oil and sweat from the body after exercise.

銅勺

Casserole

西元一世紀
銅
最長25.3公分
佛羅倫斯國家考古博物館

1st century CE
Bronze
L. (max) 25.3 cm
National Archeological Museum, Florence

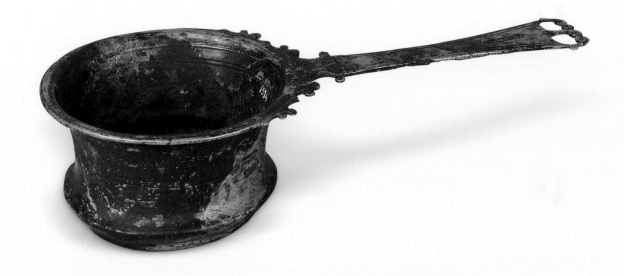

這種銅勺通常是在沐浴時與
刮身板和香水一起使用。

Used at baths along with strigils and
perfume.

小商店
TABERNAE

　　羅馬及整個帝國的街道遍佈著各色小商店(taber-nae)。

　　典型的小商店一般都是家庭經營的小酒館,專門售賣葡萄酒和食物,店裡只有很基本的陳設:石頭檯面上面放著烤箱和幾個盛著食物和飲料的大罐子,一張桌子,幾把椅子,但更多的是長條凳。在這裡,你可以找到便宜的食物(乳酪、蔬菜、雞蛋、鮮果)和更便宜的葡萄酒。這裡通常也可能發生賭博和賣淫情事。

　　其他的專門店鋪(麵包房、肉鋪、磨面坊)和技術性的手工作坊(紡織品、陶器、紙莎草甚至玻璃)會雇用幾個奴隸和學徒。生而自由的羅馬人大部分認為從事這種職業不體面。

Small shops (*tabernae*) lined the streets of Rome and other cities throughout the empire.

Typical of these were small, family-run taverns that specialized in the sale of wine and food with very basic furnishings—a stone countertop with an oven and a few large vases for storing food and beverages, a table and perhaps some chairs, but more often a bench. Here one could find inexpensive food (cheese, vegetables, eggs, fresh fruits) and even cheaper wine. Often gambling and prostitution were available as well.

Other specialty businesses (bakers, butchers, grain millers) and workshops of more artisan character (textiles, pottery, tiles, papyrus and even glass) might employ a few slaves and apprentices. Freeborn Romans often considered it beneath their dignity to engage in such businesses.

銅量器 (賽克圖斯)
Measure of Volume (*Sextus*)
羅馬帝國時期
銅
高21.5公分
佛羅倫斯國家考古博物館

Imperial Age
Bronze
H. 21.5 cm
National Archeological Museum, Florence

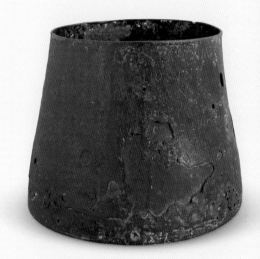

塞克圖斯既是穀物的測量單位,也是銅量器的名字。

The *sextus* was both a unit measure of volume for grain and the name for the container used to do the measuring.

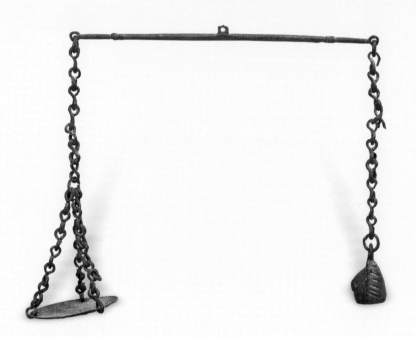

銅天秤
Small Balance
羅馬帝國時期
銅
最長20公分
佛羅倫斯國家考古博物館

Imperial Age
Bronze
L. (max) 20 cm
National Archeological Museum, Florence

這個小天秤由托盤和砝碼組合而成,可用於秤藥或妝粉。

This small balance scale, consisting of a plate and fixed weight, was probably used for measuring medicinal or cosmetic powders.

砝碼套組
Series of Weights
羅馬帝國時期
銅
最大直徑4公分，最小直徑1.5公分
錫恩納國家考古博物館

Imperial Age
Bronze
D. (max) 4 cm, D. (min) 1.5 cm
National Archeological Museum, Siena

這套碗狀砝碼與一個精確的
天秤配套使用。最大的砝碼
有一個雙搭扣的圓形蓋子，
並刻有小圓圈紋，整套砝碼
邊緣均刻有該紋飾。這種砝
碼自帝國初期出現後就一直
延用至今。

This series of bowl-shaped weights
was used with a precise balance.
The largest weight, which holds the
others, has a circular lid with a double
clasp and is decorated with a series of
small incised circles. This decoration
is repeated on the upper border of
the entire series. This type of weight
set appeared at the beginning of the
Imperial period and continued to be
used until modern times.

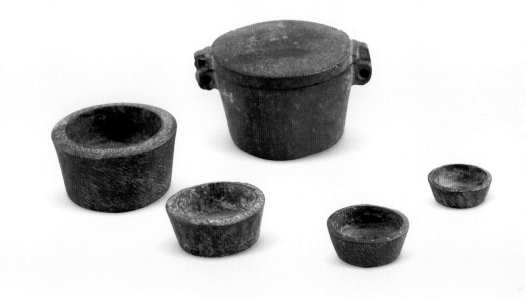

銅砝碼
Weight
羅馬帝國時期
銅
高4.7公分
佛羅倫斯國家考古博物館

Imperial Age
Bronze
H. 4.7 cm
National Archeological Museum, Florence

銅秤
Balance Scale

羅馬帝國時期
銅
長21公分
佛羅倫斯國家考古博物館

Imperial Age
Bronze
L. 21 cm
National Archeological Museum, Florence

在帝國時期，人們普遍使用天
秤來秤量貨物。物品放在懸掛
於短杆的容器裡，砝碼懸掛於
長杠杆的掛鉤上。拉丁語中有
多種不同的稱量詞彙，不同的
秤重就使用不同的詞彙。最常
見的是"提秤"，秤重簡單快
捷，同時也不失精確。

The use of balance scales for weighing
merchandise was common during
the Imperial age. The item to be
weighed was placed in a container
suspended from the shorter arm while a
counterweight was suspended from one
of the hooks on the longer arm. Diverse
words existing in Latin for balance
scales indicate that different kinds of
scales were used for different weighing
operations. The most common was the
stadera, which allowed for a relatively
easy, quick, and nevertheless exact
measurement of weight.

皇帝雕像秤頭
Weight Figurine(Emperor)
羅馬帝國時期
銅
高13公分
佛羅倫斯國家考古博物館

Imperial Age
Bronze
H. 13 cm
National Archeological Museum, Florence

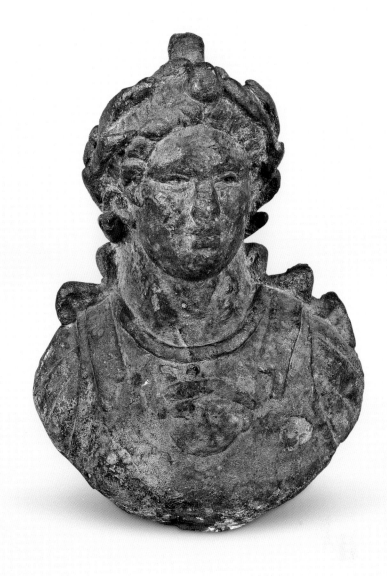

戰神雕像秤頭
Weight Figurine(Mars)
西元一世紀
銅
高13.5公分
佛羅倫斯國家考古博物館

1st century CE
Bronze
H. 13.5 cm
National Archeological Museum, Florence

雙耳陶瓶狀砝碼
Weight in the Form of an Amphora
羅馬帝國時期
鉛
高7.4公分
錫恩納國家考古博物館

Imperial Age
Lead
H. 7.4 cm
National Archeological Museum, Siena

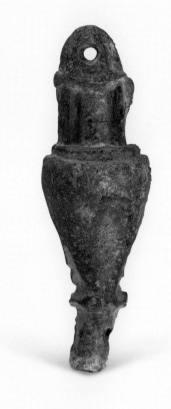

鉛錘
Weight for Thread
羅馬帝國時期
銅
最高2.3公分，最大直徑2.4公分
佛羅倫斯國家考古博物館

Imperial Age
Bronze
H. (max) 2.3 cm, D. (max) 2.4 cm
National Archeological Museum, Florence

石匠和木匠用鉛錘來校準垂直面和水平面。鉛錘同樣也是羅馬土地勘測員所使用的測量儀器格羅馬(Groma)的要件。格羅馬是一個由等長交叉的木制垂臂構成的木制十字架，鉛錘懸掛於十字垂臂的末端。測量人員可以利用格羅馬兩邊鉛錘的視覺垂線畫出垂直線。第五個鉛錘位於十字架的中心，使格羅馬能精確定位在已知點上。

Used by masons and carpenters to make true vertical and horizontal surfaces. Plumb-bobs served also as elements of a surveying instrument (*groma*) used by Roman surveyors (*gromatici*). [The groma consisted of a wooden cross with perpendicular arms of equal length attached to a long wooden rod. Plumb-bobs were attached to the ends of the perpendicular arms, and the surveyor would line up two plumb lines on opposite sides of the groma in order to create a straight line of sight. A fifth plumb-bob was attached to the center of the cross so that the groma could be placed precisely over a known point.

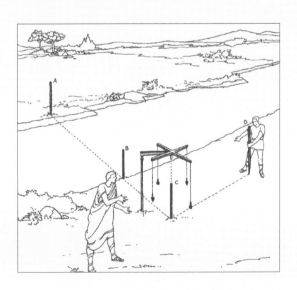

石砝碼
Weight
羅馬帝國時期
玄武岩
高6公分
佛羅倫斯國家考古博物館

Imperial Age
Basalt
H. 6 cm
National Archeological Museum, Florence

石砝碼
Small Weight
羅馬帝國時期
玄武岩
高2.6公分，直徑4.8公分
錫恩納國家考古博物館

Imperial Age
Basalt
H. 2.6 cm, D. 4.8 cm
National Archeological Museum, Siena

石砝碼
Weight
羅馬帝國時期
玄武岩
高7.5公分
佛羅倫斯國家考古博物館

Imperial Age
Basalt
H. 7.5 cm
National Archeological Museum, Florence

銅圓規
Compass
羅馬帝國時期
銅
長13.9公分
錫恩納國家考古博物館

Imperial Age
Bronze
L. 13.9 cm
National Archeological Museum, Siena

銅印章
Seal
羅馬帝國時期
銅
長6.6公分，寬2.7公分，厚2.7公分
佛羅倫斯國家考古博物館

Imperial Age
Bronze
L. 6.6 cm, W. 2.7 cm, Th. 2.7 cm
National Archeological Museum, Florence

這枚刻有盧修斯(Lucius)的
奴隸格洛特(Gelote)名字的
印章用於標記貨物、糧食等
商品。

This stamp, bearing the name *Gelote*
a slave of *Lucius*,.was used to mark
merchandise, provisions or the like.

銅印章
Seal
羅馬帝國時期
銅
高6.8公分
佛羅倫斯國家考古博物館

Imperial Age
Bronze
H. 6.8 cm
National Archeological Museum, Florence

這枚印章的印面文字顯示它屬於L. Pisentius Polyclitus。該印章在羅馬時代十分普遍，用於陶瓷及銅物件上。

This *"in planta pedis"* (on the sole of the foot) stamp belonged to *L. Pisentius Polyclitus*. This kind of stamp was common in Roman times and used for both ceramic and bronze objects.

銅印章
Seal
羅馬帝國時期
銅
高8公分
佛羅倫斯國家考古博物館

Imperial Age
Bronze
H. 8 cm
National Archeological Museum, Florence

這枚印章印面為腳部的形狀。

This *"in planta pedis"* (on the sole of the foot) stamp is shaped in the form of a foot.

銅印章
Seal
羅馬帝國時期
銅
長5公分，寬2.5公分，厚1.5公分
佛羅倫斯國家考古博物館

Imperial Age
Bronze
L. 5 cm. W. 2.5 cm. Th. 1.5 cm
National Archeological Museum, Florence

銅骰子
Pair of Knucklebones
羅馬帝國時期
銅
最長2.5~3公分
佛羅倫斯國家考古博物館

Imperial Age
Bronze
L. (max) 2.5 - 3 cm
National Archeological Museum, Florence

銅骰子
Pair of Knucklebones
羅馬帝國時期
銅
最長2.5公分
佛羅倫斯國家考古博物館

Imperial Age
Bronze
L. (max) 2.5 cm
National Archeological Museum, Florence

棋子
Gaming Pieces
羅馬帝國時期
玻璃和石頭
直徑1.3~1.7公分
佛羅倫斯國家考古博物館

Imperial Age
Glass and stone
D. 1.3 - 1.7 cm
National Archeological Museum, Florence

個人生活 PRIVATE LIFE

Art Historian, International Museum Exhibitions
Linda Carioni
國際傳物館展覽藝術史學家
琳達·卡瑞奧尼

羅馬社會是以家庭為基礎的。婚姻具有許多重要的社會意義，包括倚靠政治聯姻創造或鞏固社會地位等。相對來說，女孩十二、十三歲嫁人，男孩十四歲娶妻。在結婚前有個訂婚儀式（依照婚約），雙方父親需在場，新郎需贈禮給新娘，雙方互換戒指。舉辦婚禮那天會有一場動物祭祀儀式，此時將驗看動物的內臟，以占卜這對夫婦的婚姻是否幸福美滿。

嬰兒出生時將被放在父親的腳邊，父親可以接受或拒絕這個孩子。生理有缺陷的孩子，尤其是女孩通常會被拒絕撫養。當父親從腳邊抱起嬰兒的那一刻，便代表他承認了這個孩子作為家庭成員。未被接受的孩子通常會被丟棄在公共場所，其他人會帶回去領養。出生後九天，嬰兒會隨父姓（家族姓氏）。

男孩的教育傳統上由父親負責。到了羅馬帝國時代，這個任務落到了公立學校身上，有錢人會請一位希臘奴隸作為家庭教師來教育孩子。男孩小的時候學習讀、寫和基本的算術。學生在覆有蠟、豬皮紙或草紙的木板上用木頭、象牙或金屬尖頭筆書寫。

文學和藝術品是瞭解帝國時代的公民私生活的基本來源。大理石的私人半身像和雕像比那些用來代表帝國或公眾人物的典型雕像更為寫實。

羅馬人的日常服飾很簡單，主要是無袖束腰的外衣。以白色寬厚的羊毛罩衫托加袍纏繞身體。羅馬最為著名的服飾便是繞身穿的托加袍，長約18英尺、最寬處約5.5英尺。先把它垂在身前圍繞身體，其餘的布從右腋下經左肩披向身後。因此右臂是自由的。托加逐漸成為了儀式的禮服。在羅馬帝國時代，只有羅馬市民才能穿著托加。而女性會穿著稍長一點的短袖束腰裙斯托拉。她們在戶外會穿一種可包裹頭部的斗篷帕拉。至於鞋類，男女都會穿涼鞋和各種款式的靴子。

隨著帝國的擴張，帝國容納了不同風俗和不同氣候地區的民族，服飾上的多樣性越發明顯，逐漸朝著色彩絢麗、裝束奢華的風格發展。人們通過貿易獲得了更加多樣和考究的質料，例如來自印度的棉花和來自東方的絲綢。

羅馬服飾也反映著社會階層的劃分，上層社會名流會使用特定的顏色、質料和款式。著名的染料提爾（腓尼基）紫是從軟體動物紫螺（purpura）腺體中提取，由於提取源體積很小，該染料十分昂貴。因此，只有少數人才能穿紫色的衣服。紫色之名雖源於紫螺，紫螺卻是紫紅色的。

　　在奧古斯都統治期間(西元前27年~西元14年)，人們的髮型和裝飾都較為樸素。在羅馬帝國富庶的刺激下，個人裝飾風格和程度越來越精緻和有藝術性。女人開始佩戴昂貴的首飾，例如金耳環、珠寶、項鍊以及鑲寶石的手鐲。

　　男女都會花大量的時間打扮自己，使用香水、化妝品。上流社會的女性使用粉餅、胭脂、眼影和眼線。所使用的油、香水和化妝品通常由專職奴隸制作，他們從植物中萃取香料，將液體與橄欖油混合，存放於由大理石、玻璃或陶製的容器中。

　　女性的髮型隨著時間演進有了很大的變化，這也成了雕塑藝術斷代的依據。在奧古斯都時期，精緻的大波浪卷盛行一時。必要的梳妝工具有梳子、鐵製的卷髮棒和由銅、銀或玻璃製成的鏡子。假髮、髮夾和髮帶也常用。某些髮色特別流行，因此許多人會染髮和戴假髮。在高盧和日爾曼戰爭期間，戴戰俘髮色的金色假髮風靡一時。

　　到奧古斯都末期，男人剪平頭，後來也嘗試用卷髮棒卷成各種樣式。到西元二世紀早期的哈德良時期，男人留鬍鬚，甚至是落腮鬍，留長髮並且定期燙卷。

　　羅馬人依靠巫術、宗教和一些醫療方法預防疾病。許多在羅馬定居的希臘人受過醫學訓練，能看病和能使用草藥治療多種疾病。訓練有素的外科醫生能完成諸如剖腹產、清除白內障、拔牙、切除扁桃體和疝氣等手術。許多手術器械並非醫療專用，都是一些日常家庭中使用的工具，如鑷子等。

Roman society was based on the family. Matrimony had a number of important social consequences, serving to create or solidify position and political alliances. Girls were married by the age of twelve or thirteen; boys could take a wife by the age of fourteen. The act of marriage was preceded by the engagement ceremony (sponsalia) involving the fathers of both parties, the groom offering gifts to his bride, and an exchange of rings. The day of the wedding was celebrated with a ritual animal sacrifice followed by the examination of the sacrificial entrails to ascertain how favourable the union might be.

When a baby was born, it was placed at the feet of the father, who could either accept or reject the child. Physically deformed children were often rejected, as were girls. If the father picked up the infant and held it in his hands, then it was legitimized and became a member of the family. A rejected child was often abandoned in a public place where someone might take and raise it. Nine days after birth, the infant was given the family name (gens) that was passed from father to child.

Traditionally, the education of boys was left to the father. By Imperial times, this task was often entrusted to public schools or for the wealthy, a slave who was generally a Greek teacher. Young boys learned how to read, write and do basic arithmetic. Students wrote on wooden tablets covered with a layer of wax or paper made of pigskin or papyrus. Using a stilus made of wood, ivory or metal.

A great deal of what is known about the private lives of Roman citizens during the Imperial age is based on literary and artistic sources. Private portraiture in the form of marble busts and statues reveals a realism that is in contrast to the classical models used to represent the Imperial dynasty or other public figures.

Basic Roman attire was quite simple; the main article was the tunic, usually with no sleeves and tied around the waist. The toga, a wide cloak of heavy wool, usually white, then wrapped around the body. A toga, the garment for which Rome is most famous, was a segment of a circle, measuring about 18 feet along the chord of the segment and about 5.5 feet at its widest point. To drape it, the straight edge of the fabric was placed against the front of the body. The rest of the material was then thrown over the left shoulder, passed around the back, under the right arm, and once again over the left shoulder and arm. The right arm was therefore left free; the reason why the toga gradually became a ceremonial garment. During the Imperial Age, the toga functioned as a note of rank; wearing a toga was restricted to Roman citizens. Over a longer tunic, women wore the stola, a short–sleeved dress, belted at the waist and elegantly draped. A cloak, the palla, was worn outdoors and could also cover the head. Footwear for both sexes consisted in sandals and several other styles of boots.

As the Empire expanded, incorporating peoples of different customs and climate, a greater complexity became apparent in costume. The trend was toward a more ornate, richly coloured and luxurious attire. Through trade, more varied and elegant fabrics were available; cotton from India and silks from the East.

Roman dress also reflected divisions of social class, with certain colours, fabrics, and styles reserved for important personages. The famous dye of the classical world was Tyrian purple. This was obtained from glands in the mollusc purpura and was costly owing to the small size of the source material. Thus, the wearing of purple was reserved for a few. Although the name purpura gave rise to the word purple, the colour was actually a crimson.

Throughout the reign of Augustus (27 to 14 BCE), coiffure and adornment remained rather simple, however, with the wealth and luxury fueled by the Empire, the style and degree of personal

decoration became more elaborate and artificial. Women wore expensive jewellery such as gold earrings, cameos, necklaces and bracelets set with precious stones.

Both men and women devoted a great deal of time to their toilette and the use of perfumes and cosmetics. Face powder, rouge, eye shadow, and eyeliner were lavishly applied by upper–class women. The preparation of oils, perfumes and cosmetics was frequently the job of a specialized slave who separated fragrances from plants, mixed liquids with olive oil and stored the scents and oils in containers of alabaster, glass or terracotta.

Feminine hairstyles changed so much over time, that it is considered an indication by which to date statues. In the Augustan Age, huge, elaborate constructions of curls became fashionable. Necessary tools were the comb, the calamistrum, an iron rod heated on fire to make the curls, and the mirror, made of bronze, silver or glass. Wigs and hair pieces, combs and ribbons were also commonly worn. Certain colours of hair were more fashionable than others and the tinting of hair and hairpieces was also widely practiced. During the Gallic and Teutonic campaigns, blonde wigs made from the hair of captured slaves were in vogue.

Until the end of the Augustan period, men wore their hair short and simple, but in later times, they also began to arrange their hair in more elaborate styles and used the calamistrum to add curls. By the reign of Hadrian in the early II century CE, men were growing beards, moustaches, wearing their hair long and having it regularly curled.

Romans relied on a mixture of magic, religion and method to prevent disease. Many Greeks residing in Rome were trained in medicine and capable of both diagnosing and treating a variety of illnesses, generally with herbal remedies. There were also trained surgeons capable of performing a number of effective treatments, such as C–sections, the removal of cataracts, teeth and tonsils, as well as hernia operations. Many of the surgical instruments, such as tweezers, were not very specialized and could be put to other uses within the household.

弗拉維時期女性肖像
Bust of a Flavian Woman
西元70~80年
大理石
高52公分
佛羅倫斯國家考古博物館

70-80 CE
Marble
H. 52 cm
National Archeological Museum, Florence

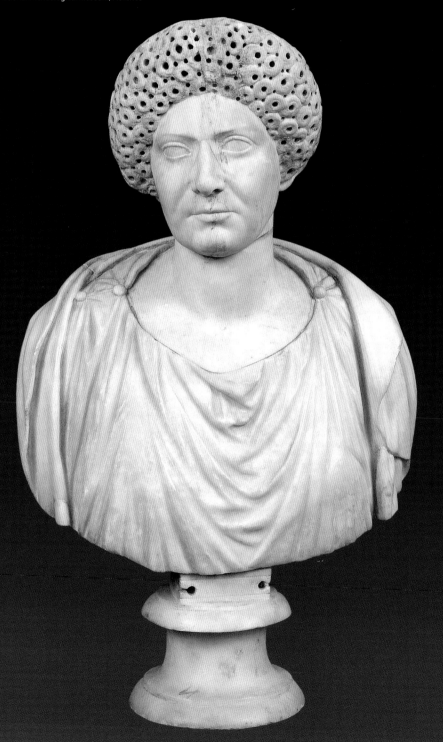

這是一尊成年女子的肖像,用鑽頭雕出小卷髮的髮冠遮蓋住了女子前額和顴骨。這款髮型在弗拉維皇帝時期風靡一時,提圖斯皇帝的妻子和女兒茉莉亞・蒂塔尤其喜歡。

This is a mature woman whose forehead and temples are covered by a high crown of small curls made with a drill. This type of hairstyle was popular during the reign of the Flavian emperors, in particular with the wife of the emperor Titus and his daughter Julia Tita.

女性肖像
Female Bust
羅馬帝國時期
大理石
高42公分，寬30公分
佛羅倫斯國家考古博物館

Imperial Age
Marble
H. 42 cm, W. 30 cm
National Archeological Museum, Florence

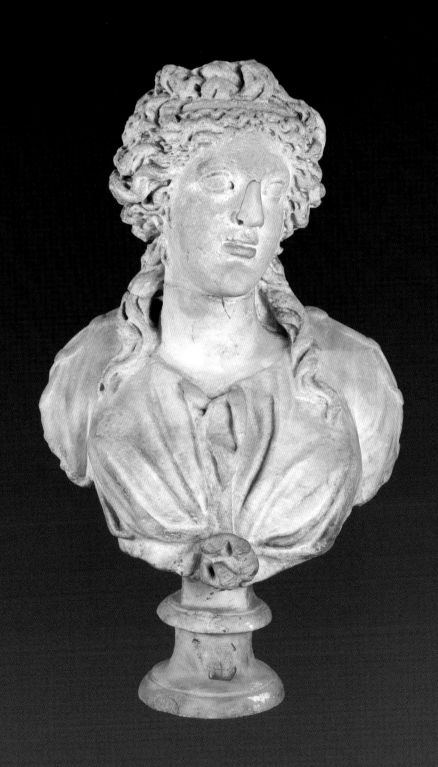

女性肖像
Portrait of Unknown Woman
奧古斯都時期(西元前27年~西元14年)
大理石
高22公分
佛羅倫斯國家考古博物館

Reign of Augustus (27 BCE-14 CE)
Italian Marble
H. 22 cm
National Archeological Museum, Florence

這是一名老婦人的肖像。她額頭佈滿皺紋，小而略微凹陷的眼睛下方有許多褶皺的眼紋。髮型盤成屋大維亞和莉維亞之類的皇室成員較為流行的圓錐形。該肖像可能出自製作過一系列老婦人半身像的城市作坊。

The portrait represents an elderly woman. She has a high forehead with large furrows, small and slightly inset eyes with numerous wrinkles underneath. The hair was placed in a conic shape according to the style that was popular among members of the imperial family, made popular by Octavia and then Livia. The portrait, perhaps produced in an urban workshop, forms part of a series of portraits of elderly women.

女性肖像
Portrait of Unknown Woman
奧古斯都時期(西元前27年~西元14年)
大理石
高30.2公分
佛羅倫斯國家考古博物館

Reign of Augustus (27 BCE-14 CE)
Italian marble
H. 30.2 cm
National Archeological Museum, Florence

這尊老婦人肖像低額，略凹的杏仁眼稍顯灰暗，豐滿的臉頰，圓圓的下顎，小嘴唇略微下垂。她的髮型、前額、顴骨的許多部位已看不清楚。她用髮夾將辮子盤繞在頭上，幾縷卷髮緊貼著臉頰。由於該婦女的前額處已損壞，無法辨認這究竟是什麼髮型，有可能是奧古斯都時期喪葬浮雕上常見的中分髮型。雕像背面雕刻粗糙，脖子處的形狀和這些特點暗示出這座雕像可能是放在壁龕中的。

The statue portrays an old woman: her forehead is low, her almond-shaped eyes are slightly sunken and shadowed, the cheeks are chubby and the chin is round while the lips of her small mouth are bent down. Many parts of the hair framing her forehead and temples are missing. The woman wears her hair in plaits pinned up around the head, while small curls lie on her cheeks. Because of damage to the forehead of the woman, it is not possible to suggest what the hairstyle looked like. It is possible she wore her hair parted in the middle, a style that is extremely common in the funerary reliefs of Augustan age. The back of the statue is only roughly carved. This feature, together with the shape of the neck, suggests that the portrait would have been placed inside a niche.

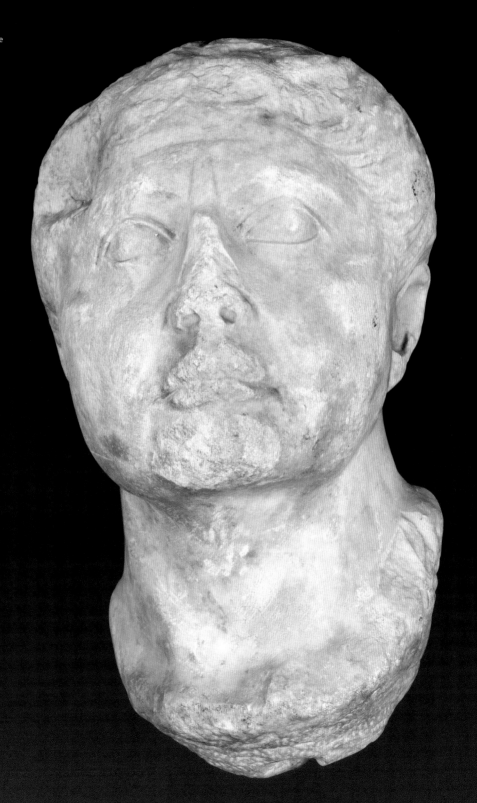

孩童肖像
Small Statue of a Child
圖拉眞時期(西元98~117年)
大理石
高115公分，寬35公分
佛羅倫斯國家考古博物館

Reign of Trajan (98-117 CE)
Marble
L. 115 cm, W. 35 cm
National Archeological Museum, Florence

梨狀藥瓶
Pyriform Unguentary
西元41~117年
玻璃
高6公分
錫恩納國家考古博物館

41-117 CE
Glass
H. 6 cm
National Archeological Museum, Siena

梨狀藥瓶
Pyriform Unguentary
西元41~117年
玻璃
高5.4公分
錫恩納國家考古博物館

41-117 CE
Glass
H. 5.4 cm
National Archeological Museum, Siena

梨狀藥瓶出現於奧古斯都時期，克勞狄至圖拉眞時期尤為盛行。

The pyriform shape (bulbous, like a pear) unguentary began to appear during the reign of Augustus, but became especially popular during the reigns of Claudius through Trajan.

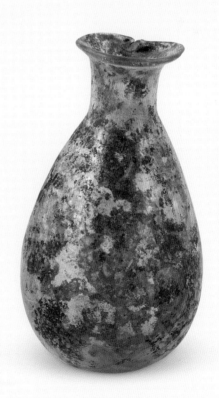

梨狀藥瓶
Pyriform Unguentary
西元41~117年
玻璃
高7公分
錫恩納國家考古博物館

41-117 CE
Glass
H. 7 cm
National Archeological Museum, Siena

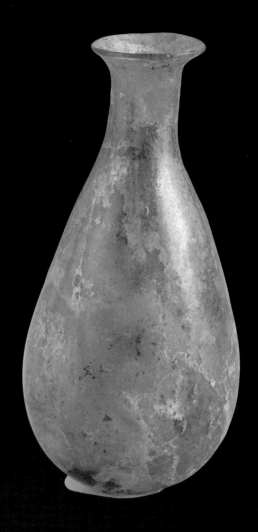

梨狀藥瓶
Pyriform Unguentary
西元一世紀初期
玻璃
高4.9公分
錫恩納國家考古博物館

First half of 1st century CE
Glass
H. 4.9 cm
National Archeological Museum, Siena

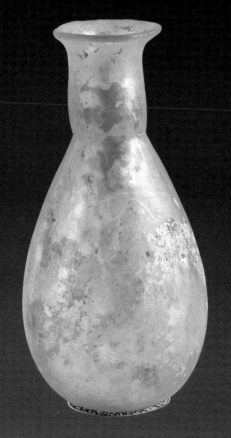

這種長梨形狀瓶可追溯到西元一世紀初期。

This elongated pyriform shape can be dated to the first half of the 1st century CE.

梳洗圖釉陶燈
Lamp with Toilette Scene

西元二世紀
粘土和紅釉
長15公分，寬11.3公分
錫恩納國家考古博物館

2nd century CE
Clay and reddish glaze
L. 15 cm, W. 11.3 cm
National Archeological Museum, Siena

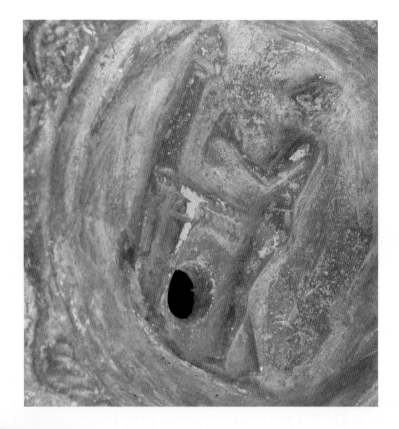

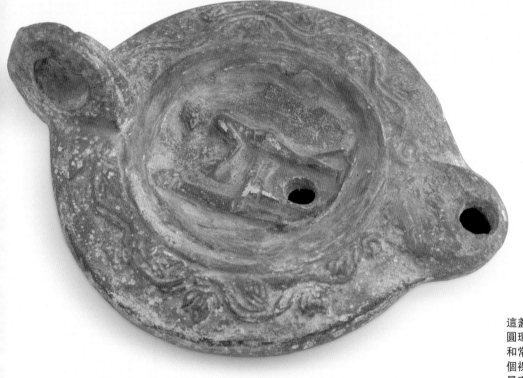

這盞盤狀油燈有一個圓口和圓環狀把手。背部以葡萄藤和常春藤作裝飾，主體有一個裸體女子梳洗的場景，場景底部圓孔用來添加油。

This oil lamp is disc-shaped with a small circular mouth and a ring-shaped handle. Its back is decorated with vines and ivy, the main body with a nude female figure grooming herself. The hole near the bottom of the scene is for filling the lamp with oil.

147

儀表
APPEARANCES

個人飾品在奧古斯都統治時期一直很簡單樸素，但在帝國後期越來越精緻和巧奪天工。

上層階級的婦女在臉龐上塗粉、胭脂，畫眼影和眼線，濃妝豔抹。她們佩戴昂貴的耳環、項鍊、手鐲和寶石。香水則保存在精美貴重的由雪花石膏、玻璃或赤陶製作的盒子裡。

婦女的髮型變化很快，這為判斷雕塑和肖像的年代提供了重要線索。男人的儀表風格也有變化。在奧古斯都時代，男人還是短髮和簡樸的形象，但在西元二世紀的末期，男人留起了帶有捲曲的長髮和鬚鬚。有時男女也染髮和戴假髮。

Personal adornment remained simple through the reign of Augustus, but became increasingly elaborate and artificial during the later years of the empire.

Upper class women lavishly applied face Powder rouge, eye shadow and eyeliner. They wore expensive earrings, necklaces, bracelets and cameos. Perfumes were stored in delicate and expensive containers of alabaster, glass or terracotta.

Women's hairstyles changed rapidly, and provide important clues for dating statues and portraits. Men's styles changed as well. In the age of Augustus, men still wore their hair short and simple. By the end of the second century CE men were wearing their hair long, having it curled, and growing beards and moustaches. Both men and women sometimes died their hair or wore wigs.

齒狀銅鏡
Toothed Mirror
西元一世紀
銅
直徑14.5公分
佛羅倫斯國家考古博物館

1st century CE
Bronze
D. 14.5 cm
National Archeological Museum, Florence

這面圓形銅鏡有一個雕刻細齒的邊框。

This big round mirror has a fret-worked frame.

寶石髮簪
Hair Pin
羅馬帝國時期
黃金和翡翠
長6.6公分
錫恩納國家考古博物館

Imperial Age
Gold and emerald
L. 6.6 cm
National Archeological Museum, Siena

銅梳
Comb
羅馬帝國時期
銅
長9.5公分，寬4.1公分
錫恩納國家考古博物館

Imperial Age
Bronze
L. 9.5 cm, W. 4.1cm
National Archeological Museum, Siena

牛骨髮簪
Hair Pin
西元一世紀
牛骨
長12.5公分
錫恩納國家考古博物館

1st century CE
Bovine Bone
L. 12.5 cm
National Archeological Museum, Siena

牛骨髮簪
Hair Pin
西元一世紀
牛骨
長10.8公分
錫恩納國家考古博物館

1st century CE
Bovine Bone
L. 10.8 cm
National Archeological Museum, Siena

銅製髮簪
Hair Pin
羅馬帝國時期
銅
長16.1公分
錫恩納國家考古博物館

Imperial Age
Bronze
L. 16.1cm
National Archeological Museum, Siena

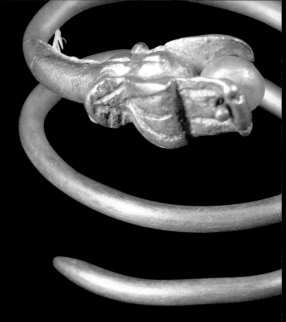

珍珠戒指
Ring with pearl
羅馬帝國時期
黃金和珍珠
直徑2.5公分
佛羅倫斯國家考古博物館

Imperial Age
Gold and pearl
D. 2.5 cm
National Archeological Museum, Florence

金臂釧
Armlet
羅馬帝國時期
黃金
直徑7.7公分
佛羅倫斯國家考古博物館

Imperial Age
Gold
D. 7.7 cm
National Archeological Museum, Florence

這個臂釧端部印有蛇頭圖
案，令人想起在羅馬帝國依
然流行希臘化的風格。

The ends of this arm band represent
snakes heads---a feature reminiscent
of Hellenistic style that was still very
common in Imperial Rome.

金胸針
Brooch
西元一世紀
黃金和玉髓
直徑4公分
佛羅倫斯國家考古博物館

1st century CE
Gold and chalcedony
D. 4 cm
National Archeological Museum, Florence

這枚輪狀胸針交替在八條放
射線兩邊精緻地裝飾有八個
小人頭，中間為玉石。

This brooch in the shape of a wheel
is elaborately decorated with eight
small heads alternating with rays. The
middle stone is chalcedony.

玻璃臂釧
Armlet
西元一世紀
玻璃
直徑9.6公分
基亞齊亞諾考古博物館

1st century CE
Glass
D. 9.6 cm
Museo Civico Archeologico delle Aque. Chianciano Terme

這種玻璃臂釧出現於希臘化
時期，其風格延續到西元一
世紀。

This type of glass armlet began to
appear during the Hellenistic Period
and remained in style into the 1st
century CE.

金戒指
Ring
奧古斯都時期(西元前27年~西元14年)
黃金
直徑2.1公分
佛羅倫斯國家考古博物館

Reign of Augustus (27 BCE - 14 CE)
Gold and cornelian
D. 2.1 cm
National Archeological Museum, Florence

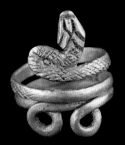

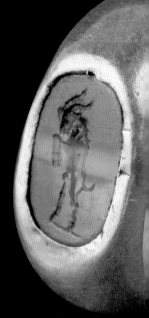

金戒指
Ring
西元前一世紀~西元一世紀
黃金和翡翠
直徑1.75公分
佛羅倫斯國家考古博物館

1st century BCE - 1st century CE
Gold and emerald
D. 1.75 cm
National Archeological Museum, Florence

金戒指
Ring
西元一世紀
黃金和瑪瑙
直徑1.8公分
佛羅倫斯國家考古博物館

1st century CE
Gold, chalcedony and agate
D. 1.8 cm
National Archeological Museum, Florence

這枚戒指的寶石上刻有山羊的圖案。

An engraved goat decorates the gemstone of this ring.

金戒指
Ring
西元一世紀
黃金
直徑1.6公分
佛羅倫斯國家考古博物館

1st century CE
Gold
D, 1.6 cm
National Archeological Museum, Florence

這枚嚴重磨損的戒指以伊西斯神半身像浮雕作裝飾。這種風格流行於西元一世紀。

This ring, badly worn, is decorated with a bust of Isis worked in relief. The style was common during the first 1st century CE.

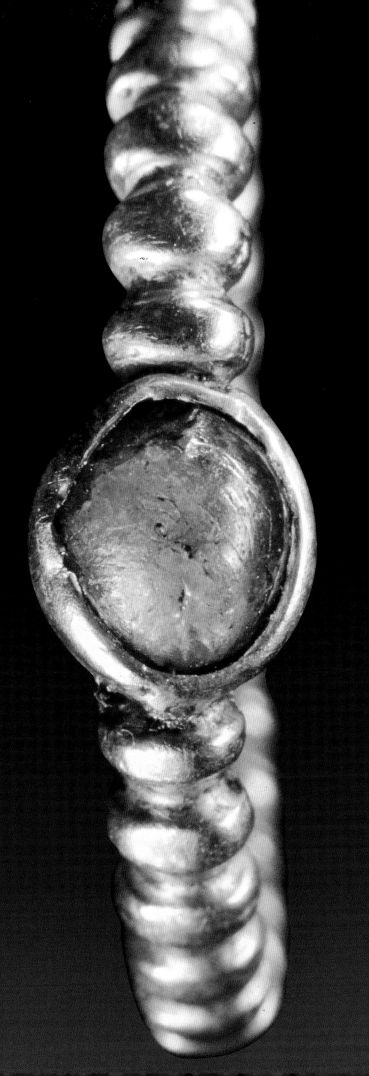

這類戒指在西元前一世紀的羅馬珠寶中極為常見。由金絲或金絲串珠絞製而成，也可點綴珍珠或其它寶石作裝飾。

This type of ring was extremely common in Roman jewelry of the 1st century BCE. They were made from a twisted wire or of a series of gold beads joined together on a wire of the same material. A pearl or another gemstone could be added as embellishment.

金戒指
Ring
羅馬帝國時期
黃金、玉髓和瑪瑙
直徑1.8公分
佛羅倫斯國家考古博物館

Imperial Age
Gold. chalcedony and agate
D. 1.8 cm
National Archeological Museum, Florence

金戒指
Ring
西元一~二世紀
黃金和翡翠
直徑1.2公分
佛羅倫斯國家考古博物館

1st - 2nd century CE
Gold and emerald
L. 1.2 cm
National Archeological Museum, Florence

金戒指
Ring
西元一~二世紀
黃金和綠寶石
直徑1.2公分
佛羅倫斯國家考古博物館

1st - 2nd century CE
Gold and emerald
D. 1.2 cm
National Archeological Museum, Florence

金戒指
Ring
西元一~二世紀
黃金和玉髓
直徑1.4公分
佛羅倫斯國家考古博物館

1st - 2nd century CE
Gold and chalcedony
D. 1.4 cm
National Archeological Museum, Florence

寶石上雕刻了一個站立著的
女性形象。

A standing female figure is engraved
on the gemstone.

金戒指
Ring
西元一~二世紀
黃金
直徑1.4公分
佛羅倫斯國家考古博物館

1st - 2nd century CE
Gold
D. 1.4 cm
National Archeological Museum, Florence

這枚戒指以浮雕的花瓣為裝飾。

This ring is decorated with a flower whose petals are in relief.

金戒指
Ring
西元一~二世紀
黃金和紫水晶
直徑2公分
佛羅倫斯國家考古博物館

1st - 2nd century CE
Gold and amethyst
D. 2 cm
National Archeological Museum, Florence

金戒指
Ring
西元一~二世紀
黃金和石榴石
直徑1.6公分
佛羅倫斯國家考古博物館

1st - 2nd century CE
Gold and garnet
D. 1.6 cm
National Archeological Museum, Florence

金戒指
Ring
西元二世紀
黃金和紅瑪瑙
直徑2.44公分
佛羅倫斯國家考古博物館

2nd century CE
Gold and onyx
D. 2.44 cm
National Archeological Museum, Florence

金戒指
Ring
西元二世紀晚期
黃金
直徑1.9公分
佛羅倫斯國家考古博物館

Second half of the 2nd century CE
Gold
D. 1.9 cm
National Archeological Museum, Florence

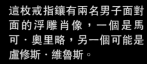

這枚戒指鑲有兩名男子面對面的浮雕肖像，一個是馬可·奧里略，另一個可能是盧修斯·維魯斯。

This ring is decorated with portraits, worked in relief and standing face to face, of two male personalities. One is Marcus Aurelius, the other possibly Lucius Verus.

金戒指
Ring
羅馬帝國時期
黃金和碧玉石
直徑2.5公分
佛羅倫斯國家考古博物館

Imperial Age
Gold and jasper
D. 2.5 cm
National Archeological Museum, Florence

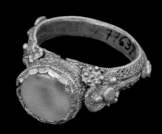

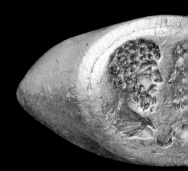

金戒指
Ring
羅馬帝國時期
黃金
直徑1.8公分
佛羅倫斯國家考古博物館

Imperial Age
Gold
D. 1.8 cm
National Archeological Museum, Florence

金戒指
Ring
西元三~四世紀
黃金
直徑2.5公分
佛羅倫斯國家考古博物館

3rd - 4th century CE
Gold
D. 2.5 cm
National Archeological Museum, Florence

這枚戒指上有兩隻面對面小鳥的裝飾。

The ring is decorated with two birds face to face.

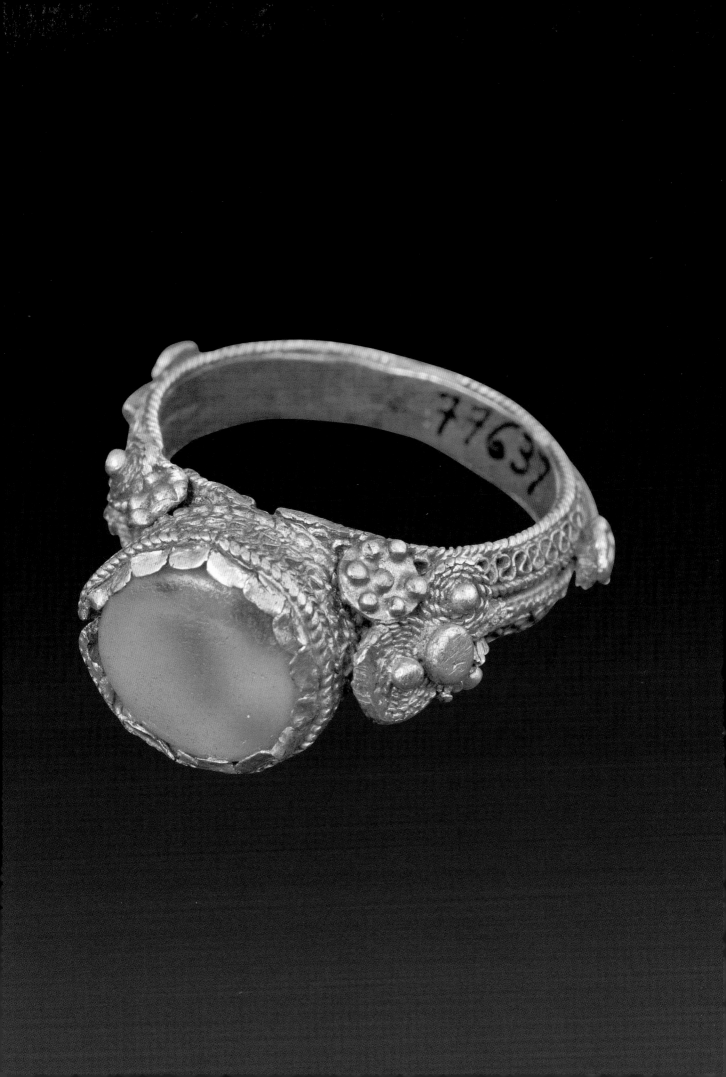

金戒指
Ring
西元三~四世紀
黃金和藍寶石
直徑1.4公分
佛羅倫斯國家考古博物館

3rd - 4th century CE
Gold and sapphire
D. 1.4 cm
National Archeological Museum, Florence

戒指做成金樹狀，中間鑲有藍寶石。

The ring was from gold leaf and provided with a sapphire setting.

雅典娜頭像金戒指
Ring with Head of Athena
羅馬帝國時期
黃金
直徑2.5公分
佛羅倫斯國家考古博物館

Imperial Age
Gold
D. 2.5 cm
National Archeological Museum, Florence

耳環
Pair of Earrings
羅馬帝國時期
黃金
直徑1.9公分
佛羅倫斯國家考古博物館

Imperial Age
Gold
D. 1.9 cm
National Archeological Museum, Florence

耳環
Earring
西元一~二世紀
黃金
長3.5公分
佛羅倫斯國家考古博物館

1st - 2nd century CE
Gold
L. 3.5 cm
National Archeological Museum, Florence

這副耳環的墜子可能是由亞寶石裝飾製成。

The pendants dangling from this earring would have been embellished with semi-precious stones.

耳環
Pair of Earrings
西元一~二世紀
黃金
長2.5公分
佛羅倫斯國家考古博物館

1st - 2nd century CE
Gold
L. 2.5 cm
National Archeological Museum, Florence

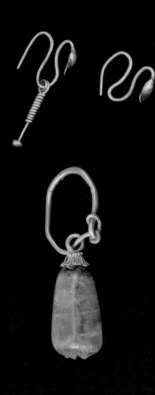

耳環
Earring
西元二世紀
黃金和翡翠
直徑2公分
佛羅倫斯國家考古博物館

2nd century CE
Gold and emerald
D. 2 cm
National Archeological Museum, Florence

瑪瑙墜子耳環
Earring with Agate Pendant
西元二~三世紀
黃金和瑪瑙
長4.6公分
佛羅倫斯國家考古博物館

2nd - 3rd century CE
Gold and agate
L. 4.6 cm
National Archeological Museum, Florence

耳環
Pair of Earrings
羅馬帝國時期
黃金
直徑1.1公分
佛羅倫斯國家考古博物館

Imperial Age
Gold
D. 1.1 cm
National Archeological Museum, Florence

將黃金融化入模具中，然後
打造成耳環。

The gold was shaped in a mold and
then bent to form earrings.

帶吊墜耳環
Earring with Pendant
羅馬帝國時期
黃金
長3公分
佛羅倫斯國家考古博物館

Imperial Age
Gold
L. 3 cm
National Archeological Museum, Florence

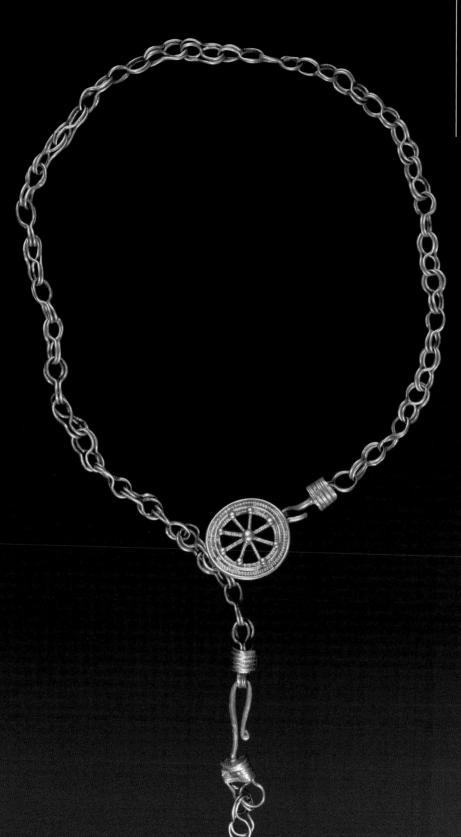

項鍊
Necklace
羅馬帝國時期
黃金
長43.5 公分
佛羅倫斯國家考古博物館

Imperial Age
Gold
L. 43.5 cm
National Archeological Museum, Florence

這串項鍊由37個 "8" 字形的
雙環扣組成。項鍊一端焊有
套管的鉤子，另一端有焊有
鉤子的一小環。項鍊扣呈輪
狀。這種項鍊自西元前三世
紀就開始出現，並一直流行
於帝國時期。

Each of the thirty-seven double links
that form the chain of this necklace is
shaped like a figure eight. The chain
ends on one end with a hook welded
to a tube, and on the other with a
small ring on which a second hook is
welded. The clasp of the necklace is
in the shape of a wheel. This type of
necklace began to be manufactured
in the 3rd century BCE and remained
popular into the Imperial Age.

帶吊墜項鍊
Necklace with a Pendant
西元三世紀
黃金
長21.4公分
佛羅倫斯國家考古博物館

3rd century CE
Gold
L. 21.4 cm
National Archeological Museum, Florence

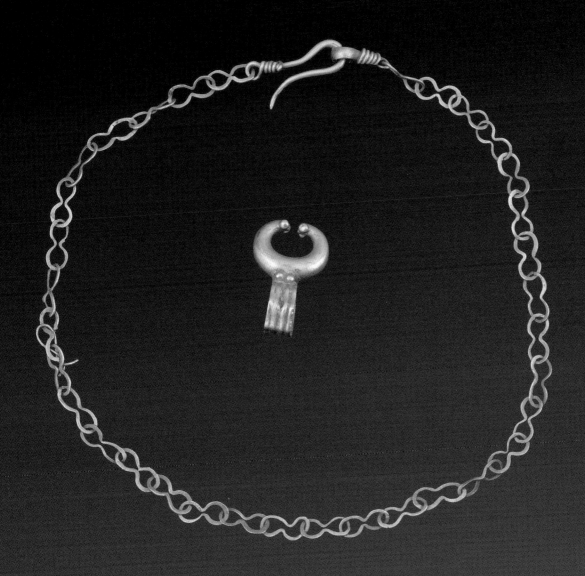

項鍊的月牙形石頭吊墜裝飾
已遺失。

The stone that embellished the
crescent has been lost.

帶吊墜項鍊
Necklace with a Pendant
西元三世紀
黃金
長21.4公分
佛羅倫斯國家考古博物館

3rd century CE
Gold
L. 21.4 cm
National Archeological Museum, Florence

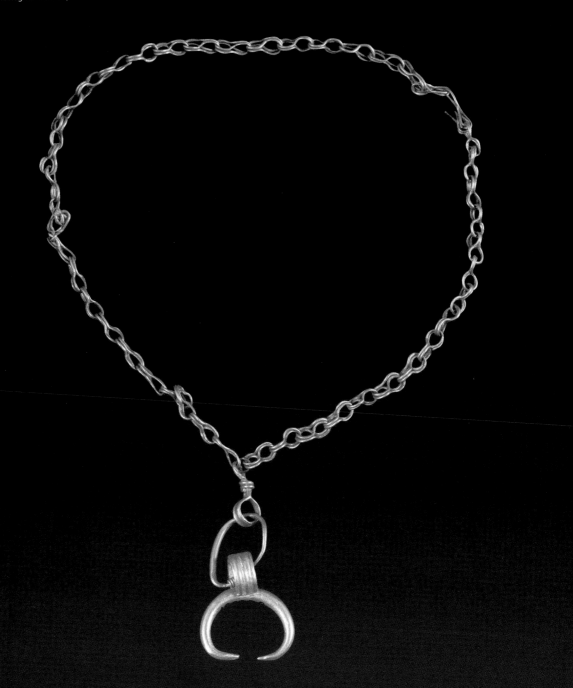

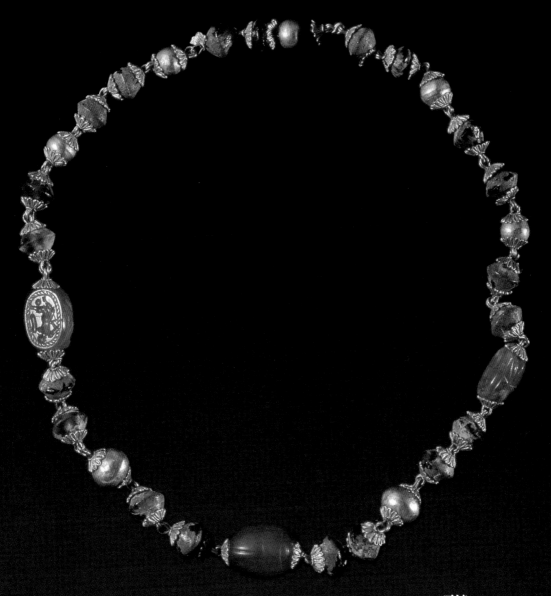

項鍊
Necklace
羅馬帝國時期
黃金，寶石，琥珀和彩色玻璃
長24.5 公分
佛羅倫斯國家考古博物館

Imperial Age
Gold gemstones, amber and stained glass
L. 24.5 cm
National Archeological Museum, Florence

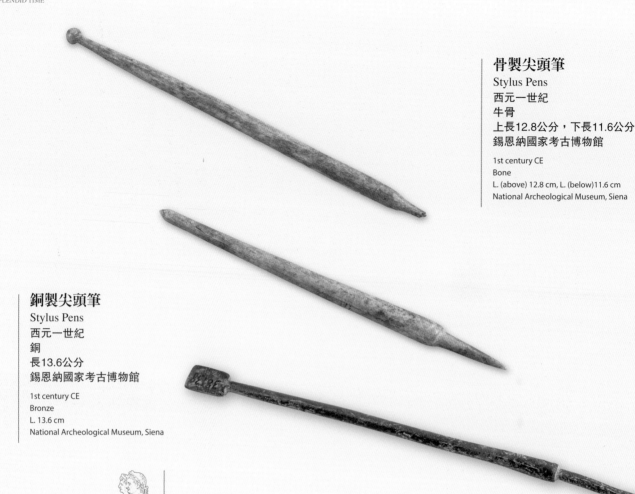

骨製尖頭筆
Stylus Pens
西元一世紀
牛骨
上長12.8公分，下長11.6公分
錫恩納國家考古博物館

1st century CE
Bone
L. (above) 12.8 cm, L. (below)11.6 cm
National Archeological Museum, Siena

銅製尖頭筆
Stylus Pens
西元一世紀
銅
長13.6公分
錫恩納國家考古博物館

1st century CE
Bronze
L. 13.6 cm
National Archeological Museum, Siena

人們至少從西元一世初期就
開始用尖頭筆在蠟板上寫
字。筆可由銅、象牙或骨頭
製成。

A stylus was used to write on tablets
covered with wax, a method employed
at least as early as the 1st century CE.
They could be made of bronze, ivory
or bone.

墨水瓶
Ink Pot
羅馬帝國時期
銅
高5.5公分 ，最大直徑7.5公分， 蓋直徑5.5公分
佛羅倫斯國家考古博物館

Imperial Age
Bronze
H. 5.5. cm, D. 7.5 cm, D. (lid)4.5 cm
National Archeological Museum, Florence

墨水瓶需要搭配墨水和筆
桿使用。通常筆桿是一支
尖頭簧片，一頭磨尖，開
一細孔。有時筆桿由金屬
製成。在藝術作品中，墨
水瓶象徵著貴族或受過高
等教育的人士。

The essential complements to an
inkwell were ink (*atramentum*) and a
quill (*calamus*). Typically the quill was
a fine-pointed reed, sharpened at one
end, and incised with a tiny hole in the
center of the point. Occasionally quills
were made of metal. When depicted
in artwork, an inkwell symbolized
nobility and education.

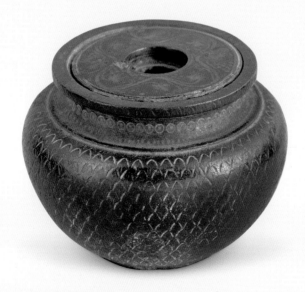

這塊大理石板曾覆蓋於一塊葬禮紀念碑之上，紀念碑是用來紀念一個名叫法拉修斯·赫爾墨的男子、他的兩任妻子、兒子以及後代。碑文下方和左邊刻有女子盥洗所需的物品和飾品。右邊刻有男性工作所需的工具。女性的物件中有髮夾、鏡子、梳子、油瓶和卷髮鐵棍。男性的物品有尺、火把、鉛筆和三角尺。

This marble slab once covered a funerary monument dedicated to man named Ferrarius Hermes, his two wives, his son, and all his descendants. Depicted below the inscription and to the left are items necessary for a woman's toilet and typical feminine ornaments. To the right are instruments typical of a man's work. Among the women's accessories are a hairpin, mirror, comb, oil holder, and iron for making curls. Among the man's, a drawing rule, torch, pencil and square.

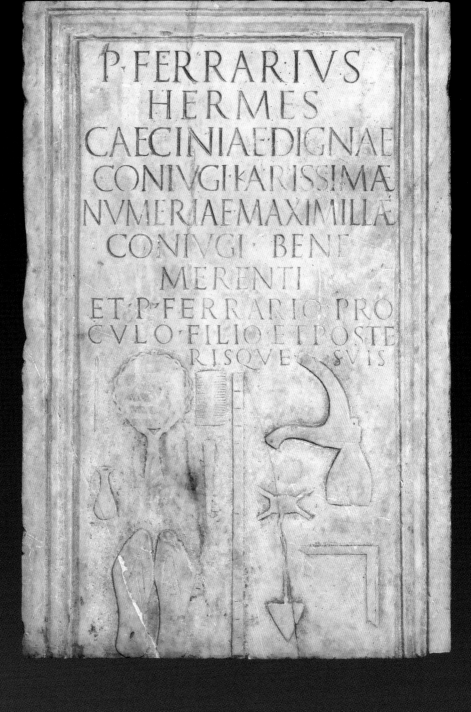

家庭

THE HOUSEHOLD

Art Historian, International Museum Exhibitions

國際博物館展覽藝術史學家

琳達‧卡瑞奧尼

　　羅馬帝國私人住宅的奢華與否取決於設計概念。一般富人宅邸內部有庭院、花園及外牆。穿過朝向街面的入口和前庭，便可進入中庭。房屋的雨水被收集於方形天井水池內，水池與主水源地下蓄水池相連。餐廳在中庭，連著一個正對門廳的大客廳。穿過客廳，就進入到帶有廊柱、裝飾噴泉和水池的寬大花園。在與世隔絕的高牆內，花園常使用大理石雕像等裝飾物。圍繞柱廊邊緣為私人生活區域，如臥室或靠牆可以放床的起居間。大多數房屋都設有小神龕（它是一個帶畫飾壁龕和雕像的小廊道）以表達對守護神和祖先的崇拜。

　　凡是重要的房間都會彩繪和粉刷，並在地板上鋪設馬賽克。大多數家庭只有少量的傢俱，畢竟上乘的傢俱價格昂貴且相對佔用空間。所有的房間都有床，有些床用於睡覺也有的用於進餐。羅馬人用油燈照明，有台座的陶燈或銅燈放在壁龕裡，或利用附件懸掛在天花板上。

　　廚房沒有明確的位置。有時安置於一個還沒衣櫥大的房間裡，有時就是房間的一處小角落，或樓梯的下方。廚房只配備一個水槽、一個烤爐和一個置於烹飪區上方的原始煙囪。至於陶或銅壺、煎鍋等統統掛在牆上，而其它一些容器和罐子不是扔進櫃子或放在架子上，就是放在靠近廚房的儲藏室裡。

　　羅馬人的主食是穀物，比如大麥和小麥熬成的粥，用準備好的橄欖油和香草調味。普通市民都以此維生，羅馬帝王和富裕的貴族卻能享用驚人的豐盛美食。多數羅馬人都是一日三餐。早餐包括浸過美酒的麵包、乳酪、雞蛋、水果和蜂蜜，這些快速簡便的食物有時也會出現於午餐中。然後是一天中最為豐盛的晚餐。晚餐通常在黃昏後開始，由三道菜組成，遇到宴會場合可能持續至深夜。

　　羅馬人的飯廳被稱為躺臥餐桌，因擺設了三個用餐的躺椅，每個可坐三位賓客。因為羅馬的宴請只接受九位賓客。羅馬人沿用了希臘人躺臥吃飯的方式。裝菜肴的盤子依據家庭的財富和地位由不同材料製作。普通的上菜盤由陶製和木製，而富人則會使用精緻的陶瓷、玻璃和銀製餐具。

　　第一道菜肴意在刺激食慾。緊接著是大量種類繁多的肉類和野味。飯後以甜點水果secundae mensae（其本意是第二桌，這樣叫法原本就是第二桌抬上來）結束。然後開始酒會（Symposium），即希臘語"一起喝酒"的意思。古代酒由於酒精含量高且呈半流質狀態，飲用前要加水進行稀釋。

　　由於地中海氣候的緣故，這裡的建築更注重光線和通風。即使皇宮也遵循這個基本原則，一系列的園林隨意地散佈在帕拉丁山，這裡就是羅馬最富裕的市民聚集區。這些概念被完好的保存下來，並迅速傳遍整個羅馬帝國，以至於歐洲北部的氣候條件下，不得不修改建築手法，增加了供熱系統。

　　在大城市中，貧民可以租用廉價公寓。這些經濟實用房屋設在城市人口密集的地段。這種房屋雖是磚瓦結構，儘管法律限制高度，但通常卻有五層或更多。街道建築的底層通常是工匠作坊和其它商鋪。經嚴密設計以節省空間的公寓套房則建於樓上，可由一個設於室內中央庭院的公共樓梯達到住處。採光和通風需來自外牆和室內庭院。許多廉租公寓帶有陽臺。然而生活品質並不太高，條件很差，略顯擁擠，大多數人還得睡地板。由於水源只能送到低樓層的住戶，因而樓層高的居民必須依靠公共供水。有限的水資源和木造房屋經常引起火災和坍塌事故。

　　大多數人在農村生活，不是在小農場，就是在城市富人擁有的大莊園裡工作。除了創造財富外，大莊園也讓那些厭倦城市生活的市民居住。在帝國時代，許多富有的家庭放棄了城市的住宅，而安身郊外的別墅裡。農莊建築有倉庫、奴隸宿舍和富麗堂皇的別墅，別墅與城市住宅的建築佈局和裝飾並無差別，但往往更加奢華。

In Imperial Rome, private residences (domus) of modest to palatial proportions were constructed around architectural concepts that emphasized interior courtyards and gardens rather than the external facade, passing through a vestibule, open to the street, and an entranceway (fauces), one entered a covered courtyard (atrium). Rainwater was collected in a basin called the impluvium that was attached to a cistern buried beneath the floor that served as the primary source of water. A dining area was located just off the atrium, along with a large living room, the tablinium, that was positioned opposite the entrance hall. Through this tablinium one could also enter a wide, colonnaded garden, the peristylium, decorated with fountains and basins. Enclosed by high walls and hidden from the outside world, the garden often contained marble statues and other decorative elements. Around the edge of the peristyle were located the private living quarters such as bedrooms (cubicula) or niches along the walls where beds were placed. Most homes also included a lararium, a niche or gallery housing tablets and statuettes honouring the Lares or family gods and ancestors.

Important rooms were decorated with paintings and stucco; the floors covered with mosaics. Most homes had relatively little furniture; fine furniture could be expensive and rooms were frequently quite small. All homes contained beds, both those for sleeping (cubiculares) and those for dinning (triclinares). For illumination, Romans used oil lamps made of ceramic or bronze placed in wall niches, in candelabra stands or attached to fixtures hanging from the ceiling.

The kitchen did not have a standard location. Sometimes placed in rooms no larger than closets, small corners, or beneath stairwells, they were equipped with a water basin, an oven, and a primitive chimney in the wall above the cooking area. Ceramic and bronze pots and pans dangled on the walls, while other containers and vases were kept either in an armoire, on a set of shelves, or in a separate, small room adjacent to the kitchen known as the apotheca.

The basis of the Roman diet consisted of grains, such as barley and wheat from which a porridge, flavoured with olive oil and herbs, was prepared. Ordinary citizens subsisted on this mainstay while the Roman emperors and wealthy aristocrats feasted on a staggering variety of foods. Most Romans ate three meals a day. Breakfast in the morning consisted of bread soaked in wine along with cheese, eggs, fruit and honey followed by a quick and simple meal at midday. Then there was the cena, the largest meal of the day, consisting of three courses, which began in the late afternoon and on a banquet occasion could last well into the night.

The dining room was called the triclinium because of the presence of three dining couches, each seating three guests since nine was the accepted number of guests for a Roman banquet. Romans ate reclined in the manner of the Greeks. Serving dishes were made of different materials depending on the status and wealth of the household. Modest serving platters were made of terracotta and wood, while the rich owned fine ceramic, glass and silver serving dishes.

During the first course, (gustatio), specialties were served to stimulate the appetite. This was followed by large quantities and varieties of meat and game. The meal concluded with

the sweets and fruit of the secundae mensae (second tables, so called because originally second tables were carried in). Then began the symposium, which in Greek means "drinking together". In antiquity, wine was always diluted with water, due to its high alcoholic content and its semi-liquid consistency.

Even the palaces of the emperors followed this essential order, consisting of a series of gardens sprawling casually over the Palatine Hill that was home to the wealthiest citizens of Rome. Due to the Mediterranean climate, construction was light and airy. These concepts were maintained and even exported as much as possible to Roman settlements throughout the Empire, even though in the northern climates of Europe, modifications had to be made to add heating.

In the large cities, the poor could rent small apartments in the insulae. These were tenement houses in an urban setting that provided economical housing where population was dense. Constructed of bricks, they often were of five or more stories, although by law, there were height limitations. The street level typically housed artisan workshops and other commercial establishments. The apartments, planned with strict economy of space, were located above and accessed by a common staircase located in an interior, central courtyard. Light and air were received from both the external facade and the interior courtyard. Many insulae were trimmed with balconies. The quality of life was not very good; conditions were crowded and most people would sleep on the floor. Water could only be pumped to the lower floors so tenants on higher floors had to depend on public water. Limited water and cheap construction caused frequent fires and collapses.

Most people lived in the countryside and worked the land, either on small farmsteads or on large estates owned by wealthy city people. In addition to generating wealth, a large estate might also serve its absentee owner as a retreat from city life. During the Imperial period, many wealthy families abandoned their urban homes, installing themselves in country villas. Along with farm buildings, storehouses and slave quarters, there would be a palatial villa, not unlike an urban domus in architectural lay-out and decoration, but often more luxurious.

宴會　THE BANQUET

羅馬的富人在他們氣派正式的餐廳裡設豪宴、開派對。

傳統上羅馬人坐著進食，但是富裕貴族們則學習希臘人的姿態斜倚在沙發上吃東西。正式的餐廳一般都在房間的三面放置沙發，因此進餐時會放置一種名為"三面有躺椅的餐桌"(triclinium)，同時在中間放一個矮桌子或幾張桌子。

Wealthy Romans gave lavish dinner parties in their formal dining rooms.

Traditionally Romans ate while seated, but gradually the wealthy aristocrats began to eat while reclined on couches in the manner of the Greeks. Formal dining rooms usually had couches arranged around three sides of the room, thus the name *triclinium*, and a low table or tables in the middle where the food was served.

宴會圖石碑
Stela with Banquet Scene
羅馬帝國時期
大理石
高48.5公分，長65公分，厚 15 公分，重90公斤
佛羅倫斯國家考古博物館

Imperial Age
Marble
L. 65 cm, H. 48.5 cm, Th. 15 cm, W. 90 kg
National Archeological Museum, Florence

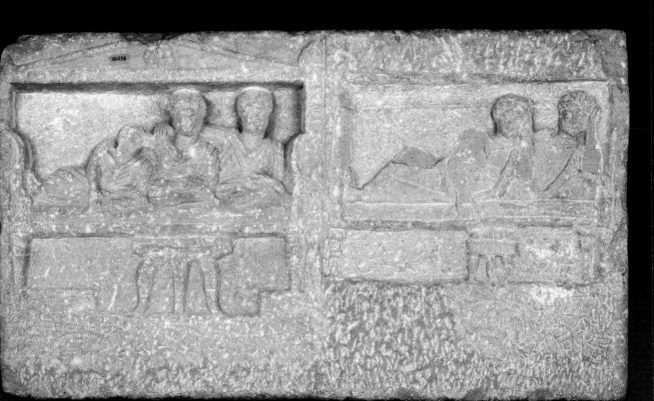

山形石牆飾

Sarcophagus Pediment with a Banquet Scene

西元一世紀
大理石
長62 公分，寬21公分，厚3公分，重40公斤
佛羅倫斯國家考古博物館

1st century CE
White marble with fine crystals
L. 62 cm, W. 21 cm, Th. 3 cm, W. 40 kg
National Archeological Museum, Florence

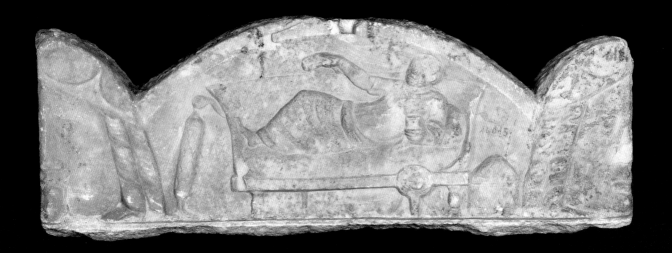

早在西元前七紀，地中海藝術
作品中就有宴會場景。該場景
在風格上是屬於西元一世紀的
風格。宴會場景在喪葬藝術中
尤為常見，有時配偶、奴隸和
動物也會出現於死者喪宴的場
景中。

Banquet scenes were common
features of Mediterranean art dating
back as early as the 7th century BCE.
This one can be dated on stylistic
grounds to the 1st century CE.
Banquet scenes were a particularly
common feature of funerary art, with
the deceased banqueter sometimes
accompanied by his spouse, his slaves
and animals.

收穫葡萄圖陶板
Slab with Scene of Satyrs Harvesting Grapes
西元前一世紀
陶土
高24.5公分，長57公分，寬13.5公分
佛羅倫斯國家考古博物館

1st century BCE
H. 24.5 cm, L. 57 cm, W. 13.5 cm
Terracotta
National Archeological Museum, Florence

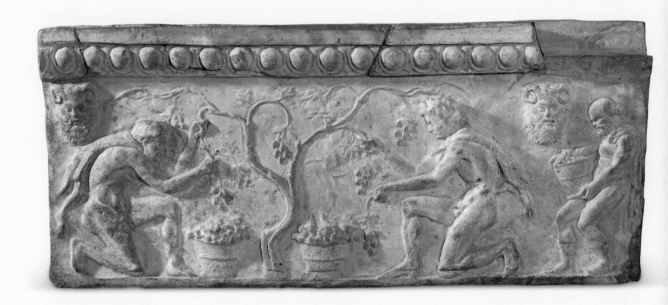

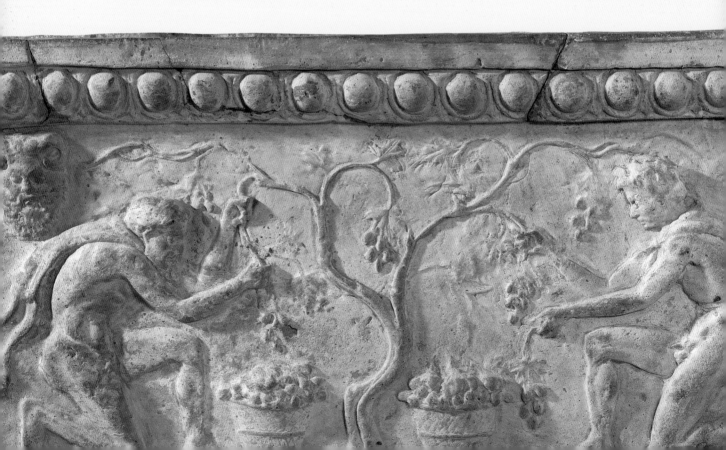

丘比特和格里芬(獅鷲)花瓶
Vase with Eros and Griffin
西元前1世紀
大理石
高62公分，直徑54公分
佛羅倫斯國家考古博物館

1st century BCE
Marble
H. 62 cm, D. 54 cm
National Archeological Museum, Florence

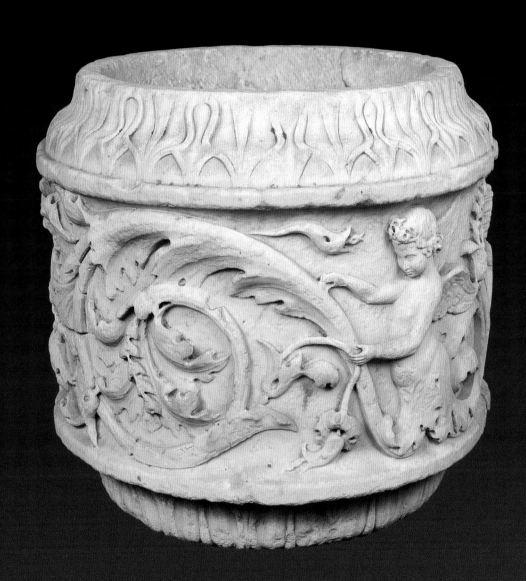

有翅膀的愛神丘比特和獅鷲被
莨苕藤包圍著。

A winged Eros and a griffin among
acanthus vines.

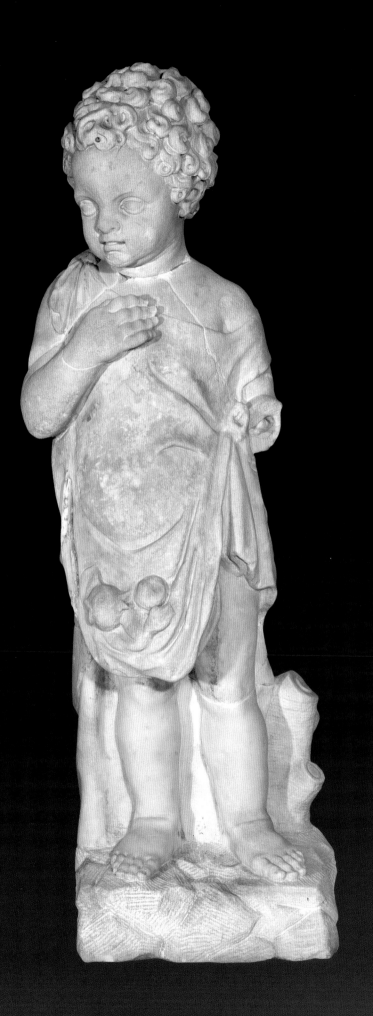

兒童和水果肖像
Child with Fruit
羅馬帝國時期
大理石
高88公分
佛羅倫斯國家考古博物館

Imperial Age
Marble
H. 88 cm
National Archeological Museum, Florence

兒童身披一種希臘和羅馬式的
罩衫，裡面還塞著一些水果。
這尊雕像可能代表了四季的饋
贈，其古老原型可追溯至西元
前三世紀。

The child has a *clamus*, a Greek and
Roman mantle, and holds in his smock
some fruit. The statue may represent
a Genius of Seasons and its ancient
prototype can be dated to the 3rd
century BCE.

兒童與狗肖像
Child with a Dog
羅馬帝國時期
大理石
高68公分
佛羅倫斯國家考古博物館

Imperial Age
Marble
H. 68 cm
National Archeological Museum, Florence

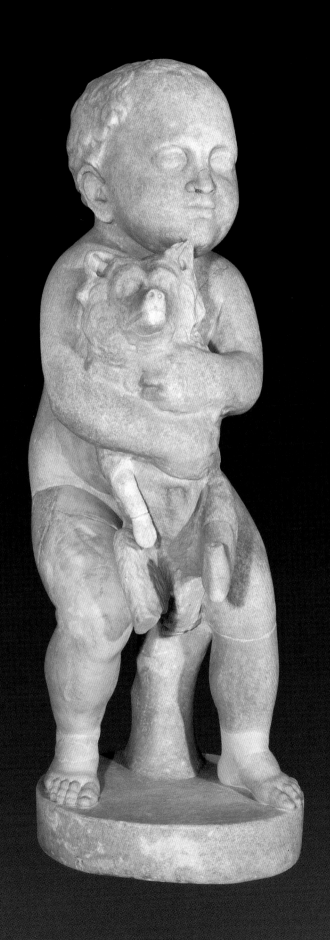

有四個與該像密切相關的作品顯示出相似性。事實上，研究者認為，包括在佛羅倫斯國家博物館保存的這類雕像在內，都是委託一家作坊為花園裝飾所製作。

The statue has a strong connection with another four artworks which show similarities in terms of representation and style. As a matter of fact, researchers believe that this kind of statue, including the version preserved in the Florentine museum, were made by the same workshop and were commissioned for the decoration of gardens.

私人家庭居所：住宅
PRIVATE FAMILY RESIDENCIES: THE DOMUS

　　私家住宅建築的重點是內部的庭院和花園而不是外牆。

　　典型的住宅在一個中軸線上鋪開，前部圍繞中廳建有一組房間，主人在中廳接待賓客。私人寢室位於住宅的後部，是一個帶有開放柱廊的庭院，四周有更多的房間。

　　客廳通常位於後面的庭院和前面的中央大廳之間，是一個開放式的起居室，也可以用簾子隔出一個私密的空間。每個住宅都有一個正式的餐廳，有時候還會因季節變化另設餐廳。有的住宅還設有具備水上遊樂設施、雕塑和噴泉的精美花園。

Private family residencies were constructed with an emphasis on interior courtyards and gardens rather than external façade.

The typical *domus* was laid out on an axis, with a suite of rooms grouped around a central hall (*atrium*) near the front. Here a homeowner could receive visitors. The family's private living quarters would be situated toward the rear of the *domus* and feature an open colonnaded courtyard (*peristylium*) surrounded by more rooms.

The *tablinum*, often situated between the *atrium* and *peristylium*, was an open living room that could be curtained off for privacy. Every *domus* had a formal dining room (*triclinium*), and sometimes additional ones for different seasons. Also there would be splendid gardens with water games, statues and fountains.

馬賽克殘件
Fragments of Mosaic
羅馬帝國時期
石頭
高40公分，寬60公分，重60公斤
佛羅倫斯國家考古博物館

Imperial Age
Stone
H. 40 cm, W. 60 cm, W. 60 kg
National Archeological Museum, Florence

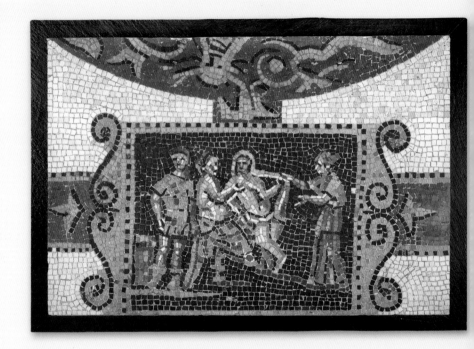

這兩塊馬賽克碎片可能是羅馬鄉村別墅中壁畫的一部分，反映出帝國時期人們常用馬賽克來裝飾別墅。

These two mosaic fragments are probably from a Roman country villa where they could have been inserted into the frescoed walls, and represent the mosaic decorations common to villas of the Imperial Age.

馬賽克殘件
Fragments of Mosaic
羅馬帝國時期
石頭
高40公分，寬60公分，重60公斤
佛羅倫斯國家考古博物館

Imperial Age
Stone
H. 40 cm, W. 60 cm, W. 60 kg
National Archeological Museum, Florence

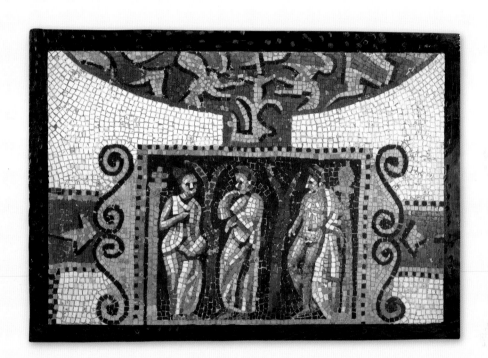

鄉村別墅　RURAL VILLAS

農業在羅馬世界是很重要的，特別是當帝國擴張到了高盧、北非和埃及這些富饒的地區。

大部分人住在鄉下並耕作土地，有些住在小型的農舍裡，有些富裕的城市居民則住在自己的大型農莊中。除了生產財富，大型農莊也是主人一個偶爾遠離城市生活的僻靜休息之處。在其他的農莊建築、倉庫和奴隸居所周邊一般都會有一個富麗堂皇的別墅，其建築佈局和裝飾上有別於都市 "住宅"。

　　Agriculture was important in the Roman world, especially as the empire expanded to include the rich and productive regions of Gaul, North Africa and Egypt.

　　Most people lived in the countryside and worked the land, either on small farmsteads or on large estates owned by wealthy city people. In addition to generating wealth, a large estate might also serve its absentee owner as an occasional retreat from city life. Along with other farm buildings, storehouses and slave quarters, there would be a palatial villa not unlike an urban domus in architectural lay-out and decoration.

建築　ARCHITECTURE

羅馬人是建築大師。羅馬帝國時期壯觀的建築遺跡，從疆域的此端至彼端散佈在整個帝國境內，至今仍安然矗立，供後人瞻仰。

羅馬建築深受希臘建築的影響，但是它們之間還是有一些區別，比如對拱門、拱頂、圓頂的廣泛應用。在建造拱門的時候，羅馬時期的建築建有粗壯的橫樑和美輪美奐的水槽。有了拱頂和圓頂，他們創造了足以遮蔽寬大的室內空間的大型結構。混凝土(水泥)是羅馬人的另一個重大發明。

羅馬的建築在西元二世紀達到了鼎盛時期，即所謂的"五賢帝時代"。那一時期兩個壯觀的例子是圖拉眞建的廣場和哈德良所建的萬神殿。

The Romans were master builders. Spectacular architectural remains from Imperial Rome are seen still today scattered from one end of the former empire to the other.

Roman architecture was influenced by Greek architecture, but there are important differences, such as the extensive use of arches, vaults and domes. With arches, architects of the Roman Period built strong bridges and amazing aqueducts. With vaults and domes, they created large structures that covered expansive interior spaces. Concrete was another essentially Roman innovation.

Roman architecture reached its zenith during the second century CE, the so-called "Era of Good Emperors." Two spectacular examples from that era are Trajan's Forum in Rome and the Pantheon built by Hadrian.

馬賽克殘件
Fragments of Mosaic
羅馬帝國時期
石頭
高115公分，長149公分，寬115公分
佛羅倫斯國家考古博物館

Imperial Age
Stone
H. 115 cm, L. 149 cm, W. 115 cm
National Archeological Museum, Florence

本件為發掘於義大利托斯卡納地區格羅塞托附近Settefinestre別墅客廳的地板殘件。

One of three floor mosaic fragments from the floor of the tablinum of theVilla di Settefinestre, excavated near Grosseto in the Tuscany region of Italy area.

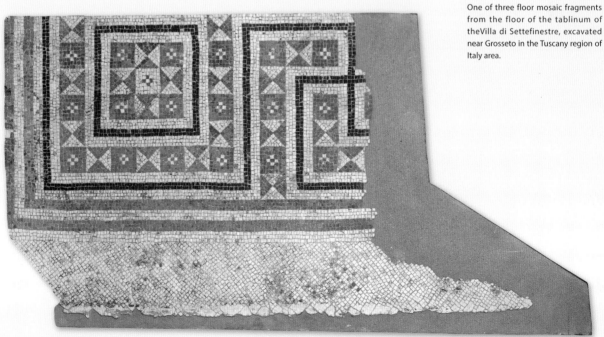

羅馬浴室
ROMAN BATHS

考古發現的羅馬浴室遺址遍及整個帝國，它是羅馬社會中最普遍、最美麗和最複雜的代表之一。

一些浴室極為精緻，特色鮮明。所有的浴室都有一個更衣區(apodyterium)、一個內設熱水池(calidarium)的熱水區、一個溫水區(tepidarium)和一個內設冷水池(frigidarium)的冷水區。這需要有充足的水源供應和爐火設備。其它設施還包括花園、露天游泳池、健身器材、按摩房、會客室、餐廳和有閱讀區域的圖書館。

最令人難忘和奢侈的浴池當屬由羅馬皇帝們興建的浴池，如提圖斯、圖密善、圖拉真、卡瑞卡拉和戴克里先。

Archaeological remains of Roman baths, found throughout the empire, represent one of the most common, beautiful and sophisticated expressions of Roman society.

Some baths were more elaborate than others and included more features. All had a dressing area (*apodyterium*), a hot water area with hot plunge bath (*calidarium*), a warm water area (*tepidarium*), and a cold water area with cold plunge bath (*frigidarium*). This required an ample water supply and furnace. Additional features might include gardens, open-air swimming pools, athletic facilities, massage rooms, meeting places, restaurant, and library with reading spots.

The most impressive and luxurious baths were those built in Rome by the emperors Titus, Domitian, Trajan, Caracalla and Diocletian.

馬賽克裝飾品碎片
One of Two Fragments of the Mosaic Decorating
羅馬帝國時期
石頭
高105公分，寬89 公分
佛羅倫斯國家考古博物館

Imperial Age
Stone
H. 105 cm, W. 89 cm
National Archeological Museum, Florence

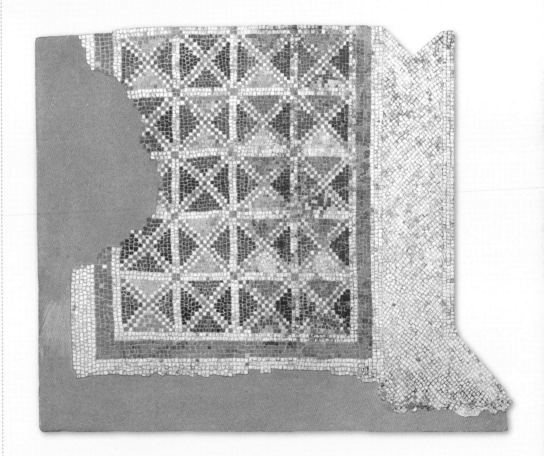

薄胎陶杯
Thin-Wall Mug(Olla)
西元前一世紀~西元一世紀
陶土
高9.5公分
佛羅倫斯國家考古博物館

1st century BCE -1st century CE
Hazelnut clay
H. 9.5 cm
National Archeological Museum, Florence

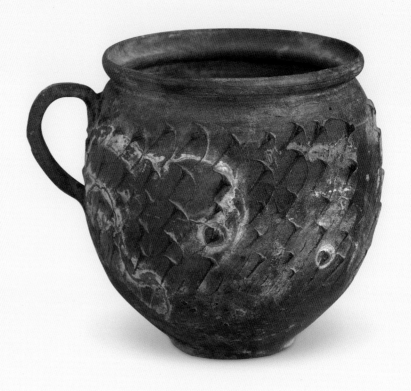

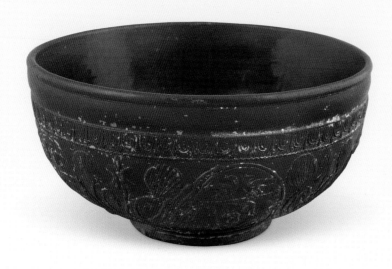

南高盧陶杯
Cup in South Gallic Sigillata
羅馬帝國時期
陶土
高9.2公分，直徑18.2公分
佛羅倫斯國家考古博物館

Imperial Age
Terracotta
H. 9.2 cm ,D. 18.2 cm
National Archeological Museum, Florence

阿瑞底姆陶杯模具
Matrix of Arretine cup

羅馬帝國時期
陶土
高11公分，直徑20公分
佛羅倫斯國家考古博物館

Imperial Age
Terracotta
H. 11 cm, D. 20 cm
National Archeological Museum, Florence

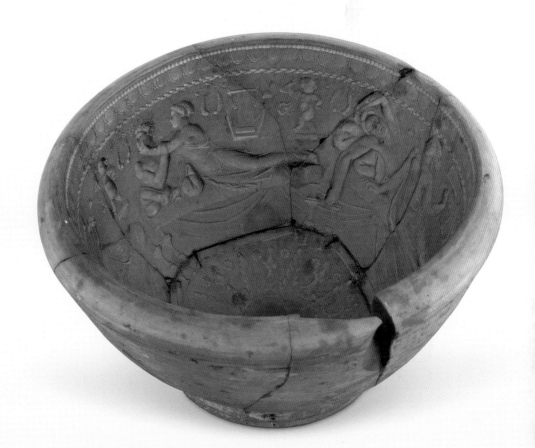

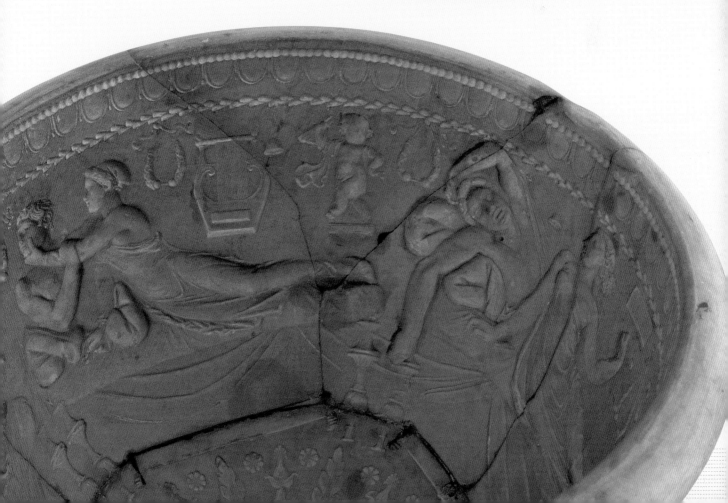

酒器
Carafes (Lagynos)
西元前一世紀~西元一世紀
陶土
左高24.6公分，右高14.6公分
錫恩納國家考古博物館

1st century BCE – 1st century CE
Terracotta
H. (left) 24.6 cm, H. (right) 14.6 cm
National Archeological Museum, Siena

陶盤
Plate of Terra Sigillata
西元前一世紀
陶土
高4.4公分，直徑22.1公分
錫恩納國家考古博物館

1st century BCE
Terracotta
H. 4.4 cm, D. 22.1 cm
National Archeological Museum, Siena

巴爾博汀陶杯
Mug with *Barbotine* Gecoration
西元前一世紀
陶土
高9.5公分，最大直徑11.5公分，口沿直徑6.5公分
佛羅倫斯國家考古博物館

1st century BCE
Glazed terracotta
H, 9.5 cm, D. (max) 11.5 cm , D. (rim) 6.5 cm
National Archeological Museum, Florence

該杯採用巴爾博汀工藝裝飾，
用刷子或刮刀把水和黏土混合
物在陶杯表面塗成凹凸不平的
層次、斑點和條紋。容器經過
燒製之後，便會出現表面隆起
或波紋的浮雕裝飾效果。

This mug is decorated with the
"barbotine" technique, which involved
applying a slip (mixture of water and
clay) to the surface of a clay vessel in
uneven layers, patches and trails with a
brush or spatula. When the vessel was
fired, this produced a relief decoration
with small bumps and ripples.

阿雷佐陶杯
Cup of Terra Sigillata from Arezzo
羅馬帝國時期
陶土
高11.5公分，最大直徑16.3公分
佛羅倫斯國家考古博物館

Imperial Age
Terracotta
H. 11.5 cm, D. (max) 16.3 cm
National Archeological Museum, Florence

阿雷佐陶杯
Cup of Terra Sigillata from Arezzo
羅馬帝國時期
陶土
高16公分 直徑19.2公分
佛羅倫斯國家考古博物館

Imperial Age
Terracotta
H. 16 cm, D. 19.2 cm
National Archeological Museum, Florence

玻璃盤
Plate
西元二世紀
玻璃
高4公分，直徑19公分
佛羅倫斯國家考古博物館

2nd century CE
Blue and green blown glass
H. 4 cm, D. 19 cm
National Archeological Museum, Florence

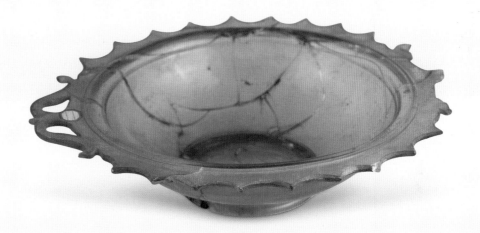

玻璃盤
Plate
西元二世紀
玻璃
高3.9公分，直徑24.2公分
佛羅倫斯國家考古博物館

2nd century CE
Blue and green blown glass
H. 3.9 cm, D. 24.2 cm
National Archeological Museum, Florence

這兩個盤子或用作托盤。從造
型和外觀來看，大約產於西元
二世紀。

These two plates were probably used
as trays. By form and shape. they are
dateable to the 2nd century.

水罐
Pitcher
羅馬帝國時期
銅
最高16.3公分
錫恩納國家考古博物館

Imperial Age
Bronze
H. (max) 16.3 cm
National Archeological Museum, Siena

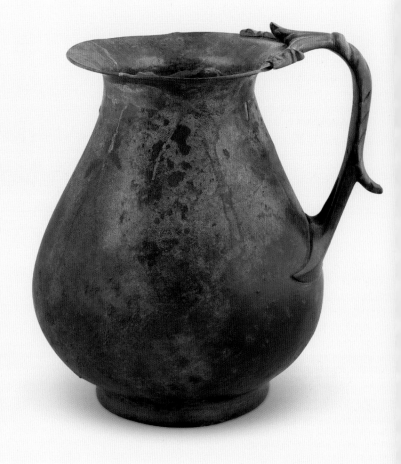

雙耳銀盃
Cup with Two Handles
西元一世紀
銀
高6.5公分，直徑10.5公分
佛羅倫斯國家考古博物館

1st century CE
Silver
H. 6.5 cm, D. 10.5 cm
National Archeological Museum, Florence

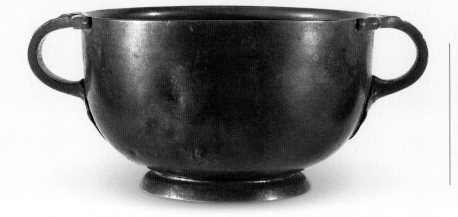

這種盛酒用的銀製器具在西
元一世紀的羅馬較為常見。

This kind of drinking vessel was very
common in Roman silverware during
the 1st century CE.

羅紋玻璃杯
Ribbed Cup
西元一世紀初期
玻璃
高5.7公分，直徑13.5公分
佛羅倫斯國家考古博物館

First half of the 1st century CE
Violet colored glass
H. 5.7 cm, D. 13.5 cm
National Archeological Museum, Florence

這種杯子起源於希臘東部，可能是敘利亞到巴勒斯坦地區。它最早出現於西元前一世紀初，以豐富的裝飾圖案和出色的製作工藝而得名，在西元一世紀較為流行。

This kind of cup originated in the Hellenistic east, probably in the Syro-Palestinian region. The earliest known examples, distinguished by their rich decoration and superior craftsmanship, date from the beginning of the 1st century BCE. They were quite common during the 1st century CE.

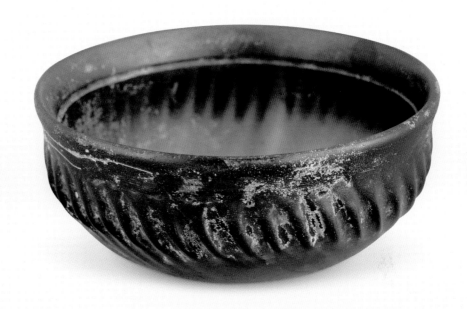

千花玻璃杯
Millefiori (striped) Cup
奧古斯都時期(西元前27年~西元14年)
玻璃
高6.6公分，最大直徑10公分
佛羅倫斯國家考古博物館

Reign of Augustus (27 BCE - 14 CE)
Blue, red, yellow, green and uncolored glass
H. 6.6 cm, D. (max) 10 cm
National Archeological Museum, Florence

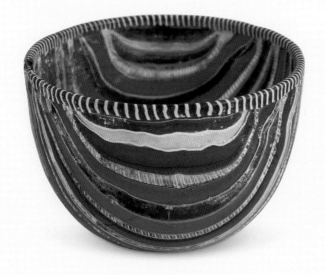

千花玻璃指的是將有色玻璃融化在容器表面的一種裝飾工藝。有色玻璃可以化作如同這個杯子上的長形條紋狀或其它圖案。千花玻璃工藝可以追溯到西元前一世紀末期和西元一世紀初期，可能是在地中海東部地區流傳開來的。

Millefiori refers to a decorative technique that involved melting colored glass on the surface of a vessel. The colored glass could be applied in long bands, as in the case of this cup, or in other patterns. The millefiori technique dates to the late 1st century BCE and the early 1st century CE, and probably was developed in the eastern Mediterranean.

千花玻璃盤
Millefiori(striped) Plate
西元一世紀
玻璃
高4公分，直徑13.1公分
佛羅倫斯國家考古博物館

1st century CE
White, amber-yellow and uncolored glass
H. 4 cm, D. 13.1 cm
National Archeological Museum, Florence

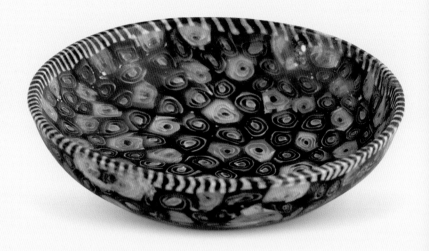

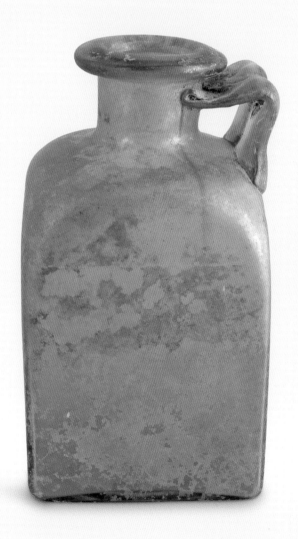

方底玻璃瓶
Bottle with Square Base
西元一世紀
玻璃
高17.8公分
錫恩納國家考古博物館

1st century CE
Blue glass
H. 17.8 cm
National Archeological Museum, Siena

這款方形瓶在西元前一世紀
中期的羅馬被廣泛用於盛
酒。它採用直接將玻璃吹到
可拆卸的方形模具中，再去
模取出的方法製成。

This type of jug—with a squared
shape. used probably for wine was
found throughout the Roman world
by the middle of the 1st century BCE.
They were produced by blowing
glass directly into a square mold with
removable walls.

雙耳玻璃瓶
Small Amphora
羅馬帝國時期
玻璃
高14.1公分
錫恩納國家考古博物館

Imperial Age
Glass
H. 14.1 cm
National Archeological Museum, Siena

雙耳玻璃瓶
Small Amphora
西元一~二世紀
玻璃
高10.5公分
錫恩納國家考古博物館

1st - 2nd century CE
Glass
H. 10.5 cm
National Archeological Museum, Siena

浮雕裝飾玻璃瓶
Small Glass Amphora with Cameo Decoration
奧古斯都時期(西元前27年~西元14年)
玻璃
高13公分
佛羅倫斯國家考古博物館

Reign of Augustus (27 BCE - 14 CE)
Blue glass
H. 13 cm
National Archeological Museum, Florence

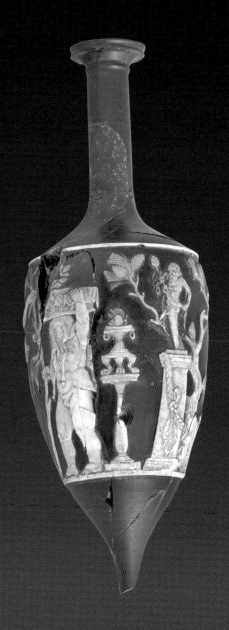

這款由浮雕玻璃製成的細頸瓶，配以酒神儀式場景做裝飾，呈現出完美的玻璃生產工藝和羅馬帝國初期流行的裝飾風格。下方的藍色和上方的白色這兩層玻璃，均採用了用尖銳工具切割白色人形直到它浮現在深色背景上的技術。該技術也用於亞寶石的雕刻中。

This amphora, made of "cameo style" glass and decorated with scenes of a Dionysiac rite, represents an extremely refined technique of glass production and decoration that was in vogue during Early Imperial Age. The technique involved superimposing two layers of glass, blue underneath and white on top, and then incising with a sharp tool until white figures emerged against the darker background. This is the same technique used for producing cameos from semi-precious stones.

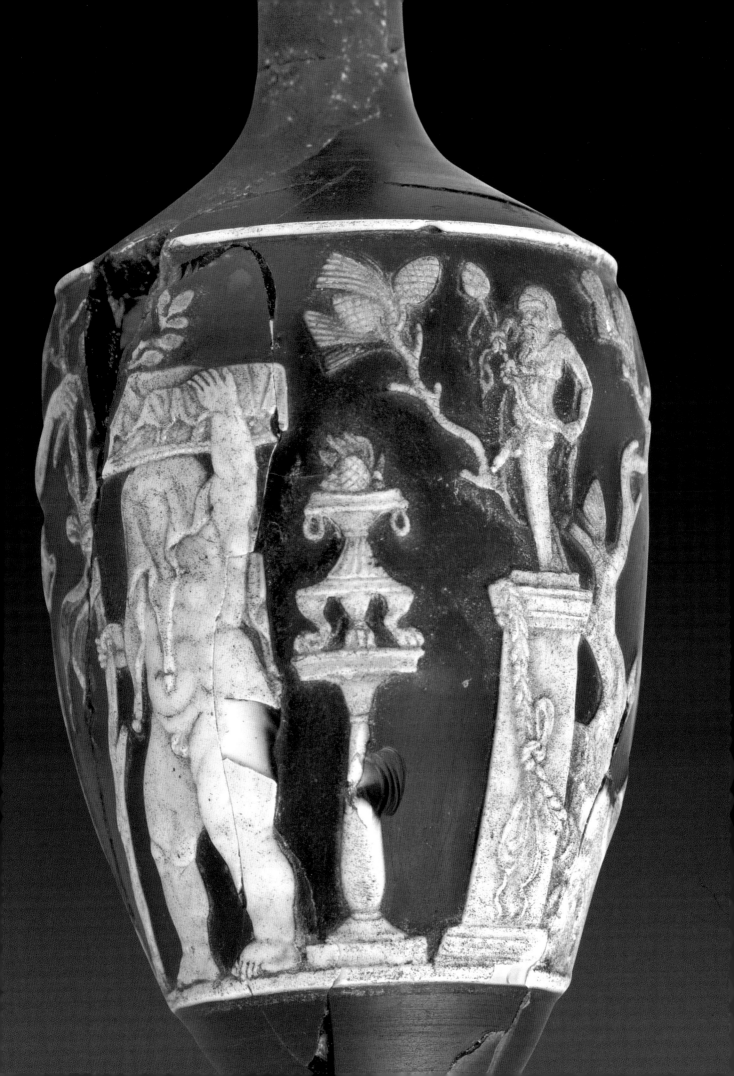

羅紋玻璃杯
Ribbed Cup
西元一世紀
玻璃
高6.9公分，直徑7.7公分
佛羅倫斯國家考古博物館

1st century CE
Glass
H. 6.9 cm, D. 7.7 cm
National Archeological Museum, Florence

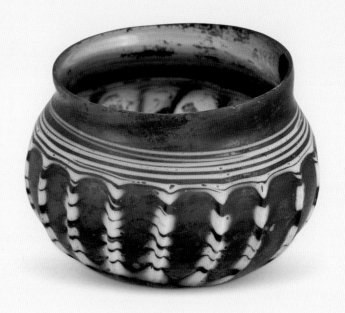

圓柱形杯
Cylindrical Glass
羅馬帝國時期
玻璃
高7.9公分，直徑7.4公分
佛羅倫斯國家考古博物館

Cylindrical Glass
Imperial Age
Glass
H. 7.9 cm, D. 7.4 cm
National Archeological Museum, Florence

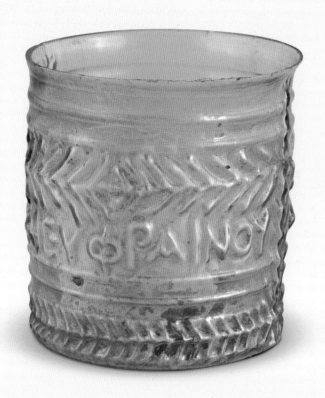

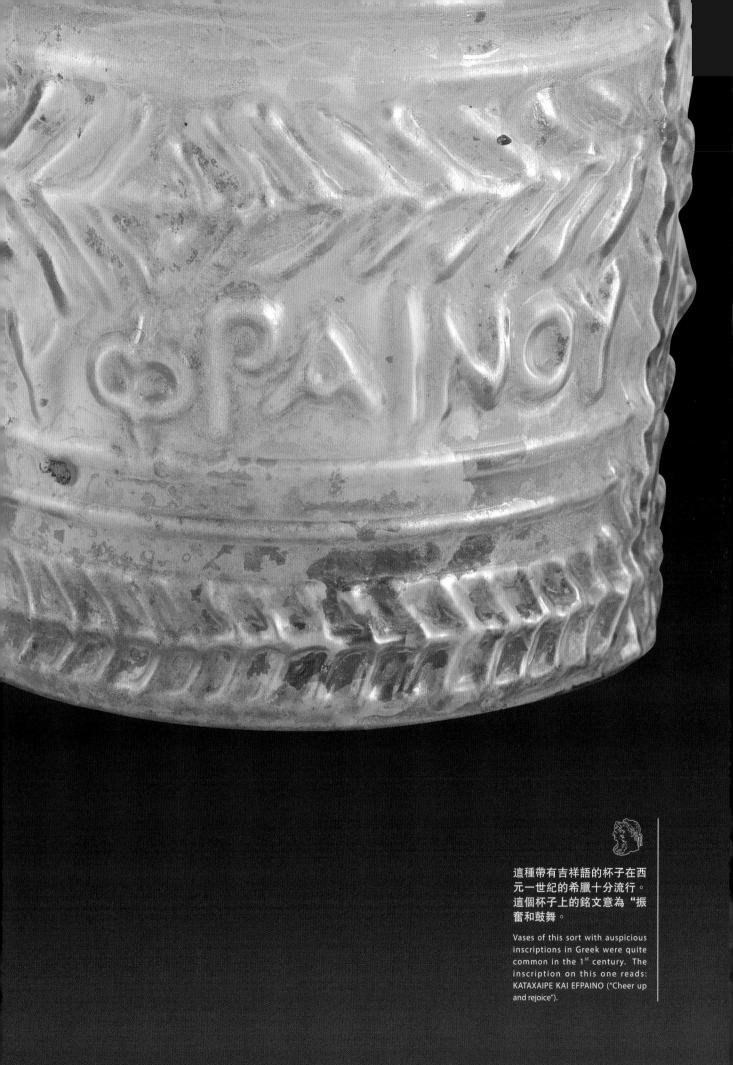

這種帶有吉祥語的杯子在西元一世紀的希臘十分流行。這個杯子上的銘文意為"振奮和鼓舞。

Vases of this sort with auspicious inscriptions in Greek were quite common in the 1st century. The inscription on this one reads: KATAXAIPE KAI EFPAINO ("Cheer up and rejoice").

銅架、銅盆
Tripode with Movable Basin
西元一世紀
銅
最高70公分，直徑44.5公分
佛羅倫斯國家考古博物館

1st century CE
Bronze
H (max). 70 cm, D. 44.5 cm
National Archeological Museum, Florence

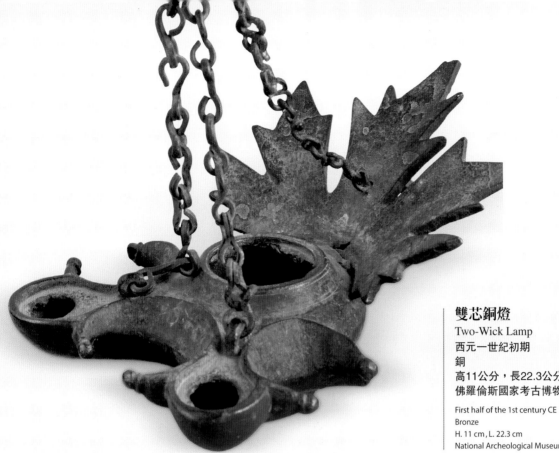

雙芯銅燈
Two-Wick Lamp
西元一世紀初期
銅
高11公分，長22.3公分
佛羅倫斯國家考古博物館

First half of the 1st century CE
Bronze
H. 11 cm, L. 22.3 cm
National Archeological Museum, Florence

這個雅致的雙燈芯燈以鏈子
懸掛於天花板上。銅燈的手
柄呈葡萄葉形狀。

This elegant two-wick lamp has an
attached chain for suspending it from
the ceiling. Its handle is in the shape
of grape leaves.

銅燭臺
Candelabra
西元前一世紀~西元一世紀
銅
高90.3公分
佛羅倫斯國家考古博物館

1st century BCE – 1st century CE
Bronze
H. 90.3 cm
National Archeological Museum, Florence

銅燭臺座
Candelabrum Base
西元一世紀
銅
高38.5公分
佛羅倫斯國家考古博物館

1st century CE
Bronze
H. 38.5 cm
National Archeological Museum, Florence

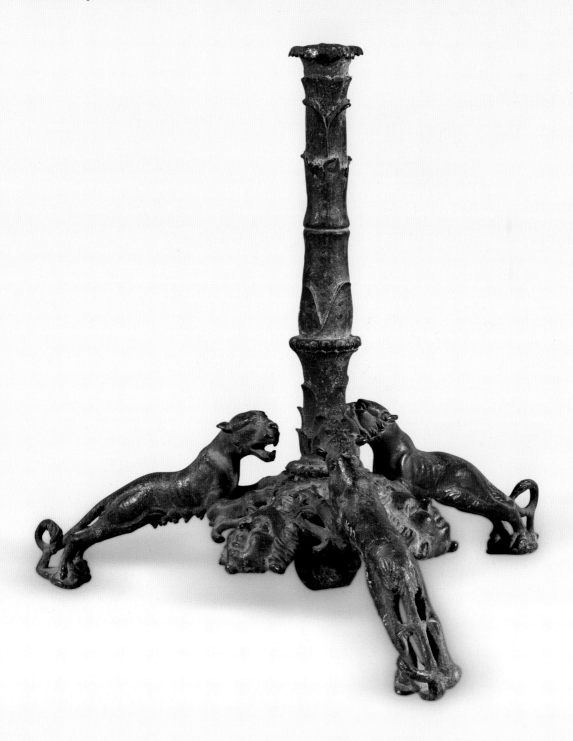

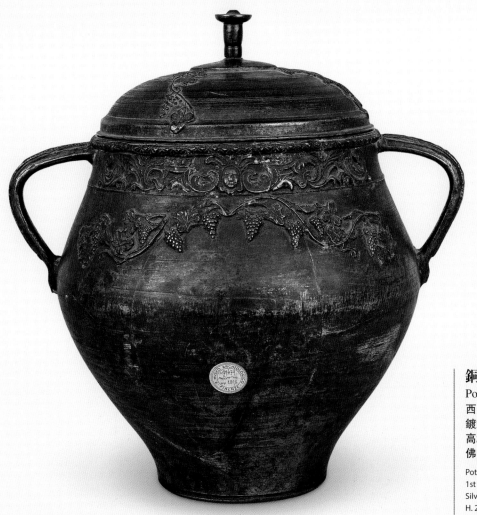

銅蓋壺
Pot with Lid
西元一世紀
鍍銀銅
高29公分，蓋直徑17公分
佛羅倫斯國家考古博物館

Pot with lid
1st century CE
Silver plated bronze
H. 29 cm, D. (lid) 17 cm
National Archeological Museum, Florence

銅燈
Lamp
西元一世紀後期
銅
高13 公分，長26.5 公分
佛羅倫斯國家考古博物館

Second half of the 1st century CE
Bronze
H. 13 cm, L. 26.5 cm
National Archeological Museum, Florence

羅馬人基本依靠油燈照明。羅馬帝國時期人們通常使用由陶土製燈，即一個封閉的壺體，頂部開有加油的小孔以及放燈芯的壺口，通常還有一個把手。貴重的油燈用銅製造而成，有些油燈可放置多枚燈芯。加鹽的橄欖油是較好的燃料，多半發黃光。也可以使用其他的油，如魚油。燈芯可由多種材料所製，如亞麻、紙草或蓖麻纖維。

The Romans depended heavily on oil lamps for artificial light. Typically the lamps used during Roman times were made of terracotta (fired clay) and consisted of a closed bowl with a hole in the top for adding oil and a spout to hold the wick. Often there was a handle. More expensive lamps were made of bronze, and sometimes a lamp would be designed to accommodate more than one wick. A favored fuel was olive oil with salt added to give the light more of a yellow color. Other oils could be used, such as fish oil. Wicks could be made of various materials such as linen, papyrus or fibers of the castor plant.

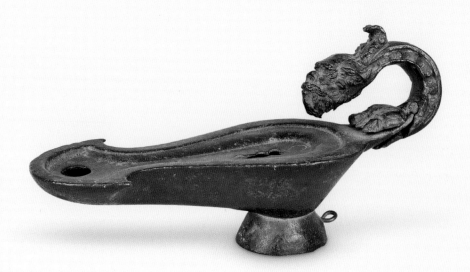

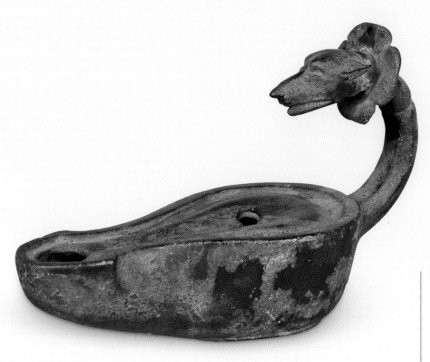

銅燈
Lamp
西元一世紀
銅
高12.7公分，長21公分
佛羅倫斯國家考古博物館

1st Century
Bronze
H. 12.7 cm, L. 21 cm
National Archaeological Museum. Florence

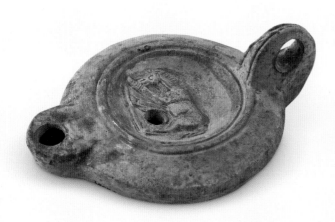

陶燈
Lamp
羅馬帝國時期
陶土
高10.7公分，直徑8公分
錫恩納國家考古博物館

Imperial Age
Terracotta
H. 10.7 cm, D. 8 cm
National Archeological Museum, Siena

月亮之神陶燈
Lamp with the Goddess Selene
羅馬帝國時期
陶土
長9.6公分，直徑6.7公分
錫恩納國家考古博物館

Imperial age
Terracotta
L. 9.6 cm, D. 6.7 cm
National Archeological Museum, Siena

這盞燈飾有月之女神塞勒涅
半身像的浮雕，其標識是她
的頭部上方懸掛新月。

This lamp is decorated with a bust in
relief of Selene (the goddess of the
Moon), recognizable by the crescent
moon above her head.

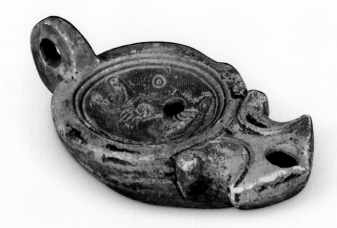

銅調羹
Spoon
西元一世紀
銅
上長14.9公分，下長15公分
錫恩納國家考古博物館

1st century CE
Bronze
L. (above) 14.9 cm, L. (below) 15 cm
National Archeological Museum, Siena

銅斗
Casserole
西元一~二世紀
銅
長27.5公分，直徑15.3公分
錫恩納國家考古博物館

1st - 2nd century CE
Bronze
L. 27.5 cm, D. 15.3 cm
National Archeological Museum, Siena

銅鍋
Cooking Pan
西元一世紀
銅
長55公分，直徑26公分
錫恩納國家考古博物館

1st century CE
Bronze
L. 55 cm, D. 26 cm
National Archeological Museum, Siena

鐵刀
Knife
西元一世紀
鐵
長29公分
佛羅倫斯國家考古博物館

1st century CE
Iron
L. 29 cm
National Archeological Museum, Florence

銅叉
Fork
西元一世紀
銅
長13.1公分
錫恩納國家考古博物館

1st century CE
Bronze
L. 13.1 cm
National Archeological Museum, Siena

銅鍋
Cooking Pan
西元一世紀
銅
高3.5公分，長56公分
佛羅倫斯國家考古博物館

1st century CE
Bronze
H. 3.5 cm, L. 56 cm
National Archeological Museum, Florence

奴隸的項圈
Slave's Collar(Torque)
羅馬帝國時期
銅
直徑13公分
佛羅倫斯國家考古博物館

Imperial Age
Bronze
D. 13 cm
National Archeological Museum, Florence

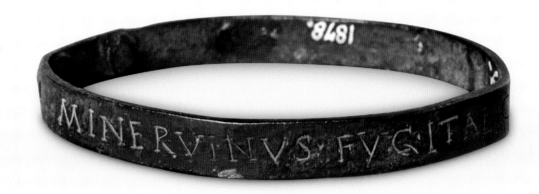

項圈用於"標識"那些曾經逃跑又被抓回主人身邊的奴隸。這個項圈暗示佩戴它的奴隸不服管教。

Collars were used to "mark" fugitive slaves once they had been recaptured and returned to their masters. The collar signaled that the slave wearing it was rebellious.

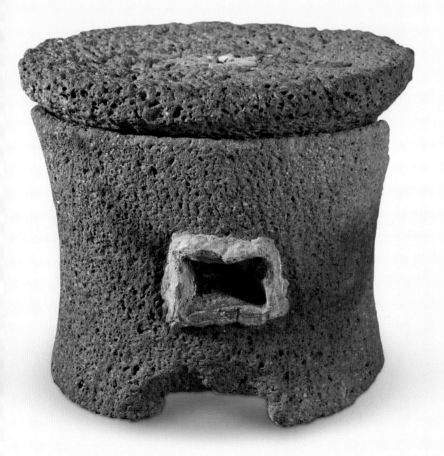

磨石
Tronco-Conic Millstone
羅馬帝國時期
石灰華
最高38公分
佛羅倫斯國家考古博物館

Imperial Age
Travertine
H. (max) 38 cm
National Archeological Museum, Florence

磨石大小不一，小至一手就能拿起，大至放置在麵包房中需要奴隸或騾子才能拖動。

Millstones existed in various sizes, from small ones like this that be turned by hand, to enormous ones in bakers' shops that were turned by slave or mule power.

羅馬的和平

PAX ROMANA

Art Historian, International Museum Exhibitions

國際博物館展覽藝術史學家

琳達·卡瑞奧尼

Linda Carioni

羅馬帝國在擴張巔峰時期，橫跨三洲大陸，北及不列顛，西至萊茵河，南到多瑙河，並佔有幼發拉底河域以西的亞洲大陸，北非的沿海和整個地中海地區。臣服於羅馬統治意味著稅收和奴役，但也意味著享受"羅馬和平"帶來的好處。羅馬帝國提供了可靠的基礎設施、軍事安全，並開放了邊貿促進當地經濟的發展。

在古代文明裡，羅馬人建造的基礎設施無人匹敵。傑出的例子是道路系統，它使帝國遙遠的邊境地區也能有效統治、管理和通商。羅馬帝國之間的溝通，尤其是軍隊在盡可能短的時間裡到達目的地的溝通至關重要，因此道路盡可能的筆直。歷史表明，羅馬人所修建的道路全長超過5萬英里，至今仍有許多道路以各種形式存在。當河山阻礙建設時，均被諸如橋樑、高架橋和連廊等宏偉工程所克服。引水橋也是羅馬的一大特點。856個公共浴場，1352個羅馬噴泉都由11個引水橋所聯通，每天能提供100萬立方的水量。

在曾為羅馬帝國的今日世界裡，隨處可見的古羅馬建築都能找到羅馬人別出心裁的設計。在羅馬帝國時期，他們的建築方式延伸到了帝國的各個角落且影響持久，其中包含了500座城市、90個露天羅馬競技場和150個戲院。羅馬持續而無可爭議的統治歸功於其非凡的軍事力量。羅馬能夠在幾個世紀中處於不敗之地，是多種因素的結果：此外，人民的戰鬥意志、嚴密的組織、軍隊的嚴格訓練、戰術和技術的優勢都是羅馬強大的原因。最初，羅馬要求每個自由公民據自身能力進行軍事培訓，在發生武裝衝突時加入軍隊。羅馬軍團發明了靈活的梯形陣勢（兩翼部隊位於中心主力前面）。在西元前一世紀，馬略組建了職業軍團，所有入伍的士兵都是羅馬公民，裝備有：頭盔、護胸甲、西班牙式短劍、盾和標槍。

在奧古斯都的統治下，羅馬軍隊又做了一次改革，此後數百年間其形式只稍有調整。每個軍團由10個大隊組成，而每個大隊分成6個分隊，每分隊80個人。指揮官是皇帝特使。17~25歲的軍人在軍團服役要滿25年，由職業軍官百夫長進行艱巨的軍訓任務。年輕士兵要學會使用各種武器、執行複雜的軍事演習、組建營地和忍受長途跋涉。在戰場上，軍訓賦予羅馬軍隊的靈活和快速的部署能力，往往就是讓敵人大為吃驚的秘密武器。另有一種值得一提的極為重要的戰術，即羅馬的龜甲陣式。軍團構成一個整體對外移動，每個甲兵只要簡單地把盾牌向外豎起就足以遮擋任何攻擊。

　　羅馬士兵都駐紮在邊界軍營，保衛國土是其永久的使命。士兵的職責還包括修建公路、橋樑、引水橋，甚至在新征服的領土開展建設。常駐營地通常建立在帝國邊境沿線的戰略要地，它會發展成一個具有浴場、醫院及劇院的集市。因此在整個羅馬帝國廣袤的土地上，軍隊起到了傳播羅馬文化的根本性作用。服役結束後，許多士兵已深深融入當地的生活，一旦退役，他們可以選擇其服役附近的一塊土地作為獎勵。

　　羅馬人還將他們壓倒性兵力的策略用於海戰，他們的軍艦上都有一個鉸鏈跳板和抓鉤（卡拉斯鐵勾），可讓大量士兵登上敵船。羅馬海軍發展之迅猛，使羅馬成為了地中海世界領先的海上力量。

　　在帝國統治期間，羅馬城的人口已經超越了100萬。供給大都市和其它羅馬城市物資的巨大挑戰都由海上運輸完成。同時，帝國擴展的省份也生產食物和供應手工藝品。事實上，創造當地財富的貿易是“羅馬和平”的重要支柱，商船比起陸地上的大篷車的運載量更多，也更快捷。為了防海盜，羅馬人建造了更小更輕便的快艇。羅馬帝國時期廣泛使用的大型陶罐作為運輸葡萄酒、橄欖油和其它食物之用。許多如精美的餐具、香水、絲綢一類奢侈品和香料等被海運到各行省以滿足羅馬各地人民的需要。

　　羅馬皇帝對海岸線的控制、港口和航線的制定給予高度重視，這也證明了海上供應系統的重要性。羅馬人認為地中海是自己的私產。然而，眾所周知拉丁文 Mare Nostrum意為“我們的海洋”。地中海流域裡徜徉的不僅有羅馬軍艦、商船和其護航艦，還有許多小艇和漁船。

At its maximum expansion, the Roman Empire encompassed Britain in the North, all of continental Europe west of the Rhine and south of the Danube, most of Asia west of the Euphrates River, the coastal areas of Northern Africa and all the Mediterranean islands. Domination and allegiance to Rome meant taxation and subjugation, but there were also benefits, signified by the expression Pax Romana, "the Roman peace." The Empire provided reliable infrastructure, military security and open borders that promoted commerce, trade and local wealth.

Among ancient civilizations, no one rivaled the infrastructure built by the Romans. One outstanding example of this is the system of roads that enabled conquest, administration and trade within its far-flung Empire. Communication between Rome, its Empire, and its armies in the shortest time possible was of paramount importance, so roads had to be as straight as possible. In all, the Romans built more than 50,000 miles of highways, many still existing in some form or another today. When rivers or hills obstructed construction, difficulties were overcome by engineering feats such as bridges, viaducts and galleries. Aqueducts were also a Roman speciality. The 856 public baths and 1,352 fountains of Rome were supplied by 11 aqueducts, capable of supplying 1,000,000 cubic meters of water per day.

Throughout the modern world in what was once the Roman Empire, testimony to the ingenuity and capability of the Romans in architecture can be found. During the Imperial age, their building program was monumental and extended to all corners of the empire, encompassing 500 cities, 90 amphitheatres, 150 theatres. The undisputed dominance that Rome exerted for such a long time was primarily due to the extraordinary military might of its armies. Invincible for centuries, Rome's military strength was the result of several factors: the warrior spirit of its people, solid organization, the extensive training of its troops, and tactical and technical superiority. In the beginning, every free citizen of Rome was called upon to arm themselves, according to their capabilities, and join their legion in times of conflict. The legion, a Roman invention, was a flexible formation of troops arranged in an echelon (two flanking units arranged ahead of a centre rear unit.) A permanent, professional army was created under the consul Gaius Marius in I BCE; all enlisted soldiers were Roman citizens, and were equally armed with the helmut, cuirass, sword (the gladium of Spanish origin), shield and javelin.

Under the reign of Augustus, the Roman army was reformed and the form it assumed would last, with only minor changes, for centuries: each legion consisted of 10 cohorts, each of which was further divided into six centuries of 80 men. The commander was called Legatus. Legionaries were enrolled at 17-25 years of age for a tour of duty lasting 25 years. Training was conducted by professional officers, the Centurions, and extremely arduous. Young soldiers learned how to handle different types of weapons, perform complex battlefield manoeuvres, build encampments and endure long marches. This training endowed Roman troops with an agility and capability of rapid deployment in the field that was often a secret weapon used to surprise the enemy. Also of utmost importance was another tactic, brilliantly employed: the testudo, a singular formation by which the legion could move forward as a single, armoured body, protected against any attack simply by turning their shields outwards both overhead and laterally.

The Roman soldier lived within the boundaries of his military camp whose maintenance and defence was his permanent duty. The soldiers' duties also included the construction of streets, bridges, aqueducts, even towns in newly conquered territories. Permanent camps, usually built in strategic location along the Empire's frontiers, evolved into larger settlements with local markets, baths, hospitals and even theatres. Thus the army itself played a fundamental role in the diffusion of Roman culture throughout the vast territories of the Empire. At the end of military service, many soldiers had developed so deep a bond with local life that once dismissed, they would choose as their reward a portion of land in the vicinity of where they had served their military duty.

The Romans applied their strategy of overwhelming force to battle at sea as well, equipping their warships with a hinged gangplank and grappling hook that permitted the boarding of the enemy ship by a superior number of men. As the Roman navy evolved so did its warships which were all quite large, enabling Rome to become the leading sea power throughout the Mediterranean world.

By the time of Imperial Rome, the city had reached a population of more than one million and the challenge to supply such a metropolis and other cities of the Empire was met through marine transport. Already much of the food supplies and artisan goods were being provided by and produced in the provinces of the extended Empire. In fact, trade which created local wealth was an important pillar of Pax Romana and merchantmen were faster and capable of carrying larger cargoes than overland caravans. To protect the merchantmen from piracy, the Romans built a smaller, lighter type of warship, the liburnian. Wine, olive oil and other foodstuffs were transported in large ceramic amphorae produced throughout the Empire. Manufactured goods such as fine tableware and luxury items such as perfume, silk and spices were also shipped from the provinces to meet the demands of Rome.

The care and attention paid by the emperors to the control of the coastline, harbours and sea routes demonstrated the importance of the maritime supply system. Romans considered the Mediterranean their own property; it was known as Mare Nostrum, our sea, and its waters constantly plied not only by large warships, merchantmen and their escorts, but also small skiffs and fishing boats as well.

軍隊
THE ROMAN ARMY

羅馬的軍事力量來自人民的勇武精神、嚴密的組織、頻繁的軍隊訓練以及在技術、戰術方面的優勢，因此幾個世紀以來戰無不勝。

最早的羅馬軍隊由羅馬的自由民組成，他們自備武器裝備，戰時就參加他們自己的軍團。西元前一世紀，奧古斯都重建了一支職業軍隊，之後的兩個世紀其架構都相對保持不變。

除了戰鬥和戍邊，軍隊也參與建設堡壘、修建道路及其它帝國基礎建設。軍隊還在傳播羅馬文化方面擔當了重要的角色。在25年服役的最後時期，許多戰士在他們服役的遙遠省份安頓了下來。

Invincible for centuries, Rome's military strength resulted from the warrior spirit of its people, solid organization, extensive training of its troops, and tactical and technical superiority.

At first Rome's armies consisted of free Roman citizens who armed themselves and joined their *legion* in times of conflict. A professional army was created during the first century BCE, reorganized under Augustus, and remained relatively unchanged in structure for the next two centuries.

In addition to fighting and guarding the frontiers, the army built forts, roads and other features of the empire's infrastructure. The military also played an important role in the diffusion of Roman culture. At the end of military service (25 years), many soldiers settled on land in distant provinces where they had served their military duty.

士兵像墓碑
Small Stela of a Soldier

西元三世紀
大理石
高30 公分，寬 20公分
佛羅倫斯國家考古博物館

3rd century CE
Marble
H. 30 cm, W. 20 cm
National Archeological Museum, Florence

碑上刻畫持矛的士兵。

The soldier is armed with a spear.

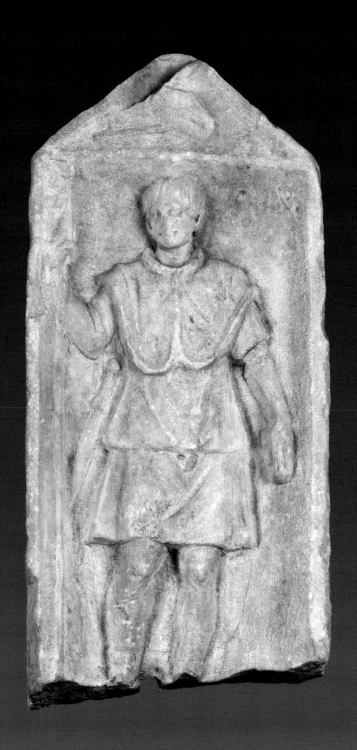

頭盔
Helmet
羅馬帝國時期
銅
最高20公分
佛羅倫斯國家考古博物館

Imperial Age
Bronze
H. (max) 20 cm
National Archeological Museum, Florence

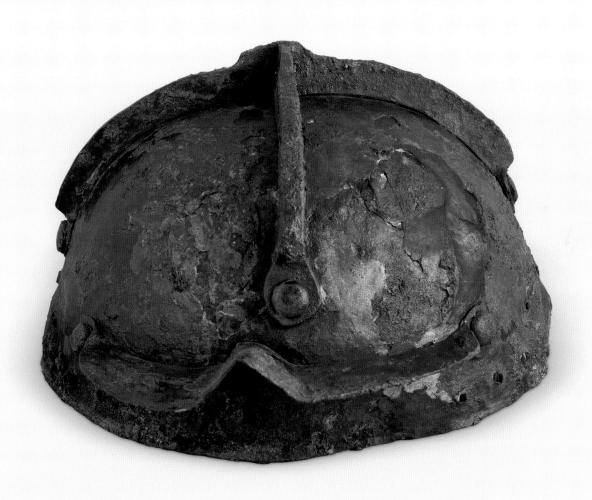

陶燈殘件
Fragment of Lamp in the Form of a Disc
西元前一世紀~西元三世紀
陶土
長15公分，寬10.5公分
錫恩納國家考古博物館

1st century BCE - 3rd century CE
Terracotta
L. 15 cm, W. 10.5 cm
National Archeological Museum, Siena

燈上飾有一個羅馬士兵的肖像。

Decoration on the lamp portrays a Roman soldier.

士兵圖陶燈
Lamp with Soldier Decoration
羅馬帝國時期
陶土
長11公分，直徑8公分
錫恩納國家考古博物館

Imperial age
Terracotta
L. 11 cm, D. 8 cm
National Archeological Museum, Siena

銅蒺藜
Tribulus (barb)
羅馬帝國時期
銅
高6.2公分
佛羅倫斯國家考古博物館

Imperial Age
Bronze
H. 6.2 cm
National Archeological Museum, Florence

帶有尖倒鉤的銅蒺藜散佈
於地面上以阻礙敵軍尤其
是騎兵的前進。

Pointed barbs like this one were
scattered on the ground to hinder
enemy advance, particularly enemy
cavalry.

銅馬具
Pendant for horse harness
羅馬帝國時期
銅
長5.2公分，寬 2.2公分
佛羅倫斯國家考古博物館

Imperial Age
Bronze
L. 5.2 cm, W. 2.2 cm
National Archeological Museum, Florence

本件源自馬具飾件，由一個方
形元件、兩片不同的盾狀片飾
組成。頂端是一小片彎曲成鉤
形的金屬舌狀物。中間部分則
飾有一個銀圈或銀環，銀環的
中心有一個鈕扣裝飾物。

This decorative pendant from a horse
harness consists of a central, square
element, with two distinct shield-
shaped pieces. The upper parts of
these pieces end in a small tongue
of metal bent back into a hook. The
central part is decorated with a silver
circle or hoop, with a button in its
center.

銅馬具
Horse Harness
羅馬帝國時期
銅
長4 公分，寬 2.6公分
佛羅倫斯國家考古博物館

Imperial age
Bronze
L. 4 cm, W. 2.6 cm
National Archeological Museum, Florence

馬具掛飾可以做多種款式，通常經裁剪或鑄造可以打開。

Pendants for horse harnesses were modeled in many styles, often with open effects obtained through cutting or casting.

銅搭扣
Buckle
羅馬帝國時期
銅
長4.2公分，寬3.7公分
佛羅倫斯國家考古博物館

Imperial age
Bronze
L. 4.2 cm, W. 3.7 cm
National Archeological Museum, Florence

銅搭扣 (帶扣)
Fibula (Buckle)
西元一世紀
銅
長5.2公分
佛羅倫斯國家考古博物館

1st century CE
Bronze
L. 5.2 cm
National Archeological Museum, Florence

銅搭扣(帶扣)
Hinged Fibula (Buckle)
西元一世紀
鍍銀銅
長5公分
佛羅倫斯國家考古博物館

Imperial Age
Silver plated bronze
L. 5 cm
National Archeological Museum, Florence

銅搭扣
Buckle
羅馬帝國時期
鍍銀銅
直徑3.2公分
佛羅倫斯國家考古博物館

Imperial Age
Silver plated bronze
D. 3.2 cm
National Archeological Museum, Florence

銅搭扣(帶扣)
Fibula (Buckle)
西元一世紀
銅和琺瑯
長4.8公分
佛羅倫斯國家考古博物館

1st century CE
Bronze and enamel
L. 4.8 cm
National Archeological Museum, Florence

銅搭扣(帶扣)
Fibula (Buckle)
西元一世紀
銅和琺瑯
長5.8公分,直徑4.3cm
佛羅倫斯國家考古博物館

1st century CE
Bronze and enamel
L. 5.8 cm, D. 4.3 cm
National Archeological Museum, Florence

士兵肖像
Head of a Warrior
西元三世紀
紅斑岩
高18公分
佛羅倫斯國家考古博物館

3rd century CE
Red porphyry
H. 18 cm
National Archeological Museum, Florence

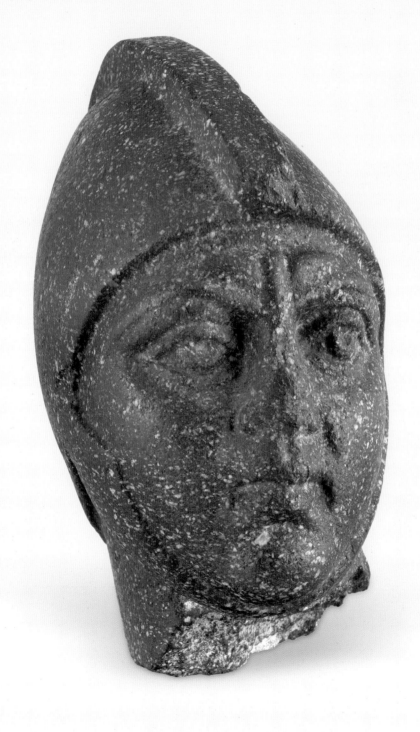

這個士兵戴著一頂有淺頂和護
頰、帽子狀的頭盔。

This soldier wears a cap-shaped
helmet with a shallow crest and cheek
guards.

士兵肖像
Head of a Soldier

羅馬帝國時期
大理石
高16公分
佛羅倫斯國家考古博物館

Imperial Age
Marble
H. 16 cm
National Archeological Museum, Florence

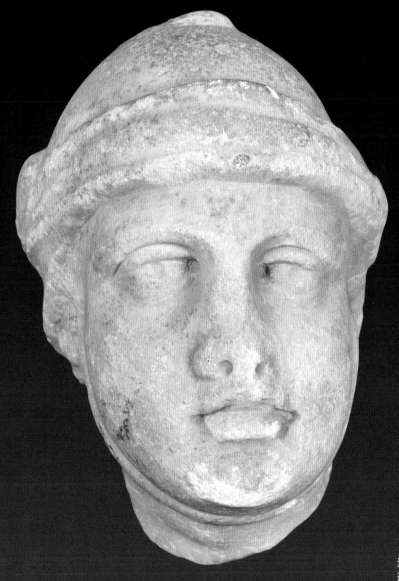

這個士兵戴著一頂出沿的球形頭盔。他的面部表情及頭部朝左，表明這尊小頭像是刻畫戰爭場面浮雕的一部分。

The soldier wears a spherical helmet with a raised visor. His facial expression and the position of his head—bent leftward and turned upward—suggest that this small head was part of a relief portraying a battle.

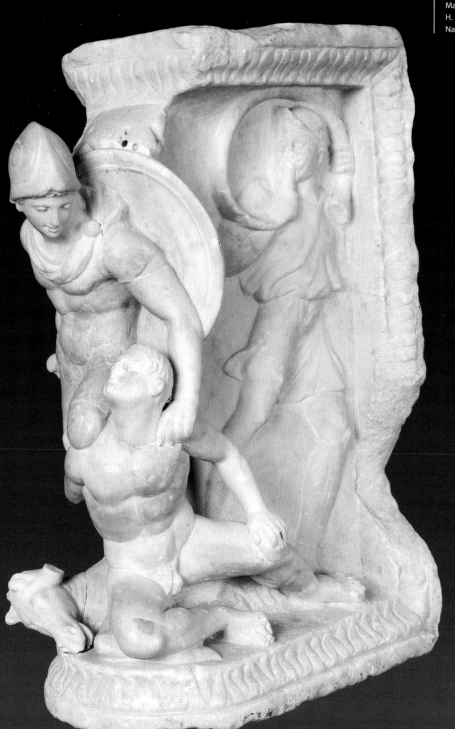

士兵和騎士浮雕桌面支架
Relief with Warrior and Knight
西元一世紀
大理石
高39公分，寬30公分
佛羅倫斯國家考古博物館

1st century CE
Marble
H. 39 cm, W. 30 cm
National Archeological Museum, Florence

這個桌面支架飾有羅馬人和蠻
族之間的戰爭場景。

This table support is decorated with a
scene of battle between Romans and
barbarians.

非洲化身銅像
Personification of Africa
羅馬帝國時期
銅
高16.4公分
佛羅倫斯國家考古博物館

Imperial Age
Bronze
H. 16.4 cm
National Archeological Museum, Florence

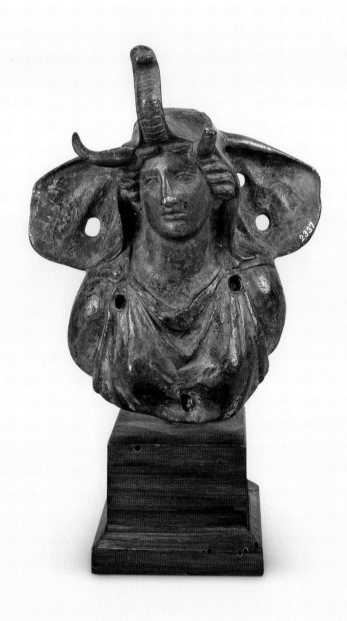

非洲化身為一位頭戴大象
皮的女性。

Africa was typically personified as a
female with head covered by elephant
skin.

達西亞人頭像
Head of a Dacian Man
圖拉眞統治時期(西元98～117年)
玄武岩
高 40公分
佛羅倫斯國家考古博物館

Reign of Trajan (98-117CE)
Basalt
H.40cm
National Archaeological Museum, Florence

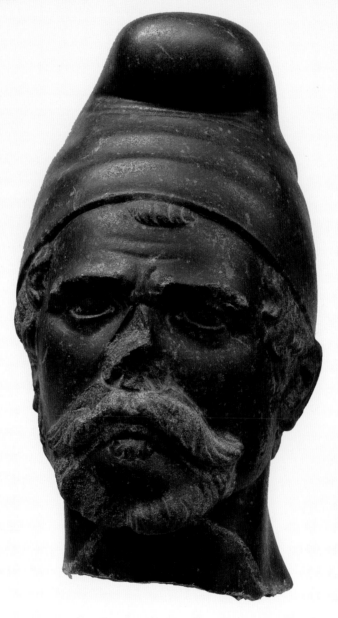

容貌特徵和帽子標誌著這是一
個達西亞人。

The physical features and cap mark
this man as a Dacian.

銅水閥
Water Valve
西元二世紀
銅
最高28公分
佛羅倫斯國家考古博物館

2nd century CE
Bronze
H. (max) 28 cm
National Archeological Museum, Florence

銅鎖具
Lock
羅馬帝國時期
銅
長8公分，寬8.5公分
錫恩納國家考古博物館

Imperial Age
Bronze
L. 8 cm, W. 8.5 cm
National Archeological Museum, Siena

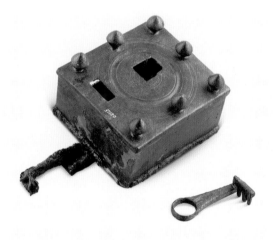

銅鑰
Key
羅馬帝國時期
銅
長4.9公分
佛羅倫斯國家考古博物館

Imperial Age
Bronze
L. 4.9 cm
National Archeological Museum, Florence

獅頭銅門環
Door-Knocker in the Shape of a Lion's Head
羅馬帝國時期
銅
直徑9.9公分
佛羅倫斯國家考古博物館

Imperial Age
Bronze
D. 9.9 cm
National Archeological Museum, Florence

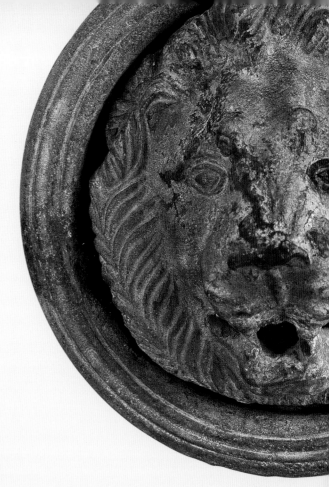

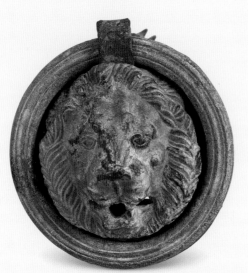

鉛潘笛殘件
Fragment of Panpipe
西元二世紀
鉛
長29公分
佛羅倫斯國家考古博物館

2nd century CE
Lead
L. 29 cm
National Archeological Museum, Florence

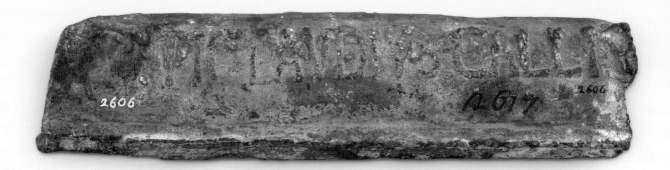

貿易與商務　TRADE AND COMMERCE

羅馬人在整個帝國發展了龐大的溝通和交通網絡，以便於軍事行動，同時也促進了商務活動。

由軍隊精心策劃並修建(或者由國家付費)的道路，連接了主要的城市。而由地方社區出資修建的二級道路，則延伸向不同的方向。地中海海岸線上港口星羅棋佈。"條條大路通羅馬"，羅馬人因此將地中海稱作"我們的海" (Mare Nostrum)。

海上運輸貨物又快又便宜。儲存在大型陶製容器雙耳陶瓶(amphorae)中的葡萄酒、糧食、橄欖油和魚醬(garum)是常見的商品。雙耳陶瓶通常有突出的底座，可以很容易地一層層的堆放起來。

The Romans developed a vast network of communications and transportation across the empire that facilitated military movement and encouraged commerce.

Carefully engineered roads built by the army (or at state expense) connected major cities, secondary roads financed by local communities branched off in various directions, and harbors dotted the shores of the Mediterranean Sea. "All roads led to Rome" and Romans referred to the Mediterranean as *Mare Nostrum* (our sea).

It was faster and less expensive to transport heavy goods by sea. Wine, grain, olive oil and fish sauce (*garum*) stored in large pottery vessels (*amphorae*) were common commodities. Amphorae often had pointed bases that made it easier to stack them in layers.

雙耳陶瓶
Amphora
西元三世紀
陶土
高94公分
佛羅倫斯國家考古博物館

3rd century CE
Terracotta
H. 94 cm
National Archeological Museum, Florence

這種被稱作"大非洲"的雙耳陶瓶製作於非洲西北部。它們用作運送魚醬汁或醃魚。在整個帝國時代，尤其是塞普蒂米烏斯·塞維魯(Septimius Severus)在位期間(西元193~211年)，非洲是羅馬和羅馬帝國西部地區的主要食物和工業製成品的原產地。

Amphorae of this type, known as *africana grande*, were produced in northwest Africa. They were used especially for transporting fish sauce or preserved fish. Throughout the Imperial period, and particularly during the reign of Septimius Severus (193-211 CE), Africa was the main source of food and manufactured goods for Rome and the Western part of the Roman Empire.

雙耳陶瓶
Amphora
西元二世紀
陶土
高84.5公分，最大直徑27公分
佛羅倫斯國家考古博物館

2nd century CE
Terracotta
H. 84.5 cm, D. (max) 27 cm
National Archeological Museum, Florence

雙耳陶瓶
Wine Amphora with Flat Bottom
西元二世紀
陶土
高63公分
佛羅倫斯國家考古博物館

2nd century CE
Terracotta
H. 63 cm
National Archeological Museum, Florence

雙耳陶瓶
Small Wine Amphora
西元一世紀
陶土
高43公分
佛羅倫斯國家考古博物館

1st century CE
Terracotta
H. 43 cm
National Archeological Museum, Florence

雙耳陶瓶

Amphora

西元二世紀

陶土

高99公分

佛羅倫斯國家考古博物館

2nd century CE

Terracotta

H. 99 cm

National Archeological Museum, Florence

雙耳陶瓶

Amphora

西元二世紀

陶土

高150公分

佛羅倫斯國家考古博物館

2nd century CE

Terracotta

H. 150 cm

National Archeological Museum, Florence

雙耳陶瓶
Amphora
西元二世紀
陶土
高100公分
佛羅倫斯國家考古博物館

2nd century CE
Terracotta
H. 100 cm
National Archeological Museum, Florence

雙耳陶瓶
Amphora
西元一~三世紀
陶土
高94公分
佛羅倫斯國家考古博物館

1st - 3rd century CE
Terracotta
H. 94 cm
National Archeological Museum, Florence

雙耳陶瓶
Amphora
西元二世紀
陶土
高120公分
佛羅倫斯國家考古博物館

2nd century CE
Terracotta
H. 120 cm
National Archeological Museum, Florence

雙耳陶瓶
Amphora
西元二世紀
陶土
高100公分
佛羅倫斯國家考古博物館

2nd century CE
Terracotta
H. 100 cm
National Archeological Museum, Florence

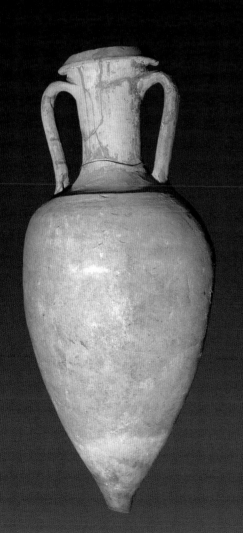

雙耳陶瓶
Wine Amphora
西元一世紀
陶土
高100公分
佛羅倫斯國家考古博物館

1st century CE
Terracotta
H. 100 cm
National Archeological Museum, Florence

雙耳陶瓶
Amphora
西元一世紀
陶土
高約90公分
佛羅倫斯國家考古博物館

1st century CE
Terracotta
H. (circa) 90 cm
National Archeological Museum, Florence

雙耳陶瓶
Amphora
西元一世紀
陶土
高約110公分
佛羅倫斯國家考古博物館

1st century CE
Terracotta
H. (circa) 110 cm
National Archeological Museum, Florence

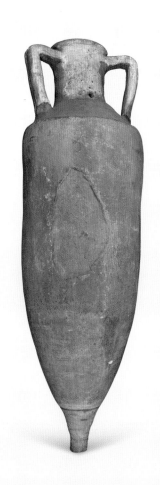

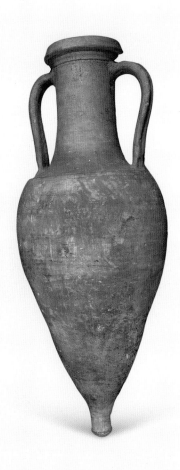

雙耳陶瓶瓶
Amphora
西元一世紀
陶土
高約90公分
佛羅倫斯國家考古博物館

1st century CE
Terracotta
H. (circa) 90 cm
National Archeological Museum, Florence

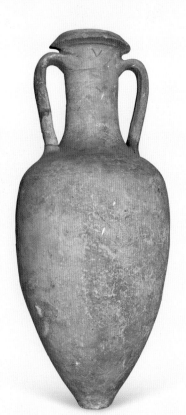

雙耳陶瓶
Amphora
西元一世紀
陶土
高約90公分
佛羅倫斯國家考古博物館

1st century CE
Terracotta
H. (circa) 90 cm
National Archeological Museum, Florence

結語
文化遺產 LAST WORD LEGACY

Art Historian, International Museum Exhibitions
Linda Carioni

國際博物館展覽藝術史學家
琳達・卡瑞奧尼

在羅馬帝國文化的大熔爐裡，羅馬統治者傳統上對其它宗教的崇拜和信仰，包括占星術和巫術都相當寬容和開放，然而在怎樣處理基督教上卻猶豫不決。基督教因堅持只有一個上帝，近乎威脅到了帝國宗教寬容原則，此原則保證帝國人民享有永久的宗教和平。同時，基督徒拒絕膜拜凱撒大帝(羅馬皇帝)，這也與帝國官方宗教產生了衝突。如此一來，在羅馬人的心中便判定了基督徒對羅馬的不忠和背叛。然而從西元四世紀，也就是西元313年開始，新皇帝君士坦丁皈依了基督教，並且恢復了宗教寬容原則，基督教因此變得日益盛行。西元380年，狄奧多西(Teodosius)皇帝正式宣佈基督教爲帝國的官方宗教。

隨著後來神聖羅馬帝國時期(西元962年)的宗教發展，羅馬文明的遺產已深深根植於今天的西方文化。在羅馬帝國的幾個世紀中，博大精深的羅馬文化廣爲傳播，爲當今曾屬於這個昔日龐大帝國的社會和國家，或多或少的共通性提供了依據。羅馬人統治的持久影響幾乎隨處可見。它們體現在我們的司法、貨幣體系裡，也體現在我們的藝術和建築遺產中。許多人所說的現代羅曼語也是從拉丁語系(如義大利語、英語、法語、葡萄牙語和西班牙語、羅馬尼亞語)演變而來，我們今天仍在運用的26個字母表，以及一年365天分12個月的儒略曆等，都進一步的說明它們曾是羅馬帝國的遺產。

In the melting pot of cultures that was the Roman Empire, the Roman rulers were traditionally quite tolerant and open to other religious cults and beliefs, including astrology and magic, however, they hesitated over how to deal with Christianity. With its insistence on only one god, Christianity seemed to threaten the principle of religious toleration which had guaranteed religious peace for so long among the people of the Empire and clashed with the official state religion of the Empire, in that Christians refused to worship Caesar. This, in the Roman mindset, demonstrated their disloyalty and treason, however, by the beginning of the IV century CE, Christianity had grown so widespread that in 313 CE, the new emperor Constantine converted to Christianity and restored religious tolerance. In 380 CE, Christianity was declared the official religion of the Empire by Emperor Teodosius.

Beyond religious ramifications of the subsequent Holy Roman Empire, the legacy of Roman civilization is deeply embedded in the western culture of today. The profound and pervasive heritage of Roman culture, so widely diffused during the centuries of Imperial Rome, has provided the basis for the many or few common denominators shared today by the societies and nations of its once vast Empire. The lasting effects of Roman rule can be found almost everywhere. They can be seen in our judiciary and monetary systems, in our art and architectural patrimony. Many populations speak in the modern Romance languages evolved from Latin (Italian, French, Portuguese and Spanish) and English as well has ties to Latin. The alphabet of 26 letters, as well as the calendar of Julius Caesar comprised of 365 days, grouped into 12 months, that we use today, are further testimony to the legacy of what was once Imperial Rome.

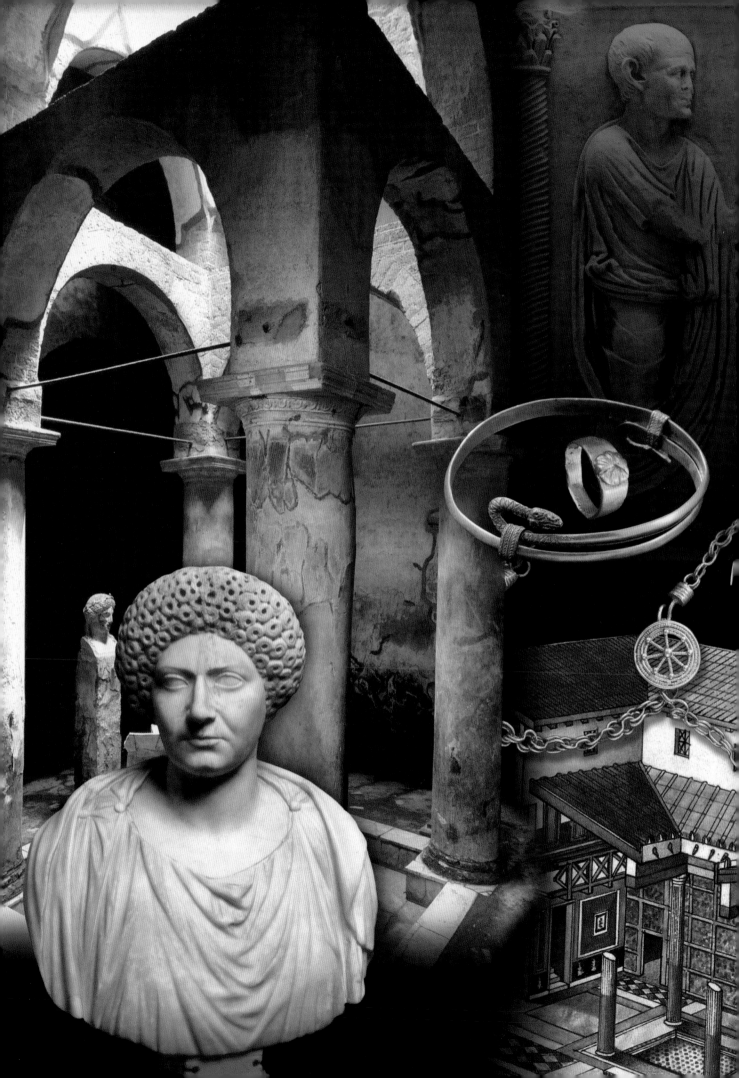

附　錄
APPENDIX

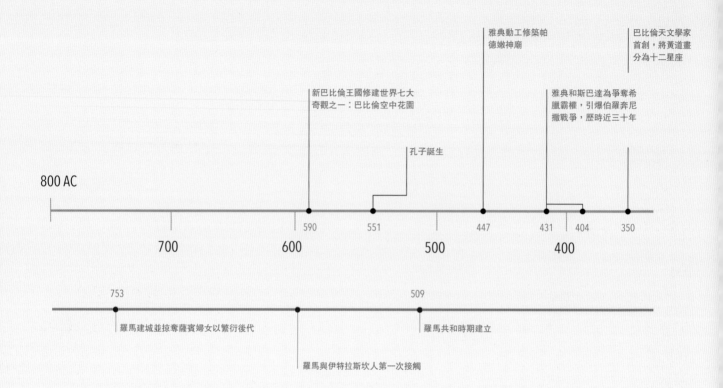

雅典動工修築帕
德嫩神廟

巴比倫天文學家
首創，將黃道畫
分為十二星座

新巴比倫王國修建世界七大
奇觀之一：巴比倫空中花園

雅典和斯巴達為爭奪希
臘霸權，引爆伯羅奔尼
撒戰爭，歷時近三十年

孔子誕生

800 AC

590 551 447 431 404 350

700 600 500 400

753 509

羅馬建城並掠奪薩賓婦女以繁衍後代

羅馬共和時期建立

羅馬與伊特拉斯坎人第一次接觸

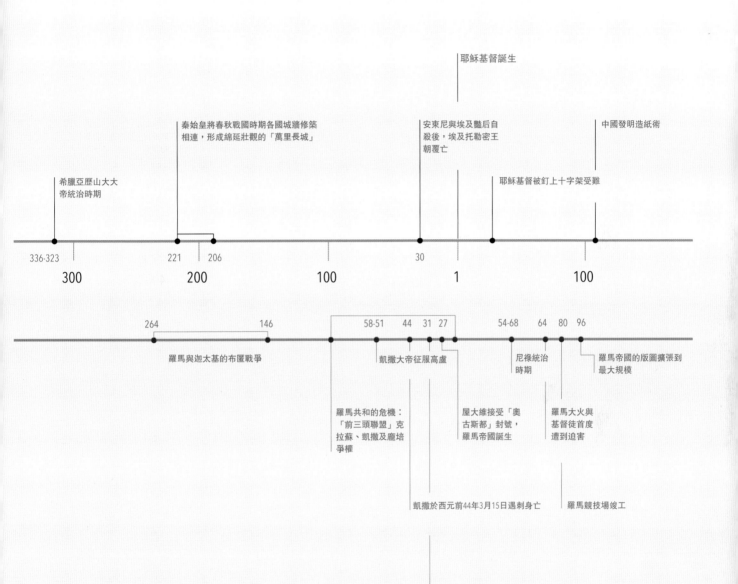

耶穌基督誕生

秦始皇將春秋戰國時期各國城牆修築
相連，形成綿延壯觀的「萬里長城」

安東尼與埃及豔后自
殺後，埃及托勒密王
朝覆亡

中國發明造紙術

希臘亞歷山大大
帝統治時期

耶穌基督被釘上十字架受難

336-323

300 200 100 1 100

264 146

58-51 44 31 27 54-68 64 80 96

羅馬與迦太基的布匿戰爭

凱撒大帝征服高盧

尼祿統治
時期

羅馬帝國的版圖擴張到
最大規模

羅馬共和的危機：
「前三頭聯盟」克
拉蘇、凱撒及龐培
爭權

屋大維接受「奧
古斯都」封號，
羅馬帝國誕生

羅馬大火與
基督徒首度
遭到迫害

凱撒於西元前44年3月15日遇刺身亡

羅馬競技場竣工

屋大維於希臘亞克興海戰打敗安
東尼，奪得羅馬霸權

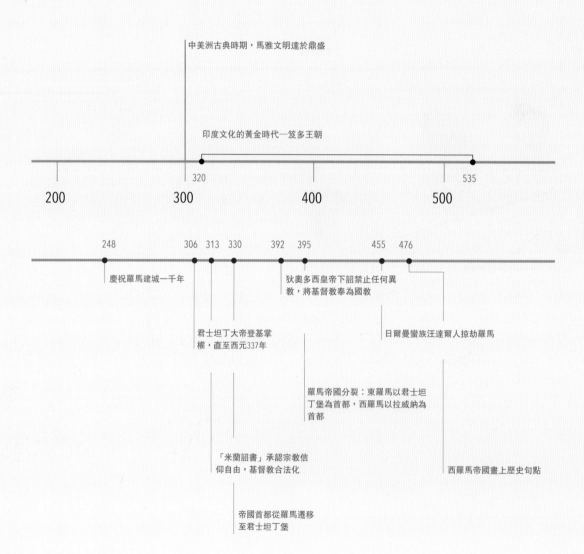

中美洲古典時期，馬雅文明達於鼎盛

印度文化的黃金時代—笈多王朝

320　　　　　　　　　　　　　　　535

200　　　300　　　400　　　500

248　　　306　313　330　　392　395　　455　476

慶祝羅馬建城一千年

狄奧多西皇帝下詔禁止任何異
教，將基督教奉為國教

君士坦丁大帝登基掌
權，直至西元337年

日爾曼蠻族汪達爾人掠劫羅馬

羅馬帝國分裂：東羅馬以君士坦
丁堡為首都，西羅馬以拉威納為
首都

「米蘭詔書」承認宗教信
仰自由，基督教合法化

西羅馬帝國畫上歷史句點

帝國首都從羅馬遷移
至君士坦丁堡

伊斯蘭教的先知穆罕默德，開始傳揚眞主啓示，
在麥加講道

查理大帝征服北方撒克遜人

612

785

600 700 800

即使羅馬帝國步入歷史，古羅馬文化
依舊輝煌。西元800年，教宗利歐三
世為法蘭克國王查理一世加冕為「羅
馬人的皇帝」；直至今日，古羅馬遺
跡與文化遺產，仍遍存於歐洲與西方
世界，俯拾皆是。拉丁文是西方語系
大多數字彙、片語的母源，而在西方
建築、行政體制、司法系統、宗教、
曆法與貨幣，無不存在著羅馬帝國的
深遠影響。

Although Imperial Rome eventually declined, its
legacy continued. In 800 AD, Charlemagne was
crowned Imperator Augustus by Pope Leo III. Even
today, the Roman legacy can be seen throughout
the western world and in virtually every aspect
of European society. Most of our languages
are rich with words and phrases derived from
Latin. Imperial Rome survives as well in our
architecture, government, judiciary system,
ecclesiastical structures, calendar and currency.

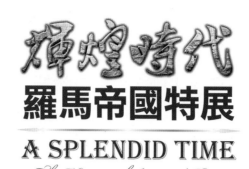

輝煌時代
羅馬帝國特展
A SPLENDID TIME
The Heritage of Imperial Rome

主辦單位	國立中正紀念堂管理處、聯合報系、義大利佛羅倫斯國家考古博物館
協辦單位	意中橋(上海)會議展覽有限公司、義大利CP公司
特別感謝	義大利文化遺產部、托斯卡那考古文化遺產局
展覽策畫	吳祖勝、梁永斐、張美美、簡惠文、黃素娟、李佳諭、鄭清煌、李威
展覽籌備	蔡怡怡、戴元琳、花穎潔、賴素鈴、蕭莉蓉、陳韻如、黃軍豪、呂明哲 劉育光、李孟璇、曾建瑋、周靜芝、侯淑穎、傅瑪琍、萬淑美
發　行	聯合報系
發行人	黃素娟
審　稿	劉增泉
校　稿	劉育光、李孟璇
出版者	聯合報股份有限公司 21161新北市汐止區樟樹里001鄰大同路一段369號2樓 TEL：(02)8692-5588　FAX：(02)8643-3548
定價	新台幣1000元